DESIGNING WEB SITE IMAGES:
A Practical Guide

Gene Berryhill, Ph.D.

DESIGNING WEB SITE IMAGES:
A Practical Guide

Gene Berryhill, Ph.D.

Delmar
Thomson Learning™

Africa • Australia • Canada • Denmark • Japan • Mexico
New Zealand • Philippines • Puerto Rico • Singapore
Spain • United Kingdom • United States

NOTICE TO THE READER

Publisher does not warrant or guarantee any of the products described herein or perform any independent analysis in connection with any of the product information contained herein. Publisher does not assume, and expressly disclaims, any obligation to obtain and include information other than that provided to it by the manufacturer.

The reader is expressly warned to consider and adopt all safety precautions that might be indicated by the activities herein and to avoid all potential hazards. By following the instructions contained herein, the reader willingly assumes all risks in connection with such instructions.

The publisher makes no representation or warranties of any kind, including but not limited to, the warranties of fitness for particular purpose or merchantability, nor are any such representations implied with respect to the material set forth herein, and the publisher takes no responsibility with respect to such material. The publisher shall not be liable for any special, consequential, or exemplary damages resulting, in whole or in part, from the readers' use of, or reliance upon, this material.

Delmar Staff:

Publisher: Alar Elken
Acquisitions Editor: Tom Schin
Editorial Assistant: Fionnuala McAvey
Executive Marketing Manager: Maura Theriault
Channel Manager: Mona Caron
Executive Production Manager: Mary Ellen Black
Production Coordinator: Larry Main
Art/Design Coordinator: Nicole Reamer/Rachel Baker

*T385
.B4658
2000*

Printed in Canada
2 3 4 5 6 7 8 9 10 XXX 05 04 03 02 01 00

For more information, contact Delmar, 3 Columbia Circle, PO Box 15015, Albany, New York, 12212-5015; or find us on the World Wide Web at http://www.delmar.com

Asia:
Thomson Learning
60 Albert Street, #15-01
Albert Complex
Singapore 189969

Japan:
Thomson Learning
Palaceside Building 5F
1-1-1 Hitotsubashi, Chiyoda-ku
Tokyo 100 0003 Japan

Australia/New Zealand:
Nelson/Thomson Learning
102 Dodds Street
South Melbourne, Victoria 3205
Australia

UK/Europe/Middle East:
Thomson Learning
Berkshire House
168-173 High Holborn
London
WC1V 7AA United Kingdom

Thomas Nelson & Sons LTD
Nelson House
Mayfield Road
Walton-on-Thames
KT 12 5PL United Kingdom

Latin America:
Thomson Learning
Seneca, 53
Colonia Polanco
11560 Mexico D. F. Mexico

South Africa:
Thomson Learning
Zonnebloem Building
Constantia Square
526 Sixteenth Road
P.O. Box 2459
Halfway House, 1685
South Africa

Canada:
Nelson/Thomson Learning
1120 Birchmount Road
Scarborough, Ontario
Canada M1K 5G4

Spain:
Thomson Learning
Calle Magallanes, 25
28015-MADRID
ESPAÑA

International Headquarters:
Thomson Learning
International Division
290 Harbor Drive, 2nd Floor
Stamford, CT 06902-7477

ISBN: 07668-1484-X

Dedication

To Alan Cole:

Professor, mentor, boss, and good friend.
You were the best.

CONTENTS

PREFACE

Change is often slow and difficult as we move away from what is familiar, comfortable, and currently acceptable. There is the fear expressed by some that technology will gain the upper hand and designers will no longer have a strong voice. In reality, when the new technology is learned and applied in conjunction with creative output, there is great strength and power. Designers and artists must realize that they have the raw technical abilities necessary just waiting to be tapped and used in new, exciting ways and on a much larger scale. Imagine, the Internet has no limitations; it is wide open. As designers, we can create and further this far-reaching visual architecture, this image as a place, the web site.

Designing Web Site Images: A Practical Guide pulls out the basic material that web site students need and makes it readily accessible. Many do not have access to, or the time to do extensive reading and research required with some of the larger, more involved books and user manuals to find the core information; perhaps the creative side is surging forward and cannot wait to get up and running. This book is a practical, straight–forward approach to web object design streamlined into simple, step-by-step instruction with projects, on–line tutorials, and recommended downloads in the chapters. It primarily covers creation and handling of graphics for the web in Adobe Photoshop, because most computer labs have this software. There are image management strategies, compression, palettes, graphic creation and manipulation, conversion, working with display text, simple animations, and "onionskinning" techniques for animation.

Instruction in HTML, Javascript, and CSS is included when directly related to specific images or text handling. These sections are brief and to the point. Resources for more extensive information and tutorials on these topics can be found in the appendices. Also within the text and appendices are the freeware and shareware application suggestions that work with the chapters, demos for the newer softwares out on the market, helpful URLs, and brief reviews of other web-related softwares.

Special features are: the overview of design chapter, which includes design tips relevant to web sites; the chapter on color covers psychology and color for web sites; and the typography section

deals with specific information about type and logo creation for web sites. Within Delmar Publishers' site, I will be providing on–line updates of the book, handling new information as it arises. With constant changes of hardware, software, techniques, and technologies related to web site image creation, this feature will keep fresh material coming between print editions. I will also potentially be offering downloads, tips, fielding questions and addressing other needs and issues for readers.

The major goals of *Designing Web Site Images: A Practical Guide* are finding the balance between quality and compression of imagery for quick viewer access, and to assist in the creation of visual language that offers opportunity for direct connection—design of inspiration and meaningful human interaction.

ACKNOWLEDGMENTS

Thanks to Molly Schneider, Director of Design Programs, University of California Irvine Extension, for her flexibility, support, and understanding, and for giving me the opportunity to teach web media design, from which this book sprang. Thanks also to the UCI team and staff. Special thanks to my students for their questions, comments, support, and criticisms. I appreciate their willingness to take risks and experiment when the known was not yet apparent. All of the credit goes to them for their unique innovations I've had the privilege to watch unfold. Gratitude is also due to my family for their love, encouragement, patience, and support.

The author and publisher wish to thank the following individuals who reviewed the manuscript and provided valuable comments:

Donna Loper
 Clark College
 Vancouver, WA

David Oscarson
 Brevard Community College
 Merritt Island, FL

Richie and Gina Prosch
 Lohman Hills
 Laurens, SC

Garret Romaine
Portland State University
Aloha, OR

Brian O'Day
Milwaukee Graphics Art Institute
Milwaukee, WI

Dan Johnson
Northwest Technical College–Moorhead
Moorhead, MN

Eric Montgomery
Arizona State University
Phoenix, AZ

John Nkemnji
University of Wisconsin
Platteville, WI

Bob Winberry
Winberry Studios
Long Beach, CA

INTRODUCTION

THIS INTRODUCTION WILL DISCUSS:

➤ Design Background
➤ Typography Background
➤ Modernism, the International Style, and Postmodernism

DESIGN BACKGROUND

It is interesting to note that great changes occur in the arts due to technological advances, which bring new ways to see, and therefore make design. The Renaissance is benchmarked as the dawn of modern science. Leonardo da Vinci , the great artist/scientist/inventor, demonstrated his visions of art and technology through anatomical studies and technological inventions. He had the unique ability to draw a single frame of a moving object. He also painted the *Last Supper*, further demonstrating his technical abilities with new innovations of perspective drawing. Earlier, the painter Giotto, reacting to a previous period of handcrafting, embraced Euclid's geometric principles of space and applied them to perspective, the mathematical technique of visually conveying three-dimensional objects and scenes on a two-dimensional surface. Giotto's use of the ordinate (y) and abscissa (x) gave us the horizontal and vertical axis from which to begin at a single stationary point for perspective. In the seventeenth century, Decartes' x and y coordinates were based on these same Euclidean principles. Various computer graphics softwares utilize these coordinates to help the designer create and place objects with precision (Figure I–1).

In the sixth century B.C., the Greek philosopher Pythagoras, asking questions about nature, found mathematics and geometry, symmetry, and the numerical ratios that make up underlying structures of things, including musical harmony. Symmetrical balance was considered perfect or ideal. The Greek formulation

| X: 0.951" | W: 6.562" | △ 0° | → | ⇕ auto | ☰☰☰▷ TimesNewRomanP ▷ 13 pt |
| Y: 1.611" | H: 9.275" | Cols: 1 | ↑ | | ☰☰ P **B** *I* ⓞ ⑤ ⑨ U̲ W̲ ᴋ ᴋ̲ ᶻ̲ ² |

QuarkXPress

Navigator	Info	Options	▶
R : 255		C : 0%	
G : 255		M : 0%	
B : 255		Y : 0%	
		K : 0%	
✚ X : 6.069		W :	
Y : 1.542		H :	

Photoshop

Info	Align	Transform
X: 7.5833 in		W: 0 in
Y: 9.1944 in		H: 0 in

Illustrator

◾ **Figure I–1.**

of the 3-to-5 ratio of the Golden Mean was meant to express ideal beauty and harmony. Plato admired Pythagoras and promoted the concept of a few ideal shapes as the foundation of the myriad of forms in the visible world. These symbols were the circle, square, and triangle. Add the cross or X to complete the basic set of abstract forms innate to the human psyche. Aristotle agreed with Plato about perfect form. Coupled with Euclid's organization of space, this is the foundation of design and form as we know it today, plus the visual basis for Western written language. (See figures I–2, I–3, I–4, I–5, I–6, I–7.)

◾ **Figure I–2.** Sumerian pictograph

Figure I–3. Babylonian Cuneiform

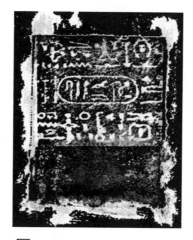

Figure I–4. Egyptian Cartouche

Figure I–5. Phoenician Linear B

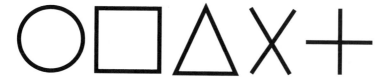

Figure I–6. Symbols to alaphabet

Figure I–7.

Before Giotto, pictures were relatively flat and symbolic. Art then shifted from sacred symbolism to a visual realism. The human being became the new hero of the age, gaining importance over God as authority, thus the rise of humanism. Ancient Greek thought was embraced from a number of sources, and as Protagoras said, "Man is the measure of all things that he is and that he is not." The concept of the continuous narrative and simultaneous representations were replaced with Giotto's frame of stopped time. More recently, the idea of the continuous narrative has resurfaced, with Modernism and then with the postmodern concept of interactivity. The new vision born during the Renaissance was that art no longer functioned as a divine symbol but as the naturalistic picture of an imaginary world. This almost sounds like the beginnings of advertising.

Also in the fifteenth century, Johannes Gutenberg of Mainz, Germany, developed the modern printing press and printed the Gutenberg Bible. He cast metal fonts and worked with the chemical development of inks that would better adhere to metal type. Nicholas Jenson was cutting dies and running one of the first printing presses in Venice, leading the way to Italian book design. He was one of history's greatest typeface designers and a master of kerning. Albrecht Durer, besides being a painter and printmaker, experimented with printing and type design, using the mathematical 10 to 1 ratio for letter proportions, like da Vinci used for drawing the human figure (Figure I–8). Durer also published a book on perspective in 1525.

Between the sixteenth and seventeenth centuries, due to the next major innovation in technology, another new way of seeing presented itself through an up-and-coming scientist, Galileo. He came across a Dutch invention, ground glass lenses attached to each end of a tube. The result was the telescope, giving the ability to see at great distance, things no one had seen before. Within the same year that Galileo died, Sir Isaac Newton was born. Newton continued the path that Descartes and Galileo had begun involving gravity, motion, and light.

Figure I–8. Durer's 10 to 1 ratio

The Industrial Revolution, occurring between 1760 and 1840, marked the arrival of mass communication. Printing presses were steam driven and massive amounts of printed materials were produced. Books, now placed into the hands of the common people, allowed individuals to read and learn on their own. There was a drift away from learning as a group experience. Individuality, begun during the Renaissance, continued to dominate art and thought in Western civilization. Lithography, or stone printing, was invented in 1796 in Bavaria. The technique was based on the principle that oil and water do not mix. Crayon was used to draw on the stone, which was then saturated with water. Oil-based ink was rolled over the stone, and then paper was placed over the image on the stone and pressed to make a print. These advancements in technology enabled the ability to draw any shape or form including type with crayon on a stone without the restrictions of metal or wood dies. Chromolithography, or color printing was developed in Germany. William Sharp brought it to the United States in 1883. This innovation led to the development of color separations or the four-color process. Designers today commonly know it as CMYK (cyan, magenta, yellow, and black). Refer to Chapter 4, Color and Palettes, for more information on CMYK.

The next major advance that affected design and the way we see was the invention of photography (writing with light) through cameras, lenses, and microscopes. In 1822 John Niepce produced the first photographic image, a sun engraving. William Talbot pioneered the photogram in 1826 and the negative in 1839. Louis Daguerre furthered the chemical process of print development by perfecting the silver–plated copper technique in 1839. The result was a vibrant print of mercury and silver compounds that varied in density in proportion to the amount of light given during exposure. The black box known as the camera obscura (Italian words meaning "dark room") was used to make the exposures. In 1880, the first photograph was published in the *New York Times*, using a half-tone screen. Manet, strongly influenced by the new photographic advances and the momentary time frame, rebelled against the prevailing ideas of realism and perspective that were established during the Renaissance. To the outrage of his contemporaries, he produced his new work and stated, "From now on, I will be of our times and work with what I see" (Shlain 102, 1991). Many believe that his new work shown in 1863 marked early beginnings of modernism.

During the 1880s, Eadweard Muybridge's groundbreaking

photography was the beginning of motion picture photography. He was commissioned to shoot a running horse to see if all four legs were off the ground simultaneously during movement. Using twenty-four still cameras, he equipped them with rapid drop shutters that slammed down by springs and rubber bands. This was the first effort since Giotto and da Vinci's motion studies to solve the frozen single frame problem in order to see the full range of a particular movement.

The modernist period, partly fueled by destructive use of technology during World War I, shook Western civilization. Traditional views including those about art and design were shattered. Ideas about color, form, and composition were changed by social and psychological uprisings proclaimed by Marx and Freud. New visions due to photography and the technologies of war continued within twentieth century graphic design with influences coming from cubism and futurism. Avant–garde groups used photography either as photomontage or indirectly with shattering and fragmentation. Cubism demonstrated the concept by showing sections of top, bottom, back, front, and sides simultaneously. Sequenced photography played a part in this idea. Countering abstract expressionism, Picasso and Duchamp rallied the cubists, and visual sequencing was highly influential, such as Duchamp's *Nude Descending the Stairs*. Other visual language movements during this period were dada, surrealism, deStijl, suprematism, and constructivism. Constructivists and futurists glorified the machine as a tool and the machine aesthetic as a style. Cubists suppressed the machine aspect except for the use of photography, and moved toward abstraction of form. Dada used the machine as an icon to comment on politics and society, generally in a nonsensical way. The work was chaotic and meant to insult the establishment. The use of irony produced irrational and contrived pieces composed of machine parts and photocollage. In 1919, Hanna Hoch designed with recycled materials, showing chance positioning with planned decisions.

Russian constructivists welcomed the Machine Age, believing that science, technology, and industry were liberating, leading to the combination of art and life. They hoped to build a new Russia and create a new social order. Rodchenko, famous for his black painting, Malevitch, and architect El Lissitsky were major forces. Often, primary colors were used and reductiveness was applied in Malevitch's *White Square*. Stalin's rise to power in 1925 ended this experimental period. Italian futurists like Severini and Marinetti

also embraced the Machine Age, by visually creating unrestrained energy. They held a positive association with power, destruction, and war. Surrealists like Dali, Magritte, Miro, and Arp incorporated ambiguous scale changes and unexpected compositions defying laws of gravity and light, instigating a new dialog about reality and illusion, truth, and fiction. The term *surrealism* means super reality, and was coined to promote hope and faith in humanity. The founder, poet Andre Breton, proposed the mysteries of the subconscious, modeled after Freud's principles. Surrealism, expressing inner life, often used organic symbols and naturalistic form that also influenced photography. Two photographers of significance were Alfred Steiglitz and Man Ray, who utilized solarization and photograms.

Many believe the Bauhaus to be the most important graphic and industrial design institute of the twentieth century, and we still adhere to many of the foundational principles set forth by this influential school. Walter Gropius, director in Weimar, Germany, founded the school in 1919 out of the ashes of World War I; it operated for twenty years, slotted between World War I (1914–1919) and World War II (1939–1945). Gropius was an architect, and as director, officially named the school Das Staatliches Bauhaus. The Bauhaus Manifesto was written and published, which focused on promoting a new social order for the rebuilding of Germany. In the creed, it stated that "the complete building is the ultimate aim of all the visual arts." Designers, artists, and artisans were to strive for the best quality in their work. Good design was applied to low–cost consumer products. Measured proportions and the use of grids were brought to the Bauhaus by Mondrian (deStijl) and El Lizzitsky (Russian suprematism). The Greek golden mean (the ideal of balance in composition) was adopted. There was a new unity of art and technology, and one goal was to solve the problems of the industrial age visually. It was believed that the artist could "breathe life into the dead soul of the machine."

The Bauhaus' goals were to integrate fine and applied art, unify life with design, and create social change and cultural revitalization. Clarity of communication was achieved through compositional principles; the camera was fully realized and used as a design tool. Some notable faculty were Paul Klee, Wassily Kandinsky, Johannes Itten, El Lissitsky, Theo van Doesburg, Piet Mondrian, Lazlo Moholy-Nagy, Herbert Bayer, and Joseph Albers. Bayer and Albers were former students who eventually

taught at the new campus at Dessau, established in 1924. Herbert Bayer created the Bauhaus sans serif typefont. The constructivist attitude of "less is more" prevailed; elementary forms and black plus one or more primary colors were used. In 1928, the school moved to Berlin under the direction of Mies Van der Rohe and was finally closed in 1933 due to Nazi pressure. Artists, writers, intellectuals, and scientists fled Germany, and a number of Bauhaus faculty migrated to the United States. Gropius went to Harvard, Albers to Yale, and Laslo Moholy-Nagy founded The New Bauhaus, which is now The Art Institute of Chicago.

TYPOGRAPHY BACKGROUND

Initially, within the early Roman to the Renaissance periods, quick visual marks were necessary, because everything such as books and letters was written by hand. The writing tools of the day were variations of the broad pen, made from reeds or quills. Nice thick and thin strokes were rendered quickly through the use of a pen, which had a squared-off point. This pen was held at a 45-degree angle so that the thick and thin stems and counters were drawn easily without having to change positions of the pen in hand. This technique was readable and efficient. As time passed, more styles were produced along the same lines, by changing the angle of the pen, varying the widths, proportions, and pen thickness, giving new variety and interest. These manipulations added to the progress of the alphabet and more specifically, the system of typography (Figure I–9).

Trajan's Column, built in Rome in 114 A.D., was a significant monument to the development of both the alphabet and typography. The Roman capital alphabet presented a new criteria for the visual forms of existing letters. The thick-thin strokes of the broad pen were copied and then chiseled onto the cylindrical tower and were used as a standard of comparison for twenty centuries against other letterforms. "Located in Trajan's forum in Rome, this masterful example of capitalis monumentalis gives silent testimony to the ancient Roman dictum, 'The written word remains'" (Meggs 1992, 37). Its influence is still prevalent today and the proportions and style are still widely used.

The Roman capitals included a new subsystem of marks added to the basic letterforms comprising small tails or wings known as serifs. These occurred at the ends and bottoms of the letter stems

■ **Figure I–9.** Calligraphy

(Figure I–10). Even today, these serifs are present on all Roman typefonts, and they are mainly what identify them as Roman when compared to the basic Gothic sans-serif font style (Figure I–11). It is speculated that the serifs were created by the chisel accidentally, the tool leaving spur marks as the letters were incised. Afterward, it was realized that these little wings or serifs were of actual value. "The spurred endings of strokes, as an example, were typical chisel marks. Later recognized as improvers of legibility and solid bases for letters, these spurs, or serifs, were adopted for use in broad-pen writing" (Gates 1969, 13).

Roman square capitals, through popular use, began to transform into other styles, and by the fourth century, more fluid forms known as Rustica capitals and uncials evolved. These fonts were less formal and the uncials were simplified to the point of needing ascenders and descenders, elongated stems on letters reaching above and below the x–height for better legibility (Figure I–12). X–height is the vertical measurement of the body of

GF GF

■ **Figure I–10.** ■ **Figure I–11.**

a lowercase letter without ascender or descender (Figure I–13).

It was the uncial system, later reduced to half-uncials, that became the beginnings of our lowercase or minuscule letters, more fully formed in the Middle Ages. ". . . the uncials (so named because they were written between two guidelines that are one uncia [Roman inch] apart) were actually invented by the Greeks as early as the third century, B.C." (Meggs 1992, 43). The use of capitals and lowercase letters together as a system did not occur until several centuries later.

In the fifth century after the fall of Rome, writing proliferated and many hand styles developed within the monasteries. These were taken to the new, smaller nations by traveling monks and scholars. A standard European style was pursued, influenced by the half-uncial during Charlemagne's reign at the close of the eighth century. These forms developed into the minuscule or lowercase letters as we know them today. However, Roman capitals and Carolingian lowercase still were not used together as integrated systems, with the capital letter mixing in with the lowercase for organizing purposes. The capital was used primarily as a large decorative element or drop initial on a page.

In the twelfth century, the Goths, while working on the Carolingian writing system, began making the forms of the indi-

▣ **Figure I–12.** Uncial

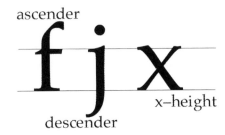

▣ **Figure I–13.**

vidual letters more elongated and vertical looking. "The round Carolingian hand slowly gave way to styles that gradually became more vertical, until finally, at least in northern Europe, all forms were straight-sided, with pointed tops and bottoms" (Gates 1969, 16). (See Figure I–14.) Though this Textura style was impressive to look at, it was less readable than Carolingian, and so the Gothic font with Roman capital influences was combined with the more rounded lowercase and the system of combined usage was established. The final refinement before the advent of printing and typography was known as the Humanistic style, the letter symbol system that is our standard for today.

In 1450 A.D., Johannes Gutenberg, living and working in Mainz, Germany, invented the first printing press with movable type. "From this time forward, the alphabet would develop within the terms of typography" (Gates 1969, 17). Gutenberg started with the Gothic script system. New typefaces were created that worked with this advancement in technology, leading to the formation of the five families of type (Figure I–15).

These families are called Old Style, Transitional, Modern, Egyptian (slab serif), and Contemporary. Old Style is based on a horizontal proportioning system of even and uneven widths of individual letters. This is one of the major features of this style and is easily recognizable by its structure. The advantage of using these irregular forms is that their unevenness looks lively on the page. They almost move and can seem to have kinetic properties. The horizontal proportions are different, because the system is based on combinations of the symmetrical circle, square, triangle, cross, and x. French printer Claude Garamond worked with success to refine this style during the sixteenth century. Another example is the English font, Caslon. The drawback of Old Style is that it requires a higher refinement of spacing, utilizing custom kerning within software programs such as QuarkXPress,

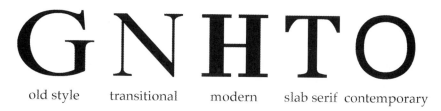

■ **Figure I–14.**
Textura

old style　　transitional　　modern　　slab serif　contemporary

■ **Figure I–15.**

Photoshop, and Illustrator. Most designers do not consider this a minus because the majority of font styles need some kerning on display type. (See Figure I–16.)

In the nineteenth century, even-width type was instigated in Venice. This system is just as it implies, the horizontal width of each letter was measured and drawn basically even. The advantage to this new system was that the letters were easier to kern or letterspace. Letterspacing, or kerning as it is commonly known, is based on the negative space within and between each letter of a word. "Although space implies nothingness, its hidden strength is monumental. To understand its true power, it must be studied in relation to the other components. Observe the shapes between the forms as well as the forms themselves, and you will begin to understand the power of space" (Solomon 1986, 15). The mental exercise is this: If you have an ounce of liquid or mass, it could be poured equally, using the one ounce amount between and within each letter. In other words, each letter and its space would hold one ounce. This would space the letters correctly for good overall balance. Additionally, whole words are most often divided by the width of an "O" taken from the font being applied to the design layout. Another consideration when working with the "O" and other circular letterforms is that they are extended slightly below and above the x-height or lettering lines. This is because curved forms create the optical illusion of being smaller than square or rectangular forms and need to be sized a little larger. Aesthetics must also be applied and the experienced eye of the designer knows through practice and exposure to letterforms what is correct.

The Industrial Revolution brought on new developments and had a major impact on the progression of typography. There were still problems to resolve in making the capital letters work well with the lowercase letters. A British printer in the late eighteenth century, John Baskerville, worked to further refine printing techniques for better legibility and readability. Stems became progressively more thick and thin on the same letter. The "stress" or

HELVETICA

◼ **Figure I–16.**

median lineup of a letter shifted from the 45-degree angle created by the broad pen to a more central position. This structural system was called Transitional and broke a long tradition. "The Old Style letters were finally overwhelmed in the early years of the nineteenth century by the brash display typography that emanated from various English and American typefounders" (Lewis 1978, 13). The Baskerville font was the pivotal type style sandwiched between Old Style and Modern. John Baskerville also worked with ink development and invented the hot press paper surface. Building on the work of Baskerville, in the late eighteenth century the Modern family of type was born, showing features such as more radical differences in stem widths, the thinner called hairline, and there were no brackets on the serifs, as is demonstrated on the Bodoni font system. (See Figure I–17.)

This total break with the broad pen form and the advent of the Industrial Revolution caused an explosion of typefonts, plus printing presses continued to improve. "Up to the last decade of the nineteenth century, most of the type foundries there had depended for the bulk of their sales on supplying newspapers with small sizes of type for text setting by hand, and had found this market killed almost overnight by the [new] Linotype machine." (Carter 1987, 24). As mass production continued to escalate, however, poor quality and lethal business practices were also on the rise. "Devastating price wars and cutthroat competition featured discounts of fifty percent plus another ten percent for cash payment. . . Design piracy was rampant" (Meggs 1992, 141).

In revolt to this lack of integrity, during the nineteenth century William Morris of the Kelmscott Press and leader of the Arts and Crafts Movement, produced fonts and designs of beauty and

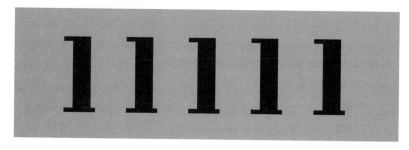

◼ **Figure I–17.** Bodoni

high quality. "Later he wrote: 'I began printing books with the hope of producing some which would have a definite claim to beauty, while at the same time they should be easy to read and should not dazzle the eye, or trouble the intellect of the reader by eccentricity of form in the letters'" (Lewis 1978, 20-21).

The next type family system to evolve was called the square serif, also known as Egyptian (Figure I–18). A more recent term is the slab serif. These serifs appeared to look like heavy slabs with chopped off ends, eliminating the graceful point of the earlier serif and were used during the Napoleon campaign against the Egyptians. "Selected because of their supposed superior legibility, they were painted on boards in a size large enough to be seen at a great distance when held aloft" (Gates 1969, 22). Modern Egyptian font examples are Century and Chaparral.

The Bauhaus School picked up a structural letterform system that was created a century earlier in Switzerland. Called sans serif, it was what the name implied—no serifs and was thought at the time to be rather dull. This completed the two categories of basic letterforms, Roman (with serif) and Gothic (sans serif). As the Gothic term can sometimes be confusing, here is a quote by Solomon for clarification: "The reason for associating the word gothic with these letters was because the tonal value of these extremely bold sans serif letters resembled the intensity of the German black letter. Although these letters are now designed in a full range of weights, the name gothic still remains" (Solomon 1986, 73). To develop the even stem widths and letter widths of this sans serif Modern style, mathematical principles were applied to the proportions and design layouts by the early Bauhauslers. "The Bauhaus typographers brought their German standards of mathematical precision to bear, so that their new typography began to assume the appearance of a blueprint governed by precise mechanical logic. The Bauhaus books, set in sans serif, with photographs boldly placed, set a new standard for illustrated books" (Lewis 1978, 48).

In the 1950s the Contemporary style was born, resulting in

EGYPTIAN

▣ **Figure I–18.**

Helvetica, originally a Swiss font. Another font created around this time was called Futura, still in high demand today (Figure I–19). An interesting feature of this type is that it has Old Style proportions combined with Modern stems, stresses, and overall condensation. Many variations of type were introduced in the early to mid–twentieth century, and the possibilities seemed endless. Revival of the font systems from the past were combined with new ideas, and the experimentation, restructuring, refining of type still continue, more recently with unbridled artistic license via computer systems.

L futura

L helvetica

■ **Figure I–19.**

MODERNISM, THE INTERNATIONAL STYLE, AND POSTMODERNISM

Also in the 1950s, there was a group emerging who felt that the cold, minimalist international style following the Bauhaus' industrial design influence was not addressing the essence and needs of the growing postmodern community. Mies Van der Rohe's 1920 statement "Less is more" now became "less is a bore" (Lovejoy 67, 1997). The Pop movement, influenced by Duchamp and technological advances in copymaking with photography and Xerox, inspired new questions about the value and sanctity of the single, one of a kind image. Andy Warhol said, "I want to be a machine," aligning himself to Xerox multiple print technology and the information society. The idea of multiple copies, photos, and Xeroxes was gaining acceptance through the '50s and '60s as "real" art. These types of prints were now being exhibited in museums and galleries. The new vision of postmodernism had a helping hand with the advancement of computers that could generate images.

Design concepts embracing postmodern thought started from European sources during the nineteenth century, inspiring twentieth century groups like the Neville Brody Visual Language Institute. Brody, who started his design career in 1974, created the concept of FUSE in the '90s, which was the digital publication of a magazine that addressed digital typography and its effect on visual language. It was "a language laboratory for the future" (Wozencroft 1994, 13). FUSE's URL is: http://www.research. co.uk/fuse/fuse-home.html. With the dawn of digital imaging came the ability to do new and radical things with typography. "We now have the opportunity to develop Freeform designs" (Wozencroft 1994, 13). The movement is toward "a language

which is more intuitive than the linear mould of Western constructions" (Wozencroft 1994, 13).

This language might be compared with Asian Kanji alphabet lettering, which is highly personal, expressive and emotional (Figures I–20, I–21). The expressive blurring and layering of Brody's visual language style reflects a transitional state, one that is not static. It is a physical process that is more "fluent and fluid" than the hard edged geometry of the International or Contemporary style of Helvetica. Digital technology enables the creation of new visual language. It is liquid, layered, out–of–focus, chaotic, and changing. Brody believes at this point that digital technology is the DNA of language. The visual information is related to feelings and meanings that are subliminal, as well as the obviously readable type. There are other designers and artists working in a postmodern direction, creating visuals without central points of interest, all things included being made to appear equally important. Corporate identity has also evolved, blending toward the idea of branding, which takes the emotional and cultural aspects of consumers into serious account. Branding is aggressively being used to capture higher levels of market share not previously realized. It ties in with the visual language ideas of Brody and has universal language/symbol potential. (See Figures I–22, I–23.)

"Even though Modernism is dead, it is still dominant" (Lovejoy 1997, 89). This is true and easily observable today. Many

▣ **Figure I–20.**

▣ **Figure I–21.**

```
<HEAD/>
<BODY BGCOLOR="#000000">
<SCRIPT WEB MEDIA
   document. Concert
<SCRIPT/>
<A HREF="concerts.html"
onmouseover="document.ball
```

Figure I–22. Postmodern

THE SOCIAL
IMPACT OF
GRAPHIC
SYMBOLISM

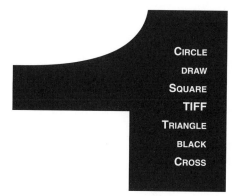

CIRCLE
DRAW
SQUARE
TIFF
TRIANGLE
BLACK
CROSS

Figure I–23. International

still believe it to be viable and not passé in spite of postmodern influences. Others welcome change as an opportunity for escape from the prevailing absolutes of Modernism. Deconstructionists work toward dismantling "Modernist dogma," while there are those who continue in the process of formulating the statutes that will create a future postmodern world. As designers, questions to consider as we move through this influx of change are, What can the human being relate to, respond to and accept visually, emotionally, spiritually? Can art and design be segregated from everyday life, propagating theories and visual language that need special knowledge and interpretation? As pluralism expands with its equalizing attributes, can we respond to visuals without focal points or directives? Will meaningful interaction between design and viewer be lost? Other considerations are, Will the new influences of postmodernism have social and cultural impact, and will these be positive or negative? Should product packaging be shown as somehow on equal footing as important human cares within the same television commercial? The sun is going down on nearly 200 years of Modernist influence. This is a new day, a chance to examine and be a contributing part to this important life–changing transition.

CHAPTER 1

OVERVIEW OF DESIGN

THIS CHAPTER WILL DISCUSS:

➤ Designing for Direct Connection
➤ Design Specifics for Web Sites
➤ Top Ten Annoying Things About Web Sites
➤ Designing with Animation
➤ Project: Layout for a Web Page

DESIGNING FOR DIRECT CONNECTION

Design frequently combines the practical, psychological, and spiritual. Well-designed, unique gestaltic combinations create new insights. Design can rise to the aesthetic criteria of art, which could be defined as something that makes us feel and think, and simultaneously take us to a new place. Gestalt applied to design is the process of putting a variety of visual objects such as type, photos, illustrations, and motifs together into a visually pleasing and meaningful composition. As Philip Meggs noted in *Type and Image,* "Diverse elements, including signs, symbols, words, and pictures, are collected and assembled into a total message." Diebenkorn related that everything is integral and all parts belong to the whole. If you remove an aspect of element you are removing its wholeness. The human interior knowledge integrates with exterior experience, reinforcing a strong bond of knowing. This interaction is necessary for direct connection, essential for successful, meaningful visual communication. The principles and elements such as balance, form, color, line, texture, space, and transition are still essential design ingredients directly applicable to web site design, even though we have experienced some recent shifts.

Because the human brain works in gestalt fashion it attempts to complete an otherwise incomplete image. It is intriguing to the mind to fill in the blanks, bridge the gaps, complete the puzzle. It

gets us involved and draws us in. We personalize it and make it our own. All of the work is not already done for us. There is something more to finish, and we can participate if we choose to, and being social creatures, we generally do. The eminent American graphic designer/illustrator Milton Glaser, part of the Conceptual Image Era in the late sixties, phrased it well in an issue of the *U&lc Journal:* "In many design problems such as this one, the issue between clarity and ambiguity is at the heart of it. You don't want to be so clear that there is no involvement on the part of the viewer, and you don't want to be so obscure that the problem cannot be solved. So you have to walk that line, which is always the problem of communication." (Chambers 1991, 18: 35). Glaser strives to delight viewers as they solve the puzzle of the visual gestalt.

During the Art Nouveau period (late nineteenth century), two brothers known as the Beggarstaffs created a technique, later known as collage. "Often they presented an incomplete image, challenging the viewer to participate in the design by deciphering the subject" (Meggs 1992, 198). Paul Garvin discussing aesthetics suggests that "the ultimate function of an aesthetic object is some further effect upon the cultural community which responds to it; and one might want to add to this that the common notions of the 'hidden meaning' of a work of art or literature may well be closely related to this ultimate function" (Steiner 1981, 103).

Gombrich (1960) adds that images or symbols on posters are for the purpose of shock and surprise through displays that are unique or novel in method, which, combined with clarity of meaning, is the appeal of design. He further contends that there are three phases of symbolic, visual perceptual experience by the viewer, which Ulric Neisser (1976) has called the "perceptual cycle." The first phase of this design technique is known as the alertness moment. This is the arousal of attention of the viewer by the designer, who uses symbolic imagery, often primary colors, strong contrasts plus the promise of meaning. The second phase is that of puzzlement. At this stage, "we are made to stay with the image and wonder what it is all about" (Steiner 1981, 22). The third phase is that of meaning. What is the gestaltic combination of visual ingredients saying that is meaningful to us? As the observer of the visuals applies efforts toward "solving the puzzle," potential mind questions are, "What are the origins of the meanings?" and "Where do they come from?"

Gombrich believes it is part of the designer's function to guide the projection, first to suggest and then to establish a meaning. If the gestalt is erroneous then the completed design is confusing to the viewer and will be ignored, because the human brain seeks out gestaltic visual order. All masterful creative works possess this "good design" attribute. Otherwise, curiosity of viewers is quickly lost. Possibly, attention phase was successful, but puzzlement was fleeting, until ultimately the audience does not care enough to pursue the meaning phase.

What the viewer can begin to relate to for meaning, according to Gombrich, is some kind of recognition, natural or learned. "The degree of cohesion, of mutual support of the features seen in the image leads to the kind of transformation which always follows the detection of meaning and its subsequent confirmation" (Steiner 1981, 40). Part of the lure of art involves the use of "baits" within learned behavioral responses to, for instance, the image of a smiling girl, and the good versus evil stereotypes of heroes and villains. Baits can arouse willingness and attention toward learning and growth, innate symbols pass along the subliminal meaning. Attention is gained as a result of attraction to the mysterious, and we find elements of uniqueness triggering a response.

Art evokes questions, which makes it enigmatic and exciting; it is emotionally charged, and people are looking for such experiences, as they want to be touched, and be known. Visual communication is born through these charged moments, working through the web media designer and then transferring to the viewer. Inspiring visual combinations representing basic, important human cares and responses are possible through graphic design when vital and fresh. Artists need to understand metaphorical truth as it relates to humans. More specifically, the creators in this age need to grasp what people want and why. We need to know ". . .the dreams that compel desires" (Gorb 1990, 52).

DESIGN SPECIFICS FOR WEB SITES

Sebeok contends that ". . . balance and order that delight—are in the characteristic idiom of each art. . . ." (Steiner 1981, 51). Dora Vallier, expresses ideas of visual balance that come from what architecture can physically achieve and show visually. The other visual arts rely on this, to create balance or not. Balance is impor-

tant for peace, happiness, and contentment and humans are drawn to this ideal.

There are basically four types of composition in design—symmetrical, asymmetrical, radial, and crystallographic (Figures 1–1, 1–2, 1–3, 1–4). These compositional formats are applied to web pages with the addition of navigational and wayfinding means. Actually, navigation has been part of art and design for centuries, just more subtly, and often not apparent to the untrained eye. Usually, a focal point was created as a starting point, supported by other principles such as gradients, line, texture, balance, and color to assist the viewer in movement toward a certain direction or along a point by point path. Often circular in motion, these directional techniques made sure that nothing would be missed within the composition, that the complete message of the artist/designer would be successfully communicated. The viewer would arrive from point A to point B through a more linear experience. The crystallographic or overall pattern compositional format has risen to new popularity more recent-

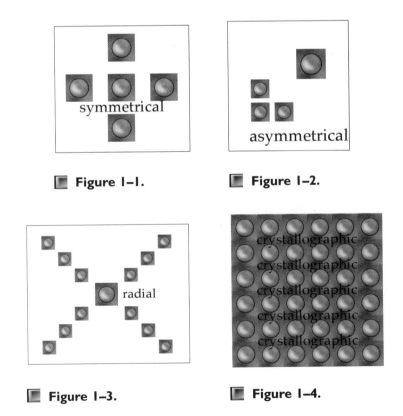

■ **Figure 1–1.** ■ **Figure 1–2.**

■ **Figure 1–3.** ■ **Figure 1–4.**

ly, and we can observe a variety of backgrounds on web sites made up of textures and objects of this type on which to navigate. The regular pattern without a strong focal point can produce a visual equality, a nonlinear experience, and invite seemingly random interactivity.

What is important within the design choice (experience) is to engage the viewer to active participation. The design challenge is to create imagery that is so interesting and attractive that visitors will take a chance and click on the graphic image to proceed to a deeper level within the site. Design your site and imagery for a specific audience, not only in content, but also use the appropriate technology such as screen size, plug–ins, and so on. If you are designing for people in this profession, the sky is the limit. If not, stick to what the general public is able to view successfully and download quickly. In this instance, less may very well be more. (See Chapter 2, Web Graphic Imaging, for management strategies.) Choose your goal for the web site and keep it firmly in mind throughout the process for consistency. This applies to the concept as well as the physical attributes of typography and image. If the splash page is 2-D, then other page levels should be designed similarly. A less flat look requires 3-D treatment but uses more memory. The site and pages should feel very natural to use, a seamless navigational experience. Ask yourself and others, "What is the automatic response?"

Think about the future of the project. How often will the graphics change? If it is on a regular basis, you may want to set up a grid format or frames for your composition that can be used repeatedly, ready to receive the new images and type, just as a magazine or newspaper would do that is printed weekly or monthly. Following the grid principle one more step, borrow from the Bauhaus School of alignment, which is, all things relate to each other in their position, size, and positive and negative space. Before establishing the final composition and layout, decide how many selections for navigation to other pages will be on the homepage. Think about how many levels, and how shallow or deep the web site will be. Design a creative but efficient menu or directory. Try some other visual solutions besides the upper left vertical column idea. Provide hypertext links of text, bar and/or icon for basic site navigation on every page. Some sites initially hide navigational items for aesthetic purposes. Rollovers can reveal text or image once the mouse "rolls over." It is a good idea to explain a less than obvious concept early on if

your audience is not used to this type of navigational action. However, if the web site is one that requires direct and speedy interaction, this design concept would not be advisable. The ultimate goal is to create visual language that offers opportunity for direct connection— design of inspiration, instruction and meaningful human interaction.

TOP TEN ANNOYING THINGS ABOUT WEB SITES

1. Type too small, especially if italicized.
2. Navigation is poor and there is no direct way out from a deeper level.
3. The ever unpopular slow downloads.
4. There is nothing introductory to do or read while waiting for the larger parts of the page to download.
5. Poor contrast between the background and type. Complicated textures can be a nightmare as a reading background (there is a reason why text areas of books have plain backgrounds). Pictures are more intriguing, but when just the facts are needed, plainer is best. With large amounts of text, good old black type on white background broken up with interspersed hypertext links may be the solution.
6. The overall site is dull and unimaginative.
7. Too many levels or tiers to go through to get to what you want. Four may be too many.
8. Unnecessary, excessive, annoying animations or audio.
9. Images and pages are not created to fit the average viewer's screen, but the site is meant for general public use. The same goes for plug-ins.
10. Web page is much too busy, crammed with too much stuff. Complex tables can be boring and painful to use.

DESIGNING WITH ANIMATION

Jean Luc Godard said that the whole world is too much for a single image; you need a chain of images. From that premise, let us consider the use of animation—what to animate and why. We have all seen web sites with too much stuff moving and blinking without any apparent reason. Keep in mind that everything on the page may not hold equal importance, so be selective. Do not

forget places of rest or pause, sometimes known as white space. You wouldn't use six different font styles on a layout just because you owned six fonts. Just as there is planned intent with design, so it should be with animation features.

Animation can give the opportunity to tell a story. It can create a focal point as a starting place or indicate the most important feature of the page. The major reason to use animation may be to engage the viewer through entertainment, mystery, inspiration, or beauty. Animation can reinforce meaning just by changing the color of an object or display type from red to blue. Here are some preliminary ideas:

When space is tight on a web page, consider animation to change the imagery several times within the same window, or various graphics could appear or disappear, fade out and in, or grow and lessen in size for economy of space and file size. Certain parts of an animation can use less memory, and can switch from higher memory to lower memory modules on a graphic. Consider doing this with backgrounds while the navigational features remain the same. If you have an identical product that comes in several colors, consider animation to switch to the various hues without changing the initial product graphic. Small animated GIFs, such as puzzles that download quickly, can be engaging to viewers while they wait for the larger graphics to download. Educational uses such as how a piece of machinery operates or how something grows or evolves can be effective. Navigation and wayfinding are good subjects for animation utilizing changing lights, signals, and movement along paths. Think what the web site is about, what is essential, and choose your animated areas with skill and good taste.

PROJECT
LAYOUT FOR A WEB PAGE

The project for this chapter is to begin designing a web site page. As a starting point suggestion, consider historical study of graphic design using on–line research for subject matter of your own choosing. Select a style, period, or designer/artist for study. Review the design principles carefully and do a preliminary layout for your page. As you progress through the book, there will

be a variety of design experiences that you can add to the project. Think about interactivity experiences for your viewers. Plan some ideas for backgrounds, graphic objects, typography, logotypes, image maps, and simple animation that you might want to try. At this stage, understanding the use of compositional styles is the most important task. By the time you come to the end of the book, ready to produce the final project, you will probably want to make adjustments and changes. For now, begin by by going through these steps:

Project Considerations

1. Compositional style, consider a focal point.
2. Colors—What do you want to say? How can color help?
3. Background, plain/textured.
4. Typography/Banner/Logotype.
5. Preliminary animation ideas.
6. Preliminary navigational ideas.

Compositional Comparisons

Check out some of the favorite URLs listed in Appendix 4 such as Designory, Landor, ISEA, Trace, and Spectacle. Decide which compositional formats are used. For comparison, look at a variety of web pages on your own. Select some that you have strong reactions to, some you really like and some you hate. Examine why you feel the way you do, and if possible, discuss these in class.

Composition Practice

Start by making a tangram (see Figure 1–5). Use traditional cut and paste methods with black paper, an x-acto knife, and small metal straightedge. Proceed by cutting out a 6-inch square from the black paper, then cut up the sections. Arrange the pieces into designed compositions, place tracing paper over them, and trace off. Make at least six different compositions by moving the pieces around and tracing as shown in Figures 1–6, 1–7, and 1–8. Outline your best ones in black and scan into your computer for future use. Refer to Chapter 5 for tangrams used in mnemosyne visual language creation and uses in animation.

tangram

Figure 1–5.

Figure 1–6.

Figure 1–7.

Figure 1–8.

CHAPTER **2**

WEB GRAPHIC IMAGING

THIS CHAPTER WILL DISCUSS:

➤ Overview
➤ Technical Considerations for Web Image Success
➤ Strategies of Management
➤ Net Etiquette
➤ Quick Illustrations from Photographs
➤ Project: Create Five Graphics

OVERVIEW

Graphics are an integral part of a web page. They must be visually stimulating enough to maintain interest. Graphics are not always the content, but are still regarded as the most effective and immediate communication. As a preliminary guide, it takes about 1 kilobyte (KB) to fill a screen with plain text, but a 1-inch icon can take from 10 to 15 KB. Planning and thought need to go into the use of text and images and to balance these appropriately according to the target audience. Our challenge as image creators is to make appealing web graphics that load quickly and easily, keeping in mind that many net users continue to be connected at speeds lower than 33.6 kilobits per second (kbps). Another factor to remember is that speed slow down for viewer image/page downloading also has to do with the amount of on–line traffic; the more people on the highway, the slower it is. Your challenge: Graphics should look great without the wait.

TECHNICAL CONSIDERATIONS FOR WEB IMAGE SUCCESS

If you are coming from a print design background as many of us are, there are new considerations for transition to web design.

For instance, a graphic in the 20 to 50m range for print should be closer to the 20 to 50k range for the Internet. A loose guide to use is, 1 k takes 1 second to download, but again, traffic on–line and equipment capability will determine true download speed. With this in mind, even 50k is really too much, so work toward the lowest amount possible without seriously deteriorating the image quality.

As a quick review, data is stored on a computer in bits. You can also refer to bits as kilo, mega, or giga. A bit is made up of 0 and 1, a binary number. Information storage is limited in 1 bit, so bits are grouped into bytes.

8 bits = 1 byte.
1 kilobyte (K or KB) = 1,024 bytes
1 megabyte (M or MB) = 1,024 kilobytes
1 gigabyte (G or GB) = 1,024 megabytes

The bit depth of an image is the number of bits used to store color information for each pixel in an image. Images can hold 1, 2, 3, 4, 5, 6, 7, 8, 16, 24, and 32 bits in depth, which is referred to as z, grouped with the x and y coordinates. Z represents depth, x is the measurement of width, and y measures height. Individual pixels can be located by their x and y coordinates and these can be located in the Adobe® Photoshop® Info dialog box (Figure 2–1). A pixel that is 200 pixels from the left and 150 pixels down from the top has x and y coordinates of 200 × 150. To see this, open the Info dialog box in the Windows menu. The Info box gives you x and y data while moving the cursor over the image.

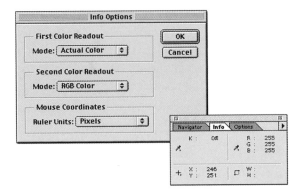

■ **Figure 2–1.**

Refer to Chapter 4 for more extensive information about color bit depth. Pixels are square and mapped out on the x and y grid, which is called a bitmap. All bitmap images are made up of pixels, and the pixel is the smallest unit of a bitmap image. A pixel can be thought of as the print equivalent of the dot, commonly used in print media. With dots per inch or dpi, there are 72 dpi in 1 inch. This establishes resolution of a particular image.

Print media must of course use a much higher dpi or resolution for high quality printable imagery. However, screen images are generally in the range of 72 ppi (pixels per inch), interchangeable with the acronym, dpi. It is best to always refer to ppi for web design because of potential confusion with points or picas. Because it works with the CRT or monitor equivalents, which is our final output or viewing destination, 72 ppi looks good on screen. One pixel in a 24-bit image has 24-bit color information, and all bitmap images are a series of tiny squares put together on a grid as mentioned earlier. By multiplying the number of horizontal pixels by the number of vertical pixels, you can find out the total number of pixels in an image. For example, 500 pixels by 300 pixels equal 150,000 pixels.

Pixel width and height information can be obtained from Photoshop by selecting Image Size or Canvas Size in the Image menu (Figures 2–2 and 2–3). Be sure and convert the units from inches to pixels. You can also alter the size of an image without cropping from the Image Size setting. The Resample Image check box must be checked in order to access the Pixel Dimensions sec-

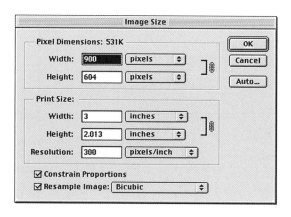

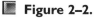 **Figure 2–2.**

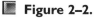 **Figure 2–3.**

tion. For most situations, keep it on the pixel setting. Check the Constrain Proportions option so that the height size and the width will automatically change also in proportion when alterations are made. Canvas Size in the Image menu adds or subtracts to alter the dimensions of an image. Choose a certain anchor block to determine what portion of the image you want to alter. It works inversely, so if you choose the top center block, the alterations will apply to the bottom center of the image.

Again, resolution refers to the number of pixels in a certain distance and pixels are measured in pixels per inch or ppi. When you want to convert an image from pixels into inches, simply divide the pixel count by 72. An image will decrease in overall screen size as the screen resolution increases.

Web pages viewed on monitors are commonly viewed as 640 × 480 pixels (Figure 2–4). Designers often have larger screens, 16 or 17 inches and handle 800 pixels wide by 600 pixels high or 1,024 pixels wide by 768 pixels high. There are some screens that are considerably larger, but may only handle 640 × 480. This type of screen shows larger pixels, not a larger image. Even now, designers must frequently design for general audience viewing, imagery that will fit on the 13- or 14-inch screen (640 × 480). Graphics should be no larger than 625 pixels wide by 320 pixels high. Frequently designers make graphics smaller, and a 450- to 550-pixel width will work on all browsers. Quicktime movies are quarter screen size at 320 pixels wide by 240 pixels high. When an

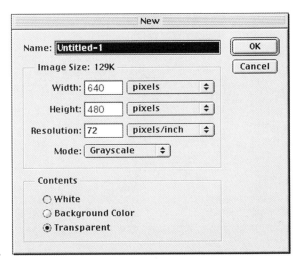

◼ **Figure 2–4.**

image is doubled in size, there are four times as many pixels, as the width and height are multiplied together. Use the rulers (comm/contr + R) to determine if your graphics are too large and scale or crop accordingly. A freeware application called Screen Ruler is available for Mac download (see Appendix 3). PC URL is www.weblife 2000.com/downloads.htm.

Download time of images for your viewer is vital. A 14.4 modem can transfer data at about 1.75 KB a second. A modem converts digital data into analog signals, via sound. Most people are hooked up to phone lines, but faster solutions are ISDN (Integrated Services Digital Network) lines, which are separate from phone lines, and have a speed rate of at least five times faster. T1 and T3 are leased dedicated connection lines. A small file can download at a rate of 1 KB per second, while a larger file might move at 4 KB per second. Joint Photographic Experts Group (JPEGs) have to decompress, Java and Shockwave need to go through processing, and Javascript and similar languages must compile, and therefore take longer. Transmission control protocol (TCP/IP) are the packets of data that reconstruct the data on the web site as it loads. Internet protocol (IP) manages the routing of data.

STRATEGIES OF MANAGEMENT

A web site visitor will probably wait no more than 30 seconds for an image to download. We want to strive for a personal best and shave the time down even lower. Here are several techniques to create a web site with graphics that download efficiently. Remember that the smaller the file, the quicker it downloads.

1. Choose a good Internet Service Provider (ISP). Preferably, use one that has T1 and T3 instead of ISDN. T1 and T3 cost more but are faster. Cable modems are said to be nearly 1,000 times faster.
2. Often several small images are better than a few large or one larger image. As a guide, 50 KB is large, 30 KB somewhat smaller, but 10 KB should be the goal.
3. Cut up a large image and puzzle it together using tables in HTML. A large image broken into chunks downloads quickly and is then reassembled on the user's screen. You might also experiment by compressing some of the pieces as Graphic

Interchange Formats (GIFs), some as JPEGs. Try lessening colors or quality of certain images to sequence them into different download times for speed and an interesting effect.

4. Use graphic compression and reduced-color strategies; in a word, optimize.

5. Crop or resize large graphic file sizes. Make images large enough for critical details to be seen, and create text large enough to be pleasantly readable. See Chapter 8 for text guidelines.

6. If you want to display large graphics, say, for a portfolio, give your viewers a choice by posting thumbnail/button versions on the opening page that link to the larger images on a deeper layer of pages (Figure 2–5).

7. Try to keep navigational/wayfinding graphics in view without scrolling, or repeat these features at the bottom of the page as well as the top. Though most viewers do not want to

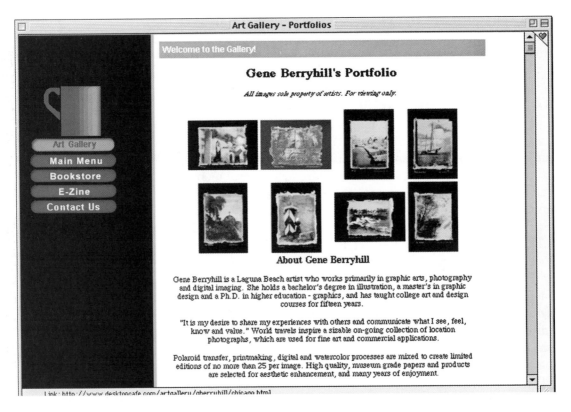

▦ **Figure 2–5.** http://www.desktopcafe.com/artgallery/gberryhill

have to scroll to see an entire image, they generally do not mind scrolling to read through a large body of text. Sometimes, scrolling can work with the design or metaphor of the web site, such as horizontal scrolling for viewing a panoramic piece, photo frames, or an art gallery or museum presentation. Think about what the human eye is accustomed to; in other words, does the horizontal scroll seem like the natural way to view your images and information. Is it seamless within human thought process?

8. Set text, puzzles, or small games above your larger graphic files to give the viewer something to do during download of the weightier pieces.

9. Preload images with the width and height attributes set to 1 within the tag. You can preload graphics for the next page while the viewer is reading text on the current page; when the next page is visited, the graphics are already in place.

10. Use borderless frames (Border=0), transparency or black, to save on memory and download.

11. Have a low resolution version of a graphic load first, then the higher resolution version so the viewer can see something of the image right away. However, it is usually better to give the viewer entertaining or readable material. Again, the idea is to provide visual occupation to keep the visitor's attention long enough to get them to stay around for the major content to download.

12. Interlace images. You will find this capability within the Photoshop software. See Chapter 3 on indexing. (See Figure 2–6.)

13. Adjust Hue and Saturation (Menu + Image + Adjust) for color management. It may work well to shift at least some of your graphics toward a similar hue, therefore sharing more of the same colors (Figure 2–7). Also, try the Colorize selection box. See multigraphic palettes in Chapter 4 for further information.

14. Select the most important section of a photo for higher quality and more maximum color input. Keep the area selected through the indexing and adaptive processes. The less important areas of the photo can have lower definition and smaller numbers of colors, reducing overall file size. Gaussian Blur can be useful in this process, because sharpness requires more memory (Figure 2–8).

15. Horizontal image formats compress more efficiently in Photoshop's GIF89a due to LZW compression because of its algorithm. The wide image works best in horizontal rows

▨ **Figure 2–6.** Interlacing in progress

▨ **Figure 2–7.**

▨ **Figure 2–8.**

using a particular color. Keep this in mind when using blends or stripes.

16. Tastefully use the same graphics on different pages, utilizing caching. Mix and match pieces that are already cached with new graphics.

Caching

Browsers have memory and disk caches. Memory cache holds the web page that is open and is limited by what is set in the browser's Preferences, 1 MB or less, typically. Disk cache stores the last few pages you visited so you can press the Back button to access them again. It is five times larger than the memory cache. When the disk cache is full, it continually purges as you visit more sites. Both Netscape Communicator and Internet Explorer can be manually purged via the Preferences setting in Netscape and the Options setting in Internet Explorer.

Browser Tips

1. Change your corporate homepage to open to any site, such as your favorite search engine. From the browser pull-down menu, select Options (Explorer) or Preferences (Netscape), and key in the URL or click on the "open to this site every time" button on the splash page of a search engine.
2. It is not always necessary to key in a URL with, .com, .edu, .org, www or index.html to reach your destination.
3. To get back to the homepage of a site, delete all address information between the base homepage address and .com.
4. To change appearances or sizes, go to Options or Preferences.
5. To customize your cache use, reset the browser's size in Preferences/Options. If you visit the same sites repeatedly, try 10 M (Netscape) or 5% (Explorer) for larger capability. A small setting would be 3 M/1%.
6. For greater speed, upgrade to a current kilobits per second (kbps) modem and/or add RAM. Keep in mind though, that 56.6K modems are not working at supposed speed levels because you are still using phone lines. The 33.6K is still the best bet until bandwidth is increased.

You can set your browser to reload the entire contents of every page it visits, which is handy when you are building your site

and updating it often. Holding down the Shift key while pressing the Reload button bypasses the browser's cache. Use the Once Per Session option for general surfing. Our ultimate goal is to create great looking web images that communicate effectively, download quickly, and stand out from the rest. Often this can be done with well-designed images without a lot of unnecessary tricks or emphasis on excessive technologies.

NET ETIQUETTE

An important part of overall management is courtesy on the Internet. Claire Belilos suggests some helpful tips:

Professionalism, Ethics And Courtesy On The Net

The Internet opens unlimited opportunities in global business, learning and networking. But if net–users abuse the privilege, digital glasnost (openness) may be crushed under an avalanche of regulation. To avoid the heavy hand of Big Brother, users should work to ensure decorum, professionalism, courtesy, and ethical behavior. Following a few simple guidelines will also keep fellow users from slamming doors in your face.

Abuses are already widespread, "spammers" who indiscriminately bombard us with their unwelcome advertising, to those who use the Internet for shady or illegal purposes. We cannot allow these to prevent us from being part of the fascinating universe of cyberspace.

Here are a few guidelines to help net "newbies" build a positive identity, win friends, and even new business partners.

❏ Do not give out others' e–mail addresses without permission – this breaches trust and invades privacy.

❏ Do not collect other people's e–mail addresses for use in bulk mailings or "spamming". That tactic will backfire. You and your company will be a web–pariah to be

avoided at all cost. If you do bulk–mail give a genuine return e–mail address to which the recipient may write to be removed from your list. No one wants unknown intruders.

❏ Behave courteously and professionally. When you ask someone for information, say "please," and/or "I would appreciate". Thank the giver for the time and attention. Don't dictate "send me," "give me," etc. That's poison.

❏ Do a little work before you ask for help. Don't presume upon the kindness of others. Do what you can do your-self. Don't try to get free professional work through the net. Expect guidance, not unpaid work by others. Show that you have invested serious effort toward your goal but find that you need advice.

Read more of Claire's suggestions for courtesy on the Net at http://www.webpromote.com/wpweekly/feb99vol1/cour-tesy.html.

QUICK ILLUSTRATIONS FROM PHOTOGRAPHS

Posterization

1. Scan and open your photograph in Photoshop.
2. Go to the Menu + Image + Adjust + Posterize. Use at least four levels (Figure 2–9).
3. Choose level 4 and see how it looks (Figire 2–10). Experiment with different levels. Notice that the photo now has a flat color look with less modeling and blending.

Brightness/Contrast

1. Scan and open your photograph in Photoshop.
2. Go to the Menu + Image + Adjust + Brightness/Contrast (Figures 2–11 and 2–12). Experiment with this setting also.
3. Try Filling (Menu + Edit + Fill) selected paths (wand tool) with new colors. (See Figure 2–13).

Figure 2–9.

Figure 2–10. Posterization - 4 levels

Figure 2–11.

Figure 2–12. Brightness/Contrast application

■ **Figure 2–13.** Use the Magic Wand tool to fill selected paths with new colors.

Four–Color Photo to Grayscale and Flat Color

1. Scan and open your photograph in Photoshop.
2. Go to Menu + Mode + Grayscale (Figure 2–14). Discard the color information.
3. Open the black and white photo in a line art conversion software such as Adobe Streamline™.
4. Go to File, convert, create outlines.
5. Fill with color.

Filters/Modes/Brushes

1. Scan and open your photograph in Photoshop.
2. Try any number of Filters from the Photoshop menu. Have some fun experimenting. Dry brush and sketch can reduce numbers of colors like posterization. (See Figures 2–15, 2–16, and 2–17).

🔳 **Figure 2–14.**

🔳 **Figure 2–15.**

🔳 **Figure 2–16.**

3. Open the Layers Palette, make a new layer, adjust the pull-down menu from Normal; also try different opacities (Figure 2–18).
4. If you want to go a step farther, make a new layer, choose the color you want in the tool box, click on the airbrush tool, and spray away. To change brush sizes, go to Menu + Window + Show brushes. Click on the appropriate size; try different sizes.

PROJECT
CREATE FIVE GRAPHICS

Make five different images and save them to use with the compression project in Chapter 3. See Figures 2–19, 2–20, 2–21, 2–22, and 2–23 for suggestions of different types of images. Create five images, 300 pixels wide by 100 pixels high each, 72 ppi. Leave as RGB Photoshop file.

Include:

1. Photo-organic, outdoor landscape
2. Photo-machine or hard-edged objects
3. Text, about 100 pts, black and white
4. Illustration
5. Gradients or blends, try a horizontal and a vertical.

◾ **Figure 2–17.**

◾ **Figure 2–18.**

Figure 2–19. Photograph: organic

Figure 2–20. Photograph: machine or hard-edged objects

Figure 2–21. Text: 100 point

Figure 2–22. Illustration

Figure 2–23. Gradient

➤ ON–LINE REFERENCE

Photographs to Illustrations
www.eyewire.com/tips

Downloads For PC Webmasters
http://www.weblife2000.com/downloads.htm
(Several items including Screen Ruler and Picture Dicer)

CHAPTER **3**

COMPRESSION TECHNIQUES

THIS CHAPTER WILL DISCUSS:

➤ Overview
➤ GIFs, JPEGs, and Indexing
➤ Dithering
➤ Compression Comparisons
➤ Project: 20-Image Chart

COMPRESSION OVERVIEW

Compression is necessary to reduce the file size of an image so it downloads quickly and works well on a web site. This is achieved by the reduction of data within the image. However, just enough data must be maintained so the image still holds its visual integrity and looks good. Optimization involves compression, reductions of colors, sizing, transparency implementation, and frame differencing, which is a technique used for animation.

GIFS, JPEGS, AND INDEXING

For compressing and optimizing images, it is a known standard that GIF is most often used for line art, and JPEG is used for photos. However, the many crossover situations make this decision more complicated, so each graphic must be handled individually according to its own content and features. Each image needs comparison and trial through application. Our main concern is deciding which are the best applications for optimization of an image. Besides GIF and JPEG, there are others like ProJPEG and Portable Network Graphics (PNG), but GIF and JPEG are used most often. PNG and GIF are good for solid flat color areas. Graphic Interchange Format (GIF) is bitmapped, lossless, and probably the most popular mode of compression. Lossless means

47

that when the image is decompressed it looks just the same; nothing is lost. GIF uses the compression algorithm, LZW (Lempel-Ziv-Welch), and decides the numeric of how many pixels of a specific color are in one horizontal row. So, in a particular row, you have a breakdown count of a certain number of red, green, and blue pixels (RGB). Because of this, blends, gradients, or stripes that run horizontally take about half as much memory as vertical banding (Figures 3–1 and 3–2). The more repetition in an image, the more compression is possible with good results.

GIF works best with some type of recognizable pattern, and the top to bottom gradients make smaller file sizes, whereas left to right gradients are larger. In "Discriminating Color Palettes" (*Adobe Magazine,* 1998) author Lisa Lopuck says that "The GIF format compresses graphics by looking at each horizontal line of pixels and recording the color changes. If there is one solid color that runs the length of a horizontal row of pixels, there's less detail to record. Therefore, the fewer color changes per horizontal row of pixels, the smaller your GIF file - and the faster it downloads. So, when possible, don't introduce extra vertical detail or noise into GIF images if you're concerned about file size and download times. For instance, if you're going to use stripes or a gradation in your image, make the stripes and the gradation run horizontally instead of vertically."

GIF89a is a GIF specification tool, an export plug-in used after Indexing, which can be found in Photoshop's File menu, within Export. GIF can only handle 256-color 8-bit images, so there is a loss

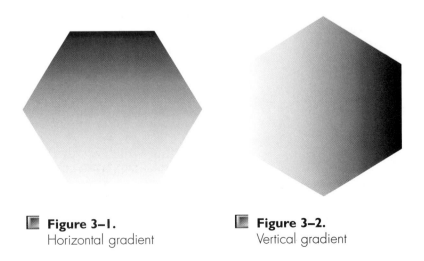

■ **Figure 3–1.**
Horizontal gradient

■ **Figure 3–2.**
Vertical gradient

of millions in the conversion. However, GIF does a good job maintaining image fidelity when compressed. Indexing refers to the reduction of an image to 8 bits or less (see Figure 3–3). This is necessary to export an image as a GIF. When an image is reduced from millions of colors to 256 colors or less, these remaining colors are indexed in a color palette where each color, including 0 is numbered and given an RGB value.

1. Open the Color Picker by double clicking on the swatch in the toolbox. (See Figure 3–4.) Look at the RGB section and note the number by each one.
2. Click on the far upper left corner of the large color field. You should see #255 or "white" as the value (Figure 3–5).

To Index a graphic, open the RGB image in Photoshop. Go to the File menu + Image + mode. Select Index. When in the Index dialog box, you will see some terms:

1. **Exact:** If you choose this, no colors will be removed. Use if the image contains 256 or fewer colors(Figure 3–6).
2. **Adaptive:** Used for the best color substitution. This palette allows choice of color depth and derives colors from the most commonly used areas in a particular image (Figure 3–7).
3. **System(Mac):** This selection only offers the Macintosh 8-bit palette and takes a uniform selection of RGB colors. It is the same situation with Windows but the two platforms have a somewhat different color palette. The Pattern option is available only in the System(Mac) palette (Figure 3–8).
4. **Web:** For web viewing. Accessible for most browsers, Mac or Windows. See color plates 8 and 12. (See Figure 3–9.)

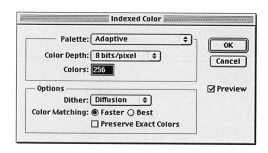

▮ **Figure 3–3.**

▮ **Figure 3–4.**

◼ **Figure 3–5.**

◼ **Figure 3–6.**

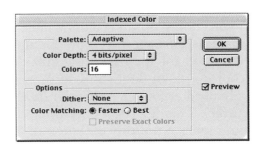

◼ **Figure 3–7.**

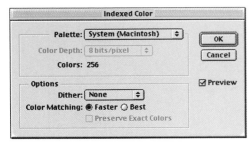

◼ **Figure 3–8.**

◼ **Figure 3–9.**

5. **Custom:** Here you can create your own palette (Figure 3–10).
6. **Previous:** Use this to access the last custom or adaptive palette (Figure 3–11).
7. **Uniform:** As the name indicates, a uniform selection from the color spectrum, working with the 8-bit uniform palette of 216 colors, which is $6 \times 6 \times 6 = 216$, or web–safe color cube. (See Figures 3–12 and 3–13; also see color plate 4.)

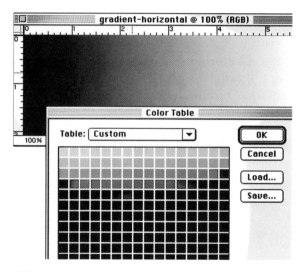

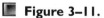 **Figure 3–10.**

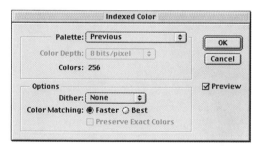

Figure 3–11.

Figure 3–12.

■ **Figure 3–13.** Netscape color cube

DITHERING

This choice in the Index dialog box shows as either a None or Diffusion option. Dithering refers to a number of colors blended together that are not included within the Indexed palette. It mixes some of the colors on the palette in an attempt to emulate actual colors. Here is Adobe's explanation from the Photoshop User Guide: "By default, Adobe Photoshop uses pattern dithering, which can result in a distinctive pattern of darker or lighter areas in the image. In contrast, diffusion dithering eliminates this distinctive patterning by using the surrounding pixels in the mix of pixel color." (See Figure 3–14.)

Large sections blended due to dithering can look unattractive and add more memory. Less colors in small graphics will not

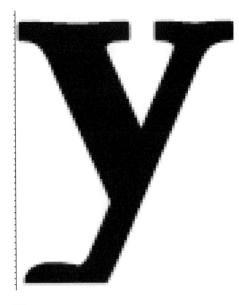

■ **Figure 3–14.**

require as much dithering and will not be significant, but a larger image with reduced or palettized colors can have unsightly pale areas between significant colors created by excessive dithering or can show a spotty or flecked looking surface (Figure 3–15). For color samples, see color plate 15.

Too little dithering or diffusion can cause posterization, but you may find that you like the way this looks, depending on the number of levels used (Figure 3–16). Flat colors look best without dithering, but with complex textures, it is not as much of a problem visually. However, a dithered object on a fairly plain background can result in a new problem known as haloing, which adds a pale ring around the object. See Chapter 6 for information on how to fix haloing problems. Photos are already diffused and GIF89a Export plug-in adds some dithering automatically, so "None" may be the ticket. Again, using filters or posterization can cut down on the number of colors, so dithering will be less.

Spend some time experimenting with the amount of dithering vs. amounts of colors. You may want to go back and add an intermediate color or two, for example, between a red and yellow orange that are next to each other. Instead of dithering to create the blend, try adding an analogous tertiary of red-orange to your palette. If you see colors that are extremely close, you may not need them, so take them out. Try the Photoshop plug-in Ditherbox at http://www.ditherbox.com.

■ **Figure 3–15.**
Excessive dithering

■ **Figure 3–16.**
Posterization

Exercises

EDITING AN INDEX COLOR TABLE

Select from the Menu + Image + Mode + Color Table. Click or drag on color(s) to be replaced. Move the slider to choose a new hue. Click the variation of the hue in the large rectangle. Click OK to exit Color Picker. Click OK. (See Figures 3–17 and 3–18.)

1. Grayscale to Indexed Color: Choose Indexed. Modify its color table. Experiment and try out the different choices. Make copies for comparison.
2. Reduce the Color Table to two Colors: Choose the Color Table. Drag across from the first swatch to last. Choose a beginning color from the Picker. Click OK. Choose your second color. Click OK, click OK.

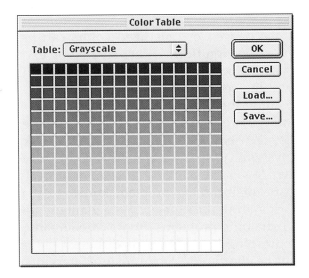

Figure 3–17.

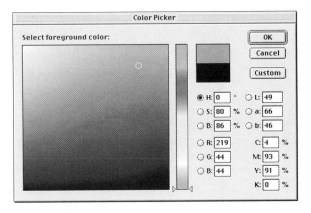

Figure 3–18.

JPEG, which is an acronym for Joint Photographic Experts Group, is used for photographic images on the Internet and supports 24 bits (millions of colors—16.7 million). This type of compression retains smooth blends and tonal qualities but is lossy, and colors may not be as accurate as GIF (Figure 3–19). Lossy means that the compressed image is no longer like the original, because image information has been lost. ProJPEG for Mac also supports interlacing and has a nice visual effect as it opens. (Download from the Killerweb sites Tools section at Killer Web-

Save a copy in:

Logo-sand-72 dpi JPG

Format: JPEG

Cancel

Save

☐ Flatten Image ☐ Exclude Alpha Channels
☐ **Exclude Non-Image Data**

■ **Figure 3–19.** Menu + File + Save a copy + JPEG

site Design Tips: http://www.killersites.com/1-design/index. html. Also, shareware.com.) ProJPEG's equivalent for PC is AIPICT. JPEG offers compression choices ranging from low quality to high. There are other options such as Baseline ("Standard"), which is recognized by most browsers; Baseline Optimized, which does as it says so far as color and file size adjustment but may not be supported by all browsers; and Progressive, which allows for a progressive, more gradual download in phases or scans. Baseline ("Standard") is often the way to go, but check out each option to see what you get, and compare the results.

COMPRESSION COMPARISONS

JPEG functions by sectioning small areas of color instead of GIF's lines of compression patterns. Numbers of colors are not a concern for JPEG, image quality is. Use it for complex, larger images. Some designers like to begin at the lowest setting and work up until the quality looks good enough. JPEG would not as a rule of thumb be used for small images like buttons (less than 100 x 100), even though they may be photographs or contain gradients (Figure 3–20). Because of decompression, JPEG can take longer to download.

■ **Figure 3–20.**

Overall, GIF is probably the best choice and dithering is not unsightly on smaller images. PNG, which sounds like ping is a replacement format for JPEG and GIF and touts superior qualities but does not work with animation. Check out PNG at: www. cdrom.com/pub/png/pngnews.html.

GIF compression is superior to JPEG with flat color and line art including text. GIF has transparency and animation capability and can also interlace, which adds slightly to the memory and is clicked on or off when exporting the image to GIF89a in

Photoshop (Figure 3–21). Interlacing is a process that makes an image visible on the web page in stages from low resolution to finished download quality. The advantage of interlacing is the viewer can see an image almost right away and watch its development, or in the case of an image map, can use its hotlinks right away. It is recommended that you not use interlacing on animations, small text, or with transparency because these have been known to cause browser problems or affect clarity.

Tips To Remember

1. Transparency requires GIF. GIF uses 8-bit colors or less and is frequently the best choice.
2. Flat-color images do well without any dithering, so using Photoshop's Indexed Color mode (with an Adaptive Palette and a Dither of None) and then saving as GIF will give you the best results with the smallest file size. The number of colors you need will depend on the image; try using the least number possible, no more than 35.

 Warning: Sometimes custom palettes do not match web-safe palettes, and it may result in an overall color shift. For graph-

■ **Figure 3–21.**

ic images containing flat colors, try indexing the image to the web palette, then remove the excess colors, especially ones that look very similar.

3. Black-and-white images without half-tones need few colors, so saving them as a GIF with Photoshop's GIF89a Export Filter lets you select a low number of colors (five or six colors work well on an image, which allows for some anti-aliasing). Preview the image to quickly see how the image will look. Shoot for something between 5 to 7k. (See Figure 3–22.)

■ **Figure 3–22.**

4. Often in JPEG, medium or low is all you need. Start with the lowest quality.

5. Images with less contrast can stand more JPEG compression.

6. As a rule, do not use JPEG for line art. Gradations look best with as many colors as possible, so JPEG Low or Medium can be the best option for gradations. (In this case, JPEG gives a much smaller file size than GIF with an adaptive palette.) Still, there are exceptions because each graphic is unique, so try them out and make charts for future reference.

7. Do not save a JPEG repeatedly because of a progressive decay in image quality. When you save a JPEG, it looks the same until you close the file and then reopen it. (**Note:** This progressive decay does not take place due to repeated viewing downloads.)

8. Browsers are case sensitive, so if you use lowercase on "gif" within your HTML, your image source "gif" must also be lowercase. Example: IMG SRC = "geneheadshot.gif". If you use uppercase, do the same and be consistent. Otherwise, your "gif" image source will not match GIF within the HTML and, therefore, not appear on the web page. Sometimes this decision is made for you, so check this out with the products you plan to use.

9. Consider manipulation of the histogram on an image to reduce less important colors by selecting the essential areas with the marquee tool and reindexing (Figure 3–23).

10. Another way to reduce file size is to turn off Image Preview within Preferences. The savings is due to having no preview icon with the actual image.

11. Do not waste time or memory on interlacing small images; it is not necessary because the download is already efficient.

▣ **Figure 3–23.**

PROJECT
20-IMAGE CHART

Compression Comparison—GIFs and JPEGs

Start with your five RGB images and try different compression schemes. Compare the results, balancing the best quality and compression. Follow the procedures as listed:

Use the five images, 300 pixels wide by 100 high each, 72 ppi that you created in Chapter 2 (Figure 3–24).

These should include:

1. Photo-organic, outdoor landscape
2. Photo-machine or hard-edged objects
3. Text, about 200 pts, black and white
4. Illustration (refer to Chapter 2 for quick illustrations from photographs)
5. Gradients or blends, try a horizontal and a vertical

Choose at least three from each group:

Group 1
❏ GIF 8-bit (256 colors), GIF 7-bit (128 colors), GIF 6-bit (64 colors), GIF 5-bit (32 colors), GIF 4-bit (16 colors), GIF 3-bit (8

◼ **Figure 3–24.**

colors), GIF 1-bit (2 colors).

❏ Experiment with and without dithering (diffusion).

Group 2

❏ JPEG Max, JPEG High, JPEG Med, JPEG Low, ProJPEG (download the demo), progressive and baseline, various qualities between 8 and 1.

❏ Try the GIF 216 Web Palette. Refer to color plate 5. Download from Discriminating Color Palettes: http://www.adobe.com/newsfeatures/palette/main.html.

❏ Compare all against the originals, then the 5-bit (32-color) selection. Use this as a standard because many graphics don't need more than this, and often less.

For each of the five images, try about twenty samples except for two-color images, like black type on a white background. To start, create and name a new folder for each image, which will hold and save your originals and compressed samples. Open an image in Photoshop, then Save a Copy. Do this for each compression sample. If you choose JPEG, make your choices according to GROUP 2 as listed above. For GIF prep, open your RGB image, and proceed with GROUP 1 listed above, indexing your colors.

Then export each to GIF89a (Menu + File). Check your image file size through Get Info under the File menu or, change your view from icon to name in your base listing window where the k is noted to the right of each file name. See Figure 3–25. Note saved samples on figures 3–26, 3–27, 3–28, and 3–29. See samples chart, Figure 3–30.

Figure 3–25.

Figure 3–26.

Figure 3–27.

Figure 3–28.

Figure 3–29.

ORIGINAL, 254K

INDEXED-ADAPTIVE 3-BIT 254K

INDEXED-UNIFORM 5-BIT, DIFFUSED 254K

JPEG MED. (4) STANDARD 127K

INDEXED-ADAPTIVE 3-BIT GIF 64K

JPEG LOW (2) STANDARD 127K

■ **Figure 3–30.** Samples Chart

Last Step

Choose your best samples of each of the five images. Start by comparing the originals against your worst or lowest k images, and move up to find the best image with the lowest k. Make a 2-inch wide × 1 inch high sample of each with the marquee tool (Figure 3–31). Open the Info palette for accurate sizing (w × h) or use Screen Ruler (Figure 3–32). Copy each sample onto a new 8.5 × 11-inch document or open each image, open the Layers Palette, and click and drag the graphic from the Layers palette to the new document. Use the move tool to line each one up evenly for comparison, vertically or horizontally. Type out the specs and settings below each sample such as how many k, compressions type, bits each sample holds, and qualities. See color plate 15 for color sample. Save all of your

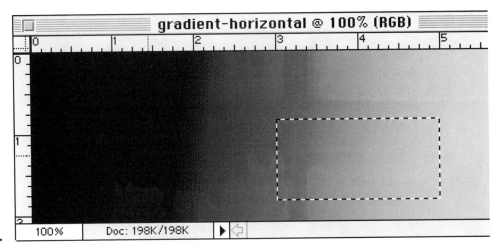

■ **Figure 3–31.**

■ **Figure 3–32.**

compressions on disk for backup and print out a hard copy of your final chart of 20. Make sure your name is on it.

Student Question:
I am working on the compression assignment right now and I do not get what to do for the last step part. Choose just one best image out of twenty samples of each and line up?

More Detailed Description

Out of all the compressions you have made, decide which ones you think are the most vital ones for a chart that will help you

with future images so far as deciding how much to compress and what type of compression to choose. However, you may make as many as you like. Some will not be worthwhile to use for your chart because there is no significant difference between certain samples. Make a 2″ wide × 1″ high sample of each one that you decide to choose. Do this with the marquee tool.

Copy the 2 × 1 sample and paste it onto a new 8.5 × 11-inch page in Photoshop. Open your next compression piece, marquee it, copy, and paste this sample next to the first one you did, and so on to fill up the page making a chart. Sample at least four of your compressed images within the group of five of the original images you made, the gradient, the nature photo, the mechanical photo, the type and the illustration. Beneath each 2 × 1 sample, use the text tool and type in the specs such as GIF or JPEG, how many k, is it maximum or medium, how many colors or bits, and so on. When you are finished you will have a chart of several compressed samples (5 images × 4 samples = 20) with typed notes.

Feel free, however, to make as many as you deem useful. Print out a color hard copy of your charts. Save all of your images in a floppy or zip disk.

➤ **ON–LINE REFERENCE**

Color and Palettes

Read the "Discriminating Color Palette" and download the 216 web palette. http://www.adobe.com/newsfeatures/palette/main.html (for Mac and PC).

ImageReady

Check out Adobe's ImageReady® software, created to automate the task of prepping and optimizing images for the Web. Features such as "Batching" with Photoshop's Actions integrate well, as does the use of Illustrator. Download the demo from www.adobe.com. Click on the ImageReady download.

CHAPTER 4

COLOR AND PALETTES

THIS CHAPTER WILL DISCUSS:

➤ Color Background
➤ Color for Web Sites
➤ CLUTS
➤ Creating/Using Web–safe Palettes
➤ Batching with Actions
➤ Hexadecimal System
➤ Project: Multigraphic Custom Palette

COLOR BACKGROUND

Color for traditional art is vast and without limit. We have infinite mixing possibilities from the primaries of red, blue, and yellow, which secondarily mix into purple, orange, and green. The tertiaries are blended from these and combine into colors of red-violet, blue-green, red-orange, blue-violet, yellow-green, and yellow-orange. Note on the illustration of the color wheel that red and green are directly across from each other and are known as complements. If you stare at a hue such as green for about a minute and then close your eyes, notice that its exact complement of red appears on the screen of your mind's eye. If the green is more lime, the complement will be a bright hot pink. Colors next to each other on the wheel are called analogous (Figure 4–1). Tints are created when white is mixed with a color such as red, creating pink. When black or brown is mixed in with a red hue, it creates the shade, dark red. Value refers to the lightness or darkness of hues or a range of values between black and white, known as the gray scale (Figure 4–2). For the color version of the wheel, please turn to color plate 1.

Certain ideas and understandings repeatedly surface about the meanings of specific colors. At the risk of some cultural bias, here are generally accepted meanings:

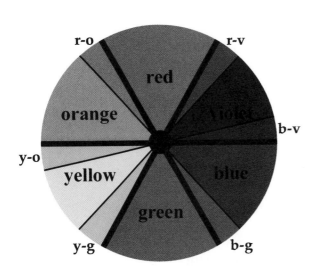

▪ **Figure 4–1.** Primaries, secondaries, and tertiaries. See Plate 1 for color version.

▪ **Figure 4–2.** Value scale

BLUE – truth, cleanliness, cool
GREEN – growth, freshness, relaxing, pastoral
RED – hot, dangerous, blood
PURPLE – royal, bizarre
ORANGE – warm, gregarious
YELLOW – bright, reflective
WHITE – purity
BLACK – evil, elegant, sophisticated, expensive, important
BROWN – earthy, grounded
GRAY – uncommitted, depressive
BEIGE – neutral, more friendly than gray

Metals:

GOLD/BRASS – a little bit can look expensive, like a good piece of jewelry. A lot can look like brass and can have a garish effect.
COPPER – similar attributes as brass, but warmer, and more friendly, casual.
SILVER – high quality, stellar.

Although these are not strict rules, warm colors such as red, yellow, and orange are said to visually advance or come toward you, while blue, green, and purple tend to recede. Test this out for yourself: How would you judge "electric" blue? Hot? Cold? Receding? Think about how you would create imagery that is warm and inviting or cool and mysterious.

COLOR FOR WEB SITES

With computerization, there are certain limitations with color, such as how many do certain hardwares and softwares provide or allow, and even within the limits of 256 colors, do we use all of these? The answer is usually "no" for web site imagery. (See Figure 4–3.)

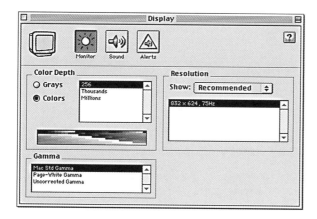

Figure 4–3. Apple Computer, Inc.™

Colors and blends have different numeric values for web site use, therefore, different amounts of memory. For instance, black has a numeric of 0 or no memory, or translated into hexadecimal, would read #00000. Why is this important? Because use of numerous colors carries large amounts of memory, and this results in slow download for potential viewers who visit your web site. If you have not done so, refer to Chapters 2 and 3 on management strategies and compression techniques for more technical assistance with your color selections.

Other color issues are the appropriate uses of modes such as RGB (red, green, and blue screen monitor colors), indexed colors, gray scale, and CMYK. This chapter handles most of these except for CMYK, which is used for print media. What is worth noting about CMYK in a web media book is that you may often be preparing images for a variety of purposes besides the Internet. So, as you contemplate creation of your web imagery, remember to initially scan and prep for high resolution use, then save copies for the net and multimedia programs at the lower resolutions (Figure 4–4). Check with the other programs as to how these copy files should be saved, such as PICT, EPS, and others. For web media, use of web–safe color palettes will be the best bet for consistent color, from browser to browser, and on different platforms, notably PC and Macintosh. Web–safe palette use and examples are placed later within this chapter. Color samples can be found in the color plate insert section of the book. With print, color accuracy is not judged by what you are seeing on your monitor,

■ **Figure 4–4.**

because color tones, shades, and hues can vary from screen to screen (What you see is NOT what you get). Ink companies such as Pantone sell swatch guides with assigned numbers, which match the numbers listed within softwares, like Photoshop, QuarkXPress, and Illustrator. You will notice that there is quite a difference when the same color with corresponding numbers is compared between screen and swatch. Final selection should be made from the printed swatch guide, whether it is a Pantone spot color or CMYK.

Briefly, CMYK stands for the color separations of cyan, magenta, yellow, and black, the four-color process. The letter K is used for black instead of the letter B so that it is not confused with blue. Each plate placed in the printing press is for each of the colors, either C, M, Y, or K. The paper is loaded in the press with one of the plates of your job, let us say the cyan (blue). The paper stock runs through the press and everything blue on your file document will print out. The next color, magenta is loaded into the press along with the magenta (red) plate. The paper with the dried blue ink is reloaded, and the red is printed, and so on, with the yellow and black plates. Since the inks have transparent qualities, various blends occur within the overlapping of colors, so for instance, whenever a red and blue superimpose and blend, violet is the result.

Bit depth or z, as some refer to it, is the number of available colors in an image. Again, x and y refer to horizontal width and vertical height, making up the three measurement factors of x, y and z. So, how do we arrive at an 8-bit, 256-color image? As discussed in Chapter 2, a byte is 8 bits, made up of either 1s or 0s, typical of the binary system. If the bits are off, you have zeros. If the 8 bits are on, the byte reads as 1s. An 8-bit image has the potential of 0 to 256 colors (0 through 255 for each color; 0 is also counted as a color). Each of these are divided by 2, making a series of bits from 8 to 1, as noted below:

8-bit	$256 \div 2$
7-bit	$128 \div 2$
6-bit	$64 \div 2$
5-bit	$32 \div 2$
4-bit	$16 \div 2$
3-bit	$8 \div 2$
2-bit	$4 \div 2$
1-bit	$2 \div 2$

An indexed image needs 1 byte (8 bits) per pixel, but a 24-bit image, uncompressed as a JPEG, requires 3 bytes, representing a considerable difference in file size. Because a number of Internet visitors can only display 256 colors, or 8-bit images (though 5-bit, 32-color graphics is preferable), we transform our imagery through Indexing, as explained in Chapter 3.

Quick Review

Indexing refers to the reduction of an image to 8 bits or less. This is necessary to export an image as a GIF. When an image is reduced from millions of colors to 256 colors or less, these remaining colors are indexed in a color palette where each color, including 0, is numbered and given an RGB value. To Index a graphic, open the RGB image in Photoshop. Go to the File menu + Image + mode. Select Index.

CLUTS

These images utilize palettes and are created and applied to reduce numbers of colors, whereas 16- or 24-bit images are without the benefit of palettes because a limited color palette is not necessary. The hues within indexed images are kept in a palette called the CLUT, or Color Lookup Table (Figure 4–5). So, indexing chooses within this limited palette which colors will look best. Please see color plates 7 and 13.

CREATING/USING WEB–SAFE PALETTES

1. Open an RGB image. Choose Menu + Image + Mode + Indexed color.
2. Choose Web Palette. Click OK.
3. Choose Replace Swatches.
4. Locate and open the Web table you have saved, or use one of Photoshop's CLUTS, which can be found within the application under Goodies + Color Palettes. Click to open.
 (See Figures 4–6, 4–7, and 4–8.)

The swatches are now the 216 colors common to Mac and PC web browsers. (See color plates 5 and 9.) There is CLUT adaptive,

Figure 4–5.

Figure 4–6. Web (browser-safe) palette. See Plate 5 for color version.

▤ **Figure 4–7.**

▤ **Figure 4–8.**

custom and uniform. Adaptive is frequently used because it attempts to pull together the best set of colors for a particular image, but remember that an adaptive palette could cause color shift when opened in a browser if there are colors included outside the web-safe color range. Also, Mac and PC system web palettes are somewhat different from each other, so try your images within both systems if possible. For a good color example of the two swatches for comparison, open up Bob Schmitt's web page titled, *In Design School, They Promised No Math* at http://webreview.com/wr/pub/97/11/28/tools/index.html. It also provides a browser–safe web palette for further comparison. See Figures 4–9, 4–10 and refer to color plates 2 and 3.

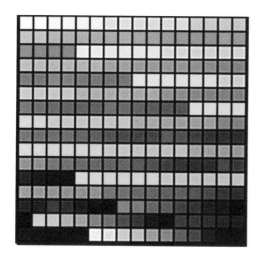
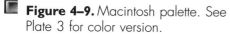

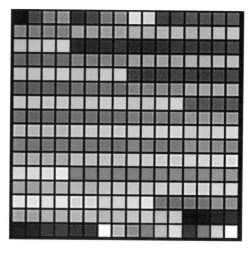

■ **Figure 4–9.** Macintosh palette. See Plate 3 for color version.

■ **Figure 4–10.** PC palette. See Plate 2 for color version.

To edit your image:

1. Open the Swatches Palette (Menu + Window), hold down the command/control key, and drag or click the scissors icon over the colors to be eliminated.
2. To add colors, click on the open space with the bucket icon after you have chosen a color from the toolbox foreground swatch. Use the eyedropper tool to pick up other colors that you want added to the palette. Many graphics can be handled successfully with no more than thirty-five colors.

Creating a Custom Palette

After indexing your graphic:

1. Select the Custom feature in the dialog box; save, for instance, an adaptive palette and then try applying it to several images (Figure 4–11).
2. Click on the Preview button to observe the different results. Use the Previous option to apply one palette to a number of graphics. Previous only works after using Custom or Adaptive palette options.

■ **Figure 4–11.**

Creating a Uniform Palette

Again, as mentioned in chapter 3, this selection refers to the web-safe color cube grouping of the 216 colors, (6 × 6 × 6 = 216), which you can open and use in Photoshop's Goodies file + Color Palettes. If the web-safe palette is missing from Photoshop's application, visit Discriminating Web Palettes, which is a web site where you can download the web-safe color palette. For the animated color cube see Killer Web sites in the appendix. Also, there is an inexpensive (about $30) program called Ditherbox for web designers who require more than the 216-color web-safe palette, put out by RDG Tools. This plug–in for Photoshop, as reviewed in *MacWeek* (vol. 11, issue 34) by Pat Soberanis:

"takes any RGB color, including custom colors, and creates a two-color, four-pixel pattern similar in tone to the original. When you click the Fill button in DitherBox's dialog box, the program tiles the pattern within your selection, creating the optical illusion of a solid color that closely matches the original. The dialog box shows the original color, the Web–safe palette, the pattern and the "legal" color created with the pattern. In theory, you could create your own patterns from Web-safe colors and fill selections using Photoshop's . . . Define Pattern command. But DitherBox automates the most time-consum-

ing task — figuring out which two-color combinations come closest to your original RGB color — and performs that task very well. Performance in other areas is also good, and the company provides shortcuts in its Web collection of frequently asked questions."

Tips to Remember

1. If you have several images you want to place on your web page, they could turn out badly because of several potential sets of 256 colors each to fit into the one set of 256 colors. The result is extreme dithering, which can add to file size.
2. It should be noted that these palettes may not be the best solution for all photos. As a final suggestion, Indexed photo images are probably best with the Adaptive Palette containing 256 colors. If this is not satisfactory, try using JPEG.
3. With mostly line art and text, use the Web Palette, unless the number of colors is very low.
4. Keep in mind that the Web Palette lacks flesh tones, so it is not the best choice for images of peoples' faces.
5. From "Discriminating Color Palettes": "Design in 24-bit. Whether you plan to use the JPEG format, GIF, or adaptive-palette GIF, always do your design work in 24-bit (RGB) mode - reducing the palette is the last thing you should do. In addition, always save the dithered version separate from the 24-bit Photoshop original. You never know when you will need to go back and make changes."

Customizing Your Palettes

First, remember that you cannot change or add new colors to an image that is indexed because the palette is already set. So check and be sure the image is set to the RGB mode before proceeding to add the new hues. Refer to color plate 9, Swatches.

1. Open the Swatches palette from the Window menu (Figure 4–12). Choose a color from the palette and click on a swatch to choose a foreground color in the toolbox. For the background color, opt/alt + click on the next color swatch.
2. To add a color to the Swatches Palette, choose a foreground color from the Color Picker, or use the eyedropper tool to select a color from a graphic or photo. Click with the cursor in

■ **Figure 4–12.**

the blank area below the swatches in the palette, then click with the paint bucket icon.

3. To replace a swatch color, shift + click on the color to be replaced.

4. To delete a color, key in Command/Control + click on a swatch using the scissors icon.

5. Go to default Swatches Palette by clicking on Reset Swatches.

6. To Save Edited Swatches, choose Save Swatches, name the swatch, then save it in a folder.

7. To replace a Swatches Set, choose Replace Swatches. Open the Color Palettes folder in Goodies within the Photoshop application or open a palette you previously saved. Double click on the new palette. It will now appear on the Swatches Palette.

8. To Load a Swatches Set, choose Load Swatches. Open your Color Palettes folder and double click on a palette. This new swatch set will now appear below the previous swatches.

Exercise

To give preference to the most important part of your image and manage file size:

1. Open graphic in Photoshop and select the featured area either with the marquee, lasso, or magic wand.
2. Use the Unsharp mask to sharpen, clarify, and enhance the area (this adds more k) (Figure 4–13).
3. Apply Inverse to select the rest of the image.
4. Choose Gaussian Blur for that selection (this reduces the k by eliminating colors) (Figure 4–14). Try different settings to get the final effect you want.

BATCHING WITH ACTIONS

The Actions Palette is very handy when you need to quickly prep a group of print images for web site use. It allows you to "batch" a number of images with one optimizing setup or action, made up of sequential commands that you designate. Actions are recorded and then replayed on a single graphic or a series of images that you want treated in the same way (Figures 4–15 and 4–16).

 Figure 4–13. ▇ **Figure 4–14.**

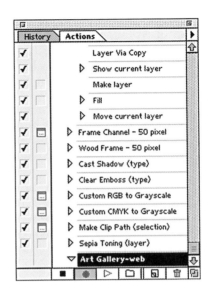

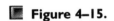

▪ **Figure 4–15.** ▪ **Figure 4–16.**

1. Open an image and click on the Actions Palette triangle on the right to access the pull–down menu.
2. Select New Action and in the dialog box, type in an appropriate name for the series.
3. Select Record and you will see that its icon is now red, which means it is recording.
4. To convert the image series so they are all the same size, go to Menu + Image + Image Size and enter your width and height specifications (pixels). This will now show up in the Actions palette. In this example, the Old Mission image is reduced by 50%. (Figure 4–17.)
5. Go to the Menu + Image + Mode + Indexed Color. Select Web from the pull–down menu, and after clicking OK, notice that Convert Mode appears in the Actions palette.
6. Select Save As from the File menu and roll down to CompuServe GIF.
7. Save to your folder created to hold the series of images. Choose to interlace or not.
8. Quit recording by clicking on the black square icon button at the bottom of the palette. (Refer back to Figure 4–16.) Notice that you can start and stop recording by clicking alternately between the red dot icon and the black square. Also note that

when the red record button is clicked off, you can now delete (drag down to the trash icon on the right) parts of the action that you no longer want.

9. To play back your custom actions on one or a file of images, go to Menu + File + Automate + Batch, then choose your Action file, in this case, ART GALLERY-WEB. Select your folder for the Source and open Choose to access your series of images folder. Click on OK and start the actions process. Whatever you programmed in Actions so far as sizing, and so on, will now be applied to all of the images when opened. They are also converted to GIF and then saved in your choice of folder. (See Figures 4–17 and 4–18.)

Student Question

How can I make my own colors for web imagery using Photoshop? Which ones are web-safe, and consistent from browser to browser?

◼ **Figure 4–17.** ◼ **Figure 4–18.**

```
Base -10 (Phshop)   Base-16 (Hex)

        0 . . . . . . . . . . . . . . .0
        1 . . . . . . . . . . . . . . .1
        2 . . . . . . . . . . . . . . .2
        3 . . . . . . . . . . . . . . .3
        4 . . . . . . . . . . . . . . .4
        5 . . . . . . . . . . . . . . .5
        6 . . . . . . . . . . . . . . .6
        7 . . . . . . . . . . . . . . .7
        8 . . . . . . . . . . . . . . .8
        9 . . . . . . . . . . . . . . .9
       10 . . . . . . . . . . . . . .A
       11 . . . . . . . . . . . . . .B
       12 . . . . . . . . . . . . . .C
       13 . . . . . . . . . . . . . .D
       14 . . . . . . . . . . . . . .E
       15 . . . . . . . . . . . . . .F
```

▣ **Figure 4–19.**

HEXADECIMAL SYSTEM

Photoshop uses a base-10 system to show RGB values. Color on the Internet is displayed through the hexadecimal system, which is base-16. So, a conversion must take place in order to broadcast what is known as BGCOLOR, comprising 6 digits, 2 for red, 2 for green, and 2 for blue, reading left to right. BGCOLOR basically stands for background color, but the system also applies to coloration of text, links and visited links, (vlinks). To find the equivalencies of the base 10 and base 16, see Figure 4–19.

Open the Color Picker in Photoshop and examine the numeric values of R (red), G (green) and B (blue) (Figure 4–20). This is the starting place for finding your final hexadecimal code of digits that can be typed or pasted into your HTML. Note on the Color Picker that the RGB selections are all set on 255 and when combined, equal white. This is because when all colors are blended together and generated through a light source, white is the result. In Figure 4–21, the chart shows the decimal equivalent of 255, or

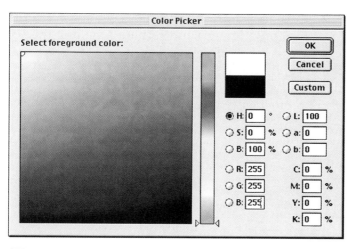

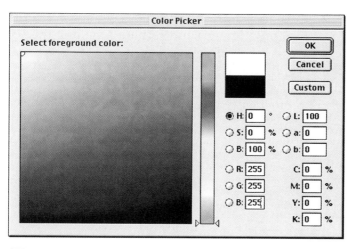

Figure 4–20.

white. The percentage is 100% and the hex value to the right is FF. If you look back at the base comparison chart on Figure 4–19, note the position of the F, and to the left, the number 15. To make this conversion, let us keep it simple and stick with the color white for our example. R (red) shows 255 on the Color Picker in Figure 4–20. To convert it from Photoshop's base 10 to hexadecimal's base 16, divide 255 by 16. The result is 15.93. Find the 15 on the Figure 4–19 chart, look to the right of it to the base 16 row, and your first digit is F. Multiply the remaining .93 by 16, which equals 14.88; round off to 15, check your equivalency chart for the base-16 comparison, and it also reads as F. Put the two Fs together and you

Percentages	Color number	Hexadecimal
0	0	.00
20	.51	.33
40	.102	.66
60	.153	.99
80	.204	.CC
100	.255	.FF

Figure 4–21.

have your BGColor code for the R (red) section. Go through the same procedure for G (green) and B (blue), making the six digits necessary to use within HTML, which in this case, since 255 is used for each color, our complete hexadecimal reads, FFFFFF, or white. Place the # sign before the six digits to complete the code and you are in business.

Create hexadecimal background colors within your HTML like this:

```
<BODY>
</BODY>
<BGCOLOR="*******"TEXT"*******"LINK="*******"VLINK="*******">
<BODY>
```

Replace the 7 ******* between the " " using the pound sign for the first digit, and follow with the six-digit code for a particular color such as white: #FFFFFF. Remember that some colors will change on different browsers, so to be browser-safe, use only these hex codes: 00, 33, 66, 99, CC, and FF in various combinations of red (R), green (G) and blue (B), utilizing the range within the 216 web-safe color cube ($6 \times 6 \times 6$). Note Figure 4–21 for these codes. Also observe that the percentages go up in 20% increments dividing into six equal sections, like the $6 \times 6 \times 6$ browser-safe web palette cube of 216 colors. However, you may find that many of the color codes listed outside the web-safe group work satisfactorily and add variety, so test them for yourself. Observe that black, white, the primaries of red, yellow, and blue, and monitor values of red, green, and blue, all have browser-safe codes, as do cyan, magenta, yellow, and black (CMYK), all basics for color mixing whether with light, paints, or printing inks. Try combining a variety of web-safe codes to make new colors. Make your own chart. Experiment and enjoy the riches of brilliant CRT color for the delight of your web site viewers. This goes arm-in-arm with my bottom line basic rule of design: "Make it look good." As you work through the technical maze of web site imagery, never lose sight of this factor and why color and design are still the most important elements in web media design.

RGB HEXADECIMAL CODE CHART
Web-safe Basic Colors

White	#FFFFFF

Red	#FF0000
Green	#00FF00
Blue	#0000FF

Cyan	#00FFFF
Magenta	#FF00FF
Yellow	#FFFF00
Black	#000000

Web-safe Combinations

(00, 33, 66, 99, CC, and FF in various combinations of red (R), green (G) and blue (B).

Dk. Gray	#333333
Lt. Gray	#CCCCCC
Peach	#FFFF99
Gold	#FFCC00
Med. Pink	#FF6666
Orange	#FF6600
Brt. Red	#FF0033
Dk. Red	#CC0000
Brt. Pink	#FF0099
Lt.Lavender	#CC99FF
Violet	#CC00CC
Plum	#990066
Grape	#660066
Mahogany	#330000
Warm Brown	#996600
Clay	#CCCC99
Khaki	#CCCC66
Olive	#999900
Drab Olive	#666600
Deep Green	#003300
Dusty Blue	#003366
Ultramarine	#000066

Process Blue #0000CC
Med. Blue #006699
Brt. Blue #0066CC
Sky Blue #99CCFF
Cyan #00FFFF
Aquamarine #339999
Lt. Blue #99CCCC
Spring Green #00FF33
Pale Blu/grn #CCFFCC
Pale Green #CCFF99
Forest Green #336633

These are mixed, so experiment:

GRAYS
X-Lt. gray #CDCDCD
Lt. gray #A8A8A8
Dk. gray #2F4F4F
Soft gray #545454
Md. gray #C0C0C0

BROWNS
Lt. tan #EBC79E
Md. tan #DB9370
Deep tan #97694F
Faint brown #F5CCB0
Lt. brown #E9C2A6
Md. brown #A68064
Dk. brown #855E42
Chocolate #6B4226
Brn/Blk #5C4033
Khaki #9F9F5F

YELLOWS
Yellow #FFFF00
Wheat #D8D8BF
Goldenrod #EAEAAE
Bright Yellow #D9D919
Yellow green #99CC32

REDS
Red	#FF0000
Magenta	#FF00FF
Maroon	#8E236B
Red violet	#DB7093
Red orange	#FF2400
Brick	#8E2323
Scarlet	#8C1717

BLUES
Blue	#0000FF
Cyan	#00FFFF
Hue blue	#5959AB
Slate	#007FFF
Sky 1	#38B0DE
Sky 2	#3299CC
Turq.	#ADEAEA
Steel	#236B8E
Lt. blue	#C0D9D9
Md. blue	#3232CD
Blue/Blk	#00009C
Neon	#4D4DFF
Navy	#23238E
Aqua	#32CD99

PURPLES
Violet	#4F2F4F
Dk. violet	#871F78
Plum wine	#EAADEA
Md. Lavender	#9370DB
Dk. Lavender	#9932CD
Purp. Blue	#9F5F9F

GREENS
Green	#00FF00
Dk. green	#2F4F2F
Bright green	#00FF7F
Sea Foam	#238E68
Green/Yel	#93DB70
Olive	#4F4F2F
Lime	#32CD32
Soft green	#8FBC8F
Hunters green	#238E23

ORANGES
Orange	#FF7F00
Peach	#FFFF99
Coral	#6F4242
Rose	#856363
Tangerine	#E47833

PINKS
Pink	#BC8F8F
Hot pink	#FF1CAE
Neon	#FF6EC7

METALS
Bronze	#8C7853
Copper	#B87333
Brass	#B5A642
Silver	#E6E8FA
Gold	#CD7F32

PROJECT
MULTIGRAPHIC CUSTOM PALETTE

If you plan to have a number of images on a particular web page, you cannot use a different custom palette for each graphic. There would be too many colors from the numerous pieces, so the browser would automatically switch over to the web palette. To solve this problem, make a custom palette that includes the colors from all your images and limit the palette to a certain number of colors, such as 5- or 6-bit. Refer to color plates 11, 12, 13, and 14.

1. Open and either paste or drag and drop all of your images that will appear on the web page onto one Photoshop document (Figure 4–22).
2. Use the move tool to arrange the graphics so that they are all visible at once on the white background, then flatten the image (Menu + Layer + Flatten Image).
3. Index it to an Adaptive Palette. Try 4- to 7-bit (Figure 4–23).

Figure 4–22.

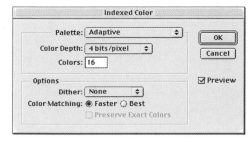

Figure 4–23.

4. Go to the Color Table from Menu + Image + Mode. (See figure 4–24.)
5. Save your finished palette in the appropriate folder.
6. Index all the graphics by opening them, one at a time, then select Custom.
7. Load the Custom Palette for the first image.
8. For the rest, use Previous Palette for Indexing (Figure 4–25).

Refer to color plates 6, 8 and 12.

Become proficient in palettes creation and manipulation. Explore and make custom, adaptive, and color cube palettes.

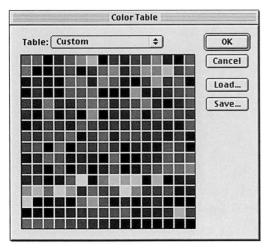

■ **Figure 4–24.** ■ **Figure 4–25.**

➤ **ON–LINE TUTORIALS FROM ADOBE**

❏ Web-safe Color Palettes.
❏ Optional: Pantone Colors to Web-safe Colors. (Be sure you have downloaded the 216 web palette listed with Chapter 3.)
❏ Also check out Adobe Design Tips, "The Discriminating Color Palette" (article) and study the Killer Web Sites color cube.

Options

1. Adobe's ImageReady is an image optimization program that you may want to look at for expediting some of these procedures. Check out the Adobe web site for information and download:
 http://www.adobe.com/prodindex/imageready/main.html. While there, look at another nifty tool, ImageStyler, for future use.
2. PhotoGIF is another Photoshop plug-in filter that aids the optimization process. It is said to be a superior compression product and can be downloaded from BoxTop Software, Inc. http://www.boxtopsoft.com.

CHAPTER **5**

GRAPHIC CREATION

THIS CHAPTER WILL DISCUSS:

➤ Simple Idesa for Graphics with Animation in Mind
➤ Image Creation/Handling
➤ GIF Conversion
➤ Sizing
➤ Placement Tricks
➤ Using Netscape's Wizard
➤ Caching/Graphic Intensives
➤ Project: Building Graphic Elements for Animation

SIMPLE IDEAS FOR GRAPHICS WITH ANIMATION IN MIND

1. Expanding or contracting circles or rectangles. Each change of circle or rectangle size goes onto a new Photoshop layer. (See Figure 5–1.)

Figure 5–1.

2. Create a black outlined logo, letter or graphic. Each successive layer fills with a different color or background. This technique could work on a product photograph, such as a car.

3. The same graphic objects are superimposed on several layers, such as balls or spheres. The colors change on each layer to create a flashing light effect. Try white or yellow. You could lay out a lineup of 3–D balls horizontally or vertically, where each layer (frame) changes color.

4. The same graphic goes through a series of filter changes, creating a metamorphosis. (This could also grow or shrink in size.)

5. Prepare a graphic image covered by a layer of solid color. The solid color cracks like glass, or earth and progressively falls away, losing pieces layer after layer. Try some of the Photoshop filters such as Splatter, Glass, Pixelate + Crystallize, Stylize + Extrude, Texture + Craquelure, or Stained Glass, Cut Out, and Fresco. (See Figure 5–2.)

6. Flashing type–1 layer on, the next off, or leave blank. See Chapter 9 for the HTML method. (See Figures 5–3 and 5–4.)

7. Open a larger background photo. Flash certain objects or selected areas on the surface.

8. Create text that can vibrate or move along a path.

9. Distort text in Photoshop's Free Transform. Each layer should show a different position of a progressive distortion. (See

▣ **Figure 5–2.**

FLASH

■ **Figure 5–3.**

■ **Figure 5–4.**

Figure 5–5.) Try putting different letters on different layers. See chapter 8 for other text manipulation ideas.

10. Create a logo or logotype (see Chapter 8 for ideas and exercises) that will move, break apart, or come together.
11. Make simple graphic objects that can spin, bounce, collide, or fluctuate such as a 3–D disk, ball, or other basic shape symbols. Consider how these might evolve into animated logo designs. Use filters to create an exploding effect of two colliding objects. (See Figure 5–6.)

■ **Figure 5–5.**

■ **Figure 5–6.**

12. Use mnemosynes as preliminary graphics for animation construction and practice. Be sure and place each tangram piece on a separate layer, and check that all backgrounds are transparent. Later, you can replace the triangular objects with other images as you create them, such as letters, parts of a logo, or other graphic elements (Figure 5–7).

IMAGE CREATION/HANDLING

Mnemosynes Using the Tangram

A mnemosyne is an image that is for the purpose of assisting or improving the memory. The word comes from Mnemosyne, the Greek goddess of memory. Here, we will use the concept to create a type of code for a design project.

1. Create a different position for each tangram piece within a grid for every letter of the alphabet. Start by scanning the tan-

tangram

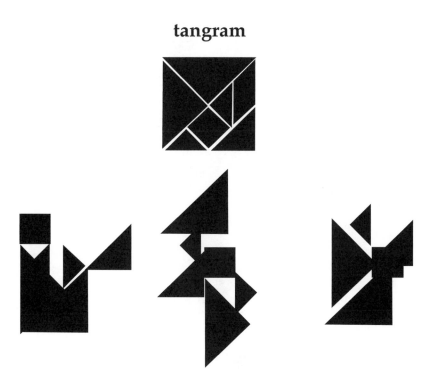

⊓⊓⊓⊓⊓⊓⊓⊓⊓⊓**Each piece goes on a separate layer**⊓⊓⊓⊓⊓

■ **Figure 5–7.**

gram. Open it in Adobe® Illustrator® where you will be selecting/copying/cutting out the pieces. After selection of the individual pieces, fill with either black, or try using a set of four different colors.

2. Open a new document and draw a grid in Illustrator made up of 26 one-inch boxes, black outlines, all connected together. In each of the 26 boxes, place a letter of the alphabet in succession (A, B, C, and so on). Next, copy and paste the tangram pieces, one at a time, in each box. When using the same shaped and sized piece repeatedly, be sure it is in a different position than the previous box. Try the rotation and scaling tools for variety. (See Figures 5–8 and 5–9.)

3. Now look at the visual language or code (mnemosyne) you have created, and proceed to spell words by superimposing

▨ **Figure 5–8.**

▨ **Figure 5–9.**

the boxes of your chosen word. For example, spell out the word, "cat." Be sure that your boxes are transparent; if not, go back and make them so now (use the Eliminate White Photoshop Plug–in). (See Figure 5–10.)

4. Layer the C, the A, and the T on top of each other, matching up the boxes so the edges are exactly even with each other. Here is your first visual word design, known as a mnemosyne. Continue to spell more words in this same way. To use in animation, each mnemosyne position or box must be on a separate layer.

Black and White or Gray Scale Web Graphics

It is necessary to convert from the gray scale mode to RGB so that you can select/deselect the various gray values within the black and white half-tone image. Also, this conversion allows use of the GIF89a Export feature. When you open Export from the File menu, be sure that Interlacing is off because it may not be needed for the small file sizes of gray scale images.

Exercise

1. Open the image, change to RGB, go to GIF89a Export.
2. Consider the Preview, click OK, then work toward reducing

■ **Figure 5–10.**

the numbers of values in the Adaptive palette. Start at about 32 and work down until you have the least number of values, but still a decent-looking image when compared to the original graphic.

Graphics with Gradients and Textures

1. Make an oval shape, and fill with a dark color. Create a new layer and name it oval.
2. Click on the Channels tab within the palette and choose Save Selection by clicking on the icon. To see it, click on the channel name. It is a good idea to make an Alpha Channel when you may use a selection repeatedly, and you want to have quick access. Key in Command/Ctrl and click on the channel to make it active. (See Figure 5–11.)
3. Choose a black and white gradient and foreground to background by double clicking on the gradient tool in the toolbox then selecting from the pull–down menu. Light areas will let color show through; dark areas block out the final color. If you do not use black and white, use highly contrasting hues on the blend. Save. (See Figure 5–12.)
4. To make a Radial Gradient, click and drag on the selected gradient tool in the toolbox. Choose radial. Drag with the mouse across your selected object. Experiment with the different gradient selections. (See Figure 5–13.)

▪ **Figure 5–11.**

■ **Figure 5–12.**

■ **Figure 5–13.**
Select gradient tool.

5. Hold down Command/Ctrl key and click on the channel name to load the new channel. It may not look like all of the image is actively selected due to transparencies involved, but it is completely intact and ready for the next stage.
6. Go back to the Layers Palette and select the oval layer. Select the layer mask icon while the gradation is still selected and save it as a layer mask. Create new layers with other textures and colors for more depth and interest or duplicate the original one by Option/Alt, dragging the oval layer onto the New Layer icon at the bottom of the palette. This multilayering creates depth of color, somewhat like the old masters' technique of painting multiple washes on top of each other to enhance the painting's beauty.
7. Fill the new layer with new foreground color, remembering to

select the Preserve Transparency box to fill the graphic object only. Layer masks are very handy if you want to change the colors—just be sure that Preserve Transparency is on.

8. Add the texture with the layer mask selected. Go to Noise or another Filter/Texture choice from the menu. Noise is used in the finished example. You can add several layers; try a number of different textures superimposed together.

9. The background layer was filled with Clouds from the Filter menu, then a setting of Noise, 27, Uniform. Airbrushing was added last on a new layer. Try these procedures on other objects, such as a logo, as shown.

(See Figures 5–14, 5–15, 5–16, 5–17, 5–18.)

GIF CONVERSION

Use the GIF89a Export, which also provides transparency features. Again, transparency is used to mask out background or a part of an image. Suggestion: Use Transparent GIF for a web page background with an irregular pattern. See color plates 10 and 14.

1. To start, go to menu + File + Export + GIF89a Export (Figure 5–19).

2. Select the Adaptive Palette, decide the number of colors you want to use, then select or enter the appropriate amount for

■ **Figure 5–14.**

■ **Figure 5–15.**

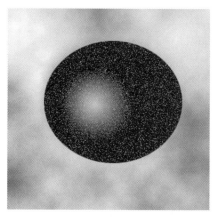

 Figure 5–16.

 Figure 5–17.

 Figure 5–18.

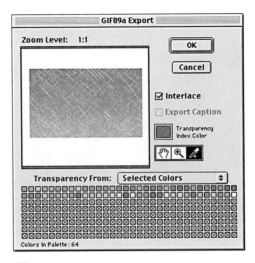

■ **Figure 5–19.**

the image. Again, the goal is to represent an image effective-
ly using as few colors as possible.

3. Click Preview to check color settings on the image. Click OK.
4. Reduce the number of colors and preview the image to see if
 its quality is adequate.
5. Click interlace if you wish. Do not use on small images, ani-
 mations or small type.
6. If you want to redo the image, hold down Option and click
 Reset to restore and start over. Click OK. Save to your web
 site folder.

To make the rectangle irregular texture sample shown with the
GIF89a Export, go through similar steps as listed earlier, follow-
ing the illustrations shown in Figures 5–20, 5–21, 5–22, 5–23.

■ **Figure 5–20.**

■ **Figure 5–21.**

■ **Figure 5–22.**

■ **Figure 5–23.**

SIZING

Note: The maximum size for a 13-inch monitor is 640 wide by 480 pixels in height. A suggested size is 500 pixels wide by 570 high. Select graphic sizes according to your intended audience of viewers by reviewing the following data.

Quick Review

Pixel width and height information can be obtained from Photoshop by selecting Image Size or Canvas Size in the Image menu (Figure 5–24). Be sure and convert the units from inches to pixels. You can also alter the size of an image without cropping from the Image Size setting. The Resample Image check box must

◼ **Figure 5–24.**

be checked in order to access the Pixel Dimensions section. For most situations, keep it on the pixel setting. Check the Constrain Proportions option so that the height size and the width will automatically change also in proportion when alterations are made. Canvas Size in the Image menu adds or subtracts to alter the dimensions of an image. Choose a certain anchor block to determine what portion of the image you want to alter. It works inversely, so if you choose the top center block, the alterations will apply to the bottom center of the image.

Again, resolution refers to the number of pixels in a certain distance and pixels are measured in pixels per inch (ppi). When you want to convert an image from pixels into inches, simply divide the pixel count by 72. An image will decrease in overall screen size as the screen resolution increases. As mentioned earlier, web pages viewed on monitors are commonly viewed at 640 × 480 pixels. Designers often have larger screens, 16, 17 inches, or more and can handle 800 width × 600 height or 1,024 width × 768 height. There are some screens that are considerably larger, but may only handle 640 × 480. This type of screen shows larger pixels, not a larger image.

Still, designers must frequently design for general audience viewing, imagery that will fit on the 13- or 14-inch screen (640 × 480). Some recommend that graphics should be no larger than 625 pixels wide by 320 pixels high. You will find variations on this, and frequently designers make graphics smaller, such as a 450 to 550 pixel width, which will work on all browsers. Quicktime movies are quarter screen size at 320 wide by 240 high.

When an image is doubled in size, there are four times as many pixels, because the width and height are multiplied together. Use the rulers (Command/Control + R) to determine if your graphics are too large and scale or crop accordingly. A freeware application called Screen Ruler is available for download, which gives the ability to see and use a bright yellow ruler on your screen for quick horizontal and vertical measure. For Windows go to http://www.weblife2000.com/downloads.htm. For Mac: http://www.kagi.com/microfox.

Trimming Down Images with Feathered Edges

It is important to web site design to make the smallest most efficient graphics possible, while maintaining good design composition and exciting imagery. There are a variety of ways to accomplish these goals as discussed in previous chapters, like cutting down numbers of colors, cropping, histogram manipulation, transparency, and carefully prepared gradients. Following is another useful technique to make feathered graphics.

When working with an image that has feathered edges, it can be difficult to crop without clipping off the soft, diffused edges. In the Layers palette, make the layers you want to use visible by clicking on the eye icons. Disregard the others by simply clicking off the eyes. This includes a background you may want to eliminate. Select one of the chosen layers by clicking and go to Merge Visible in the Layers Palette menu. If you flatten the layers, the unselected ones are eliminated. To keep your original set, choose Duplicate from Menu + Image + Merged Layers Only. This way you have an original set of layers plus the new merged layer file. Select the transparent background with Magic Wand (0 to 10 tolerance), then go to Menu + Similar to be sure that all transparent pixels are enclosed (you may have to shift click some additional areas). Invert. (See Figures 5–25, 5–26, 5–27, 5–28, and 5–29.)

Make a rectangular selection and crop. For more detailed practice, refer to the Adobe® on-line tutorial listed at the end of this chapter.

Tips to Remember

1. Use layering for composition and preview purposes on items such as backgrounds, tiles, text, or other graphics. Create

◼ **Figure 5–25.** Creating a transparent background

◼ **Figure 5–26.**

◼ **Figure 5–27.**

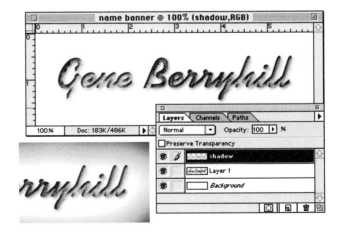

◼ **Figure 5–28.**

■ **Figure 5–29.**

several ideas and make visible the items you decide to use for the final web site.

2. Check out various filter applications on separate layers. Try intensifying one filter selection on each progressive layer.
3. Examine and work with aliased vs. anti–aliased type.
4. Change size, restack, recolor, or change positions from layer to layer.
5. Use the same image again and again on different layers for animation purposes.

Student Question:

I have created my images for web site use at 72 ppi. In hindsight, I am wondering, what if I need to print some of these images out? Will the print quality look good enough?

The answer is no, for most images; they will not look as nice as images created at 300 dpi. However, when they must be printed, you may want to try Resampling. Look at the Resampling figure and note that the starting size is 6 inches square with a ppi of 72. Change the resolution to 300 and notice that the size increases from 432 pixels square to 900 pixels. Make sure that Constrain Proportions and Resample Image: Bicubic are selected. Then change Print Size to 3 inches. Click OK, and look at your image at 100%. This is about the quality that will print out. You can improve on it somewhat by using Unsharp Mask under Filters + Sharpen. Of course, the best way is to scan images initially at a high resolution, save copies, then optimize those with a resolution of 72 dpi for web site use. (See Figure 5–30.)

Resampling

Image Size

Pixel Dimensions: 547K

Width: [432] [pixels ▼]

Height: [432] [pixels ▼]

[OK]
[Cancel]
[Auto...]

Print Size:

Width: [6] [inches ▼]

Height: [6] [inches ▼]

Resolution: [72] [pixels/inch ▼]

☒ Constrain Proportions
☒ Resample Image: [Bicubic ▼]

Change the 72 dpi to 300dpi and reduce the 6"x6" to 3"x3." It is now 2.32 mg.
Go to Unsharp Mask. Set: 100% Amount,1.0 pixels, 0 Threshold.

Image Size

Pixel Dimensions: 2.32M

Width: [900] [pixels ▼]

Height: [900] [pixels ▼]

[OK]
[Cancel]
[Auto...]

Print Size:

Width: [3] [inches ▼]

Height: [3] [inches ▼]

Resolution: [300] [pixels/inch ▼]

☒ Constrain Proportions
☒ Resample Image: [Bicubic ▼]

■ **Figure 5–30.**

PLACEMENT OF GRAPHICS ON A WEB PAGE—OTHER THAN LEFT, CENTER, OR RIGHT

1. Make a transparent pixel:
 Create a 1 pixel transparent GIF document to use for placement/alignment of other images on your page. Alter the size of the pixel by changing the height and width measurements within the HTML tag. Then place it appropriately according to where you want your actual image to be positioned. For instance, if you want the image 1 inch from the left

edge and 1 inch down from the top edge, you would type in into the transparent pixel tag.

2. Fill in areas to the left or above your graphic with type characters the same color as your background. Black is quick and easy.

3. Use a transparent table. Start by creating the table cells according to the authoring software's instructions. This usually involves clicking and dragging on the Tables icon in the toolbar, then choosing how many cells and rows you wish to make. Turn table borders off, so they will not show. The HTML is, BORDER=0. Place your images or text in the table cells where you want them to be located on your page layout. Since these cells can change in size from browser to browser, you may want to set the width of each cell. If you want relative size (changes according to the window size), use percentage. For absolute size, specify pixel width.

Relative: <TD WIDTH="20%">
Absolute: <TD WIDTH="72">

More space may be added by using cellpadding or cellspacing. Padding has to do with the space inside the cell and spacing deals with the area outside the cell. You may enter numbers after the names accordingly:

CELLPADDING="5"
CELLSPACING="5"

To make color solids next to each other look seamless, place each section of color or image in one table cell, then place the second object in a cell next to the first. Turn the table borders off. It is important to be sure that the table tag is ended correctly for a seamless or invisible appearance. Do not press return and place the ending tag </td> on a separate line, or the gaps within the table will show. (See Figures 5–31, 5–32.)

Table Exercise

Some designers prefer this method to making the traditional type of image map, though a table can become an image map as well. Take a photograph or graphic and cut it into block–like pieces. For

▣ **Figure 5–31.** Table borders on

▣ **Figure 5–32.** Table borders off

PC, there is a downloadable software named Picture Dicer (http://www.weblife2000.com/downloads.htm) that will handle this task. Each piece is on a separate layer. For creative variety, you can treat individual pieces in a number of interesting ways, which can also facilitate faster download times due to different amounts of memory. Consider different filter applications, colors, opacities, modes, and so on. After Indexing and GIF preparation (or other compression), place each piece within a table cell. Experiment until you get the effect and speed you want.

USING NETSCAPE'S WIZARD TO POST/REVIEW GRAPHICS

During the creation process, one way to do a quick test of your graphics and animations is to utilize Netscape's Wizard. Go through the step–by–step instructions to create your first web page. All colors displayed within the Wizard for your selection are web safe. To start, open Netscape and go to Menu + File +

Page from Wizard. Click on Start and follow the simple instructions to create browser–safe colors on text, hotlinks, and backgrounds. There is also a texture palette available. When finished with the basic settings, click on the Build button. Proceed to Menu + File + Edit Page. Look at the tool bar at the top of the document. Here you can manipulate colors, type style and sizes, alignment, and you may import your own graphics by clicking on the image icon. (See Figure 5–33 .)

The next dialog box, Figure 5–34 will give you a Choose File button to locate the appropriate optimized image. Do so, then

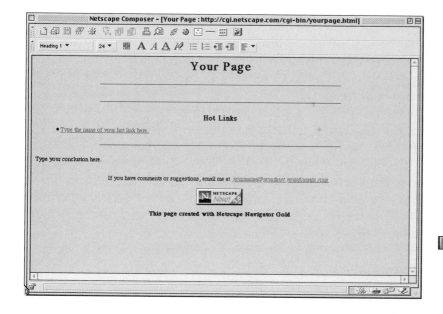

Figure 5–33. Copyright © 1999 Netscape Communications Corporation

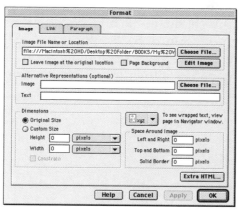

Figure 5–34. Copyright © 1999 Netscape Communications Corporation

click on OK. Be sure to save your page when finished. If you need to re–edit, open the saved page and, once again, go to Menu + File + Edit Page. Save again. You may publish your page via Menu + File + Publish. Also, refer to File Transfer Protocol (FTP) in Chapter 10 for more ways to upload your site onto the Internet.

CACHING AND GRAPHIC INTENSIVE SITE VIEWING

As was mentioned in Chapter 2, browsers have two types of caches: memory and disk. Memory keeps the current web page in memory, and browser preferences determine the size of the memory cache, which is usually no more than 1 MB. Disk cache, on the other hand, is over five times larger, and dumps older contents as new is added. More current visited pages are kept in the disk cache, accessible repeatedly by pressing the back button. You can clean the cache via Preferences in Netscape and Options in Internet Explorer.

When you quit the application, the memory cache empties, but again, the disk cache remains on your hard disk. Purge the caches by pressing the Clear Memory Cache Now (Macintosh) and Clear Disk Cache Now buttons in the cache. Try increasing the disk cache to between 2,000 and 5,000 kilobytes (2 and 5 megabytes) if your system can afford this amount. If there are delays when you quit the program, reduce the size of the disk cache to an appropriate amount.

For graphic intensive site viewing, increase the Disk Cache to 10 MB by going to Menu + Edit + Prefs + Advanced + Cache. To adjust the Memory, select the Communicator (Netscape) Icon. Go to Menu + File + Get Info, and enter the new amount in the Info Box. File size is shown within the Get Info box on Macintosh, not at the bottom left of the open window, as is often assumed (Figure 5–35). Windows keeps the file size in the File Manager. Cache size and location preferences are set in the cache panel, allowing you to set the directory location of the disk cache.

Figure 5–35.
File size: 64K

PROJECT
BUILDING GRAPHIC ELEMENTS FOR ANIMATION

Create simple graphic elements, playing off some of the ideas suggested at the beginning of the chapter. Make sure you save a copy of a file with the layers intact for potential animation use. Look for more graphics ideas in upcoming chapters, like Chapter 6 Backgrounds, Chapter 7 Buttons and Other Navigational Graphics, and Chapter 8 Text and Logotypes.

➤ **ON-LINE TUTORIAL**

Trimming Graphics to Their Smallest Possible Size
 http://www.adobe.com/studio/tipstechniques/wpdphsd4/
 main.html

CHAPTER **6**

BACKGROUNDS

THIS CHAPTER WILL DISCUSS:

➤ Overview
➤ Tiling
➤ Textures
➤ Creating Seamless Tiles
➤ Cloning
➤ Transparency
➤ Project: Prepare a Background for Button Compositing

OVERVIEW

Graphics that fill the backgrounds of web pages are a dominant feature in web design. They create the initial impression of your site, and necessarily require extensive design consideration. The background must work well with the other graphic elements and it is essential to be able to read the type on the chosen background colors and styles. Small type will be difficult if not impossible to read on a heavy texture, Figure 6–1, or complex photo, especially if italicized or interlaced. Wallpaper or gift wrap looking patterns are also not recommended. Try for less contrast within your textured background for better readability. Also, subtle textures use less colors, making smaller file sizes. Refer to Chapter 8 for more extensive information on typography for web sites.

Most web site backgrounds are solid color or textured and may be GIFs or JPEGs. If your background is to be a solid flat color, it is a simple matter to use the hexadecimal system as explained in Chapter 4. (There are also helpful color charts.) It is possible to have a solid color background and a textured background. The solid color comes up first, then the texture downloads. Your textured tile is the .gif and the solid background is followed by the hexadecimal bgcolor="#00FF33".

■ **Figure 6–1.**

Quick Review

Photoshop uses a base 10 system to show RGB values. Color on the Internet is displayed through the hexadecimal system, which is base 16. So, a conversion must take place in order to broadcast what is known as BGCOLOR, comprising 6 digits, 2 for red, 2 for green, and 2 for blue, reading left to right. BGCOLOR basically stands for background color, but the system also applies to the coloration of text, links, and visited links (vlinks). Replace the 7 ******* between the " " using the pound sign for the first digit, and follow with the six-digit code for a particular color such as this example, which displays white: #FFFFFF.

Create hexadecimal background colors within your HTML like this:

```
<BODY>
</BODY>
<BGCOLOR="*******"TEXT"*******"LINK="*******"VLINK="*******">
<BODY>
```

Backgrounds can be of any image though it is generally not a good idea to use a background with recognizable pattern, because the seams may look bad when tiled. (See Figures 6–2,

■ **Figure 6–2.**

6–3.) But it depends on the image and your intended use. For instance, it is best not to use photos that make superimposed type unreadable, but there are ways of manipulating a photo or background tile, such as less contrast or use of analogous hues within a similar value range. Contrast your colors and values accordingly when dealing with backgrounds and text. (See Figures 6–4, 6–5, 6–6.)

Work toward a balance between yet another boring, ho-hum subtle canvas texture in some pastel, and a texture that is so bizarre that it is the main event of the site and nothing else in text or graphics matters. An exception might be the opening splash page. Strive for something that effectively communicates coupled with uniqueness that draws a crowd. (See Figure 6–7.)

Try different combinations, because the results can be surprising. Neon blue text can look fine against one background and fuzzy on another. As with all art and design projects, this is going to take a lot of trial and error but it is time well spent to come up with something user friendly and visually amazing.

◼ **Figure 6–3.**

■ **Figure 6–4.**

■ **Figure 6–5.**

■ **Figure 6–6.**

■ **Figure 6–7.**

Quick Review

During the creation process, a good way to do a quick test of your graphics and animations is to open up Netscape Communicator's Wizard, and go through the step-by-step instructions to create your first web page. All colors displayed within the Wizard for your selection are web safe. See Chapter 5 for more detailed information.

TILING

Tiling is used to manage file size. Instead of a large background GIF or JPEG, which would have to be 640 × 480 to fill the screen, a small background graphic is created, which is called a tile. When put through the process of tiling, this one small graphic is repeated over and over until the entire 640 × 480 surface is filled. The advantages to this procedure are smaller file size and speed. Once the small tile is downloaded into the cache, the duplicates load very quickly. Textured tile graphics should look seamless when composited together. Note the exercises under Three Ways to Fix Seams to make corrections and create visually smooth transitions between tiles.

A good approximate tile size is between 2 and 3 inches and it does not have to be a perfect square. (2 inches = 144 pixels, 3 inches = 216 pixels.) Small tiles (half inch or less—36 px) are not advised because it takes longer to process and download numerous small pieces. You may want to experiment with a very wide tile (640) with a thin vertical height (72) for some interesting effects. The tile can be a vertical or horizontal rectangle, but keep in mind the memory load for GIFs, as they compress horizontal runs of color more efficiently. Though if color choices are carefully considered with the rest of the graphics in mind, a limited color palette on vertical banding may not be significant.

Quick Review

GIF uses the compression algorithm, LZW (Lempel-Ziv-Welch), which decides the numeric of how many pixels of a specific color are in one horizontal row. So, in a particular row, you have a breakdown count of a certain number of red, green, and blue

(RGB) pixels. Because of this, blends, gradients, or stripes that run horizontally take about half as much memory as vertical banding. GIF works best with some type of recognizable pattern and the top to bottom gradients make smaller file sizes while left to right gradients are larger.

TEXTURES

Make a Full Background of Sand

1. Open a new 640 × 480 pixel document (8.8 in. × 6.6 in.) in Photoshop.
2. Choose a tan/brownish color from the color cube or load web/multigraphic custom palette to avoid dithering. Fill.
3. Add noise filter, then gaussian (25), monochromatic.
4. Apply Filter + Gaussian Blur (1) to see the effect.
5. For sand underwater, keep Gaussian Blur.
6. Go to your web-safe color swatches and click on a light blue.
7. Fill a New Layer with the blue; adjust opacity to about 30%.
8. Try adding Filters such as Ripple for some interesting effects.

(See Figures 6–8, 6–9, 6–10, 6–11, 6–12, 6–13, 6–14.)

■ **Figure 6–8.**

Figure 6–9.

Figure 6–10. 1.8M

Figure 6–11. 66K

Figure 6–12. 66K

Figure 6–13. 396K

Figure 6–14.

Make a Sand Tile

1. On the sand background, select a 2 by 2 inch (144 × 144 pixel) area with the marquee tool. (See Figure 6–15.)
2. Copy and paste the selection into a new 2 × 2 inch document. Open the Show Info Palette to help with sizing.
3. Save for creating a seamless tile page.
4. Compare file size with the full background. It is beneficial to compare several file sizes at this point. Note that the original large Sand Background before any compression is 1.8 MG (refer back to Figure 6–10, page 120). Compressed as a GIF, indexed to four colors, the graphic is 66 k. The JPEG at medium quality is 66 k and the PNG produced 396 k. Compare these with the 2-inch sand tile: The original is 176 k, GIF is 22 k, JPEG is 44 k, and the PNG compressed to 66 k. From this range of file sizes, with comparable image quality, the GIF 22 k is the best choice. (With this type of texture, various compression types all look much like the original, so select the lowest memory.) (See Figures 6–16, 6–17, 6–18, 6–19, 6–20, 6–21.)

Figure 6–15.

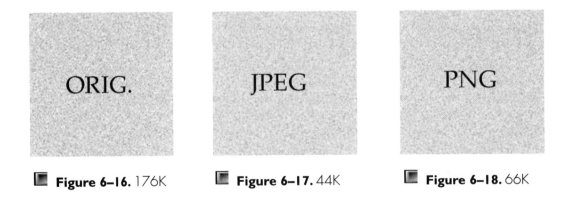

Figure 6–16. 176K **Figure 6–17.** 44K **Figure 6–18.** 66K

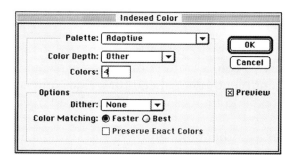

■ **Figure 6–19.** Original background: GIF, indexed to 4 colors = 66K

■ **Figure 6–20.** 22K

■ **Figure 6–21.** Finished background with logo graphic

Make a Wide, Thin Gradient Tile

1. Open a new 640 by 72 pixel document (8.8 × 1 inch).
2. Select the two colors from your web-safe swatches palette for the gradient blend. Plan ahead for values and contrasts, considering text and images that will be placed over the gradient at a later time.
3. Click on the gradient tool and while drawing a horizontal line across, hold down the shift key to make the line straight. Save to use as a tile.
4. Save a copy; then draw the gradient tool line vertically also, for a banded striping or smooth gradient on your finished tile page.

 (See Figures 6–22, 6–23, 6–24, 6–25, 6–26.)

CREATING SEAMLESS TILES

1. Open the RGB 2 × 2 inch sand graphic for the first tiling exercise.
2. Save a copy for later touch-ups, if necessary. Set it aside for after the Offset Filter is applied.
3. Select the tile image and go to Filter, Other, Offset.
4. Choose Wrap around and enter half the horizontal and vertical values (72 × 72).

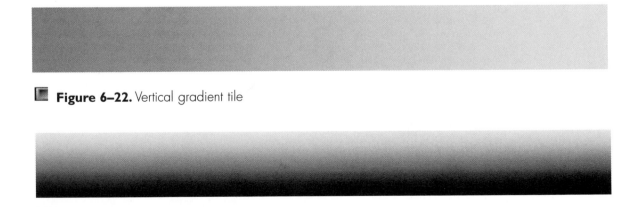

▪ **Figure 6–22.** Vertical gradient tile

▪ **Figure 6–23.** Horizontal gradient tile

Figure 6–24.

Figure 6–25. Vertical center band gradient tile

Figure 6–26. Finished vertical tile - center band on web page

This puts the exact middle section on the outside edges. Experiment with these numbers for some interesting effects. (See Figures 6–27, 6–28, 6–29.)

Try a Tile Composite Before Uploading

1. Open the horizontal gradient tile and Select all.
2. Go to Menu + Edit + Define Pattern.
3. Open a new document 640 × 480 pixels.
4. Select Fill from the Edit menu and choose the Pattern option, then click OK.

(See Figure 6–30.)

Figure 6–27. Seamless tiling without touchups

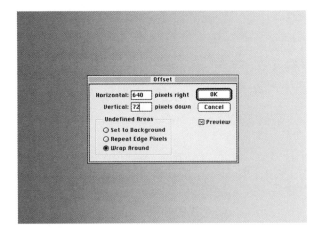

Figure 6–28.

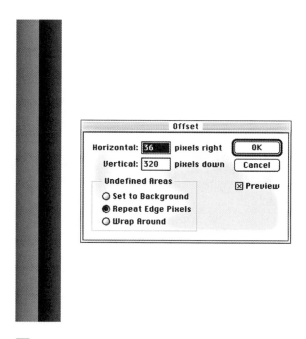

▇ **Figure 6–29.**

▇ **Figure 6–30.** Tiled horizontal gradient web page

Fixing Tile Seams

1. Try Cut or Copy + Paste + Feather. Use the copy you saved earlier of your tile. (Try getting into the habit of using the key commands Comm./Cont. + C for Copy and Comm./Cont. + V for Paste.) Click on the Move tool to position the pasted patch over the seam.
2. Use the clone tool. (Select the clone tool. Press the Option/Alt key + click on the area you want to clone.) Experiment with Brush size (open Brushes Palette from the Windows menu) for a good match.
3. Also, try these three tools: smudge / paint / airbrush. Experiment again with sizing brushes. Notice in the Blue Amoebae tile composite figure that this texture can be difficult and time consuming to make look seamless and the superimposed text is also hard to read (Figures 6–31, 6–32).

CLONING

Practice Using the Clone Tool

(From Adobe's On-line tutorial, Making Seamless Tiles)

1. Do this process before indexing.
2. Open a background. Select an area with the marquee tool to make a tile.
3. Hold down the Control key, press the mouse on the selected area, and choose Layer via Copy.
4. Create a duplicate of layer 1 via the pull-down menu to the right of the Layers Palette.

■ **Figure 6–31.** Heavily textured tile - Blue Amoeba

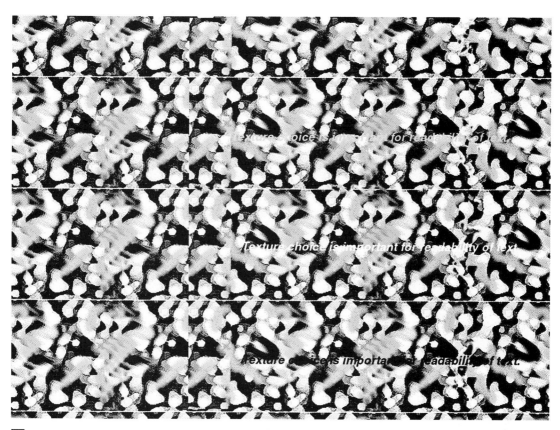

◼ **Figure 6–32.** Small text is difficult to read on this texture

5. Enlarge your window and turn off the background layer (eye icon) so you can see the two tiles.
6. Use move tool and place tiles side by side. Zoom in for better visibility of detail.
7. Click on Preserve Transparency if you do not want the cloning to go beyond the tile edges.
8. Select the layer that you want to clone. Select Layer 1 dup. Start to use the clone tool on Layer 1 to begin to blend its edge into the Layer 1 dup.
9. Throw away layer 1.
10. Retest your tile.

Make a Blue and Green Curtain Background with Tiling

1. Open a new 480 high × 72 wide pixel document (Figure 6–33).
2. Select a green (try R51 G153 B51) and blue (R51 G51 B255) from the web-safe palette.
3. Click on the gradient tool and draw a horizontal line across the tall, thin document.
4. Select the tile image and go to Filter, Other, Offset.
5. Experiment with Repeat Edge Pixels on subsequent tries to see if you like it better than a repeat of Wrap Around. Enter half the horizontal and vertical values (480/240 × 72/36).
6. Follow the Testing Your Tile instructions tile to make the composite background curtains.

(See Figure 6–34.)

Make a Two-Panel Background

1. Create an RGB document in Photoshop 200 pixels wide by 480 pixels high.
2. Make a new layer and fill it with black.
3. Add a drop shadow to the right side of the shadow layer by using menu + Filters + Blur + Gaussian (try 9.6).

▦ **Figure 6–33.**　　　▦ **Figure 6–34.**

4. With the shadow layer selected, click on the move tool (hold down Comm/Contr.) and shift to the right. Merge the layers.
5. Index to reduce unnecessary grays in the shadow blend. Use just enough values to make it look good.
6. Export the black panel as a GIF89a.
7. Place the GIF onto a white background created in your web site authoring software. You may remember that the hexadecimal code for white is #FFFFFF.

(See Figure 6–35.)

Combine the Black and White Two-Panel with Textured Clouds

(See Figures 6–36, 6–37, and 6–38.)

1. Open a new RGB document, 72 ppi, 128 pixels × 128 pixels. Select a color or colors from the toolbox swatches, or remember to choose from the web-safe swatches. Try a medium to light blue and a yellow green. Go to Menu + Filter + Render + Clouds. Try choosing Clouds a few times to see the changes. If you think you went too far, use either Fade Clouds in the Filter menu or delete unwanted repeats in the History Palette. Experiment with different fill colors until you have the right look for your project.

■ **Figure 6–35.**

■ **Figure 6–36.**

▣ **Figure 6–37.** ▣ **Figure 6–38.**

2. Adjust Brightness/Contrast in the Image menu, as needed.
3. Save a copy from the File menu if you are happy with the results and want to keep this original.
4. Go to the Texturizer filter from the Texture menu and try the various settings, including the several choices offered for lighting. You can also load other textures you may have created before from this pull-down menu (Figure 6–39).
5. Test your tile and use the seamless tile techniques if necessary, as explained earlier (See Figure 6–40).
6. Reduce the colors (try 10) during Indexing.
7. Export it to GIF89a.
8. Open the black panel with the drop shadow as a graphic image, flush left, and the Cloud Texture as the background in your authoring software, such as Adobe's Pagemill or Macromedia's Dreamweaver. (See Figure 6–41.)

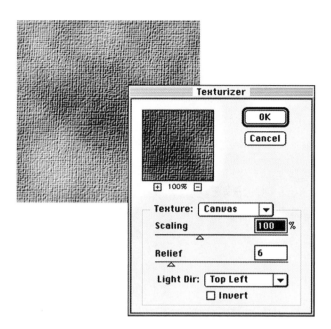

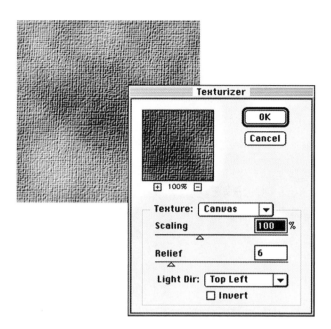

Figure 6–39.

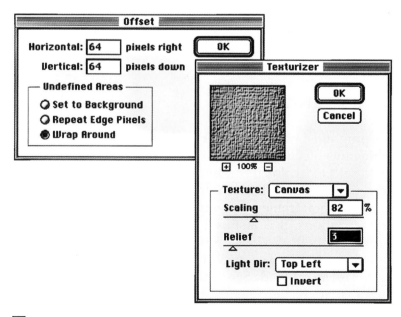

Figure 6–40.

■ **Figure 6–41.**

TRANSPARENCY

You might wonder why you would want to make part of a graphic invisible. Browsers supporting GIF89a will show all pixels of a selected color in an image as transparent, allowing the background to show through. Imagine that you have an animation with several frames showing the same image on them, just in various positions. It is a substantial saving of memory for only one frame to hold the background color or texture, because the field never changes. This way the rest of the frame backgrounds carry no memory load. See Chapter 7, under Photobuttons for more transparency techniques.

Using the White to Transparent Plug-in for Photoshop

First, download this free plug-in. Instructions on how to install and use the plug-in are under the Eliminate White Read Me icon. Steps 1 through 3 are simple and straightforward. I mention step 3 here due to an upgrade or software error. To find Remove White Matte, go to Menu + Image + Matte + Remove White Matte.

To utilize Transparency directly in Photoshop via the GIF89a Export, the first step is to decide which color(s) will be transparent, and that color will be replaced everywhere else it appears within your image.

Note: This does not work through the SAVE AS + GIF option.

1. Locate and open an Indexed image, as the graphic must be Indexed for transparency to work.
2. Choose GIF89a Export from File + Export menu.
3. In the Options box choose the color that will be transparent.
4. Select colors directly from the image or the swatches below for transparency using the eyedropper. The space bar can be used to pan, or double space on the hand tool to see the entire image.
5. To deselect colors hold down the Comm/Contr. key. You may also choose the background color of your web page.
6. To change the transparent color, click on the large color swatch labeled transparency Index Color (default gray). Select a hue that is more obvious or contrasty, because it will be easier to see. Be sure to choose a color that is not already in the graphic. Keep in mind that if you choose one color for transparent, everything in that color will be transparent.

(See Figures 6–42 and 6–43.)

Tips to Remember

1. A 128 pixel image will tile seamlessly using Clouds filters, and using less contrast eliminates problems.
2. Do not use transparency and interlacing together as problems may ensue with some browsers.
3. Use interlacing for images 200 × 200 or larger.
4. Use Transparent GIF for a web page background with an irregular pattern.

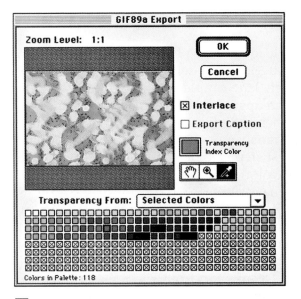

▣ **Figure 6–42.**

▣ **Figure 6–43.** GIF tile, transparency applied.

5. Do not be tempted to use a large background (even if the k is small) instead of tiling due to image inflation problems on some browsers. Other browsers may load it fine, but there will be those that freeze, load slow, or crash due to the memory load added. This inflation can happen in the decoding process, giving the height and width of the image times 8 with a GIF. JPEGs would multiply by 24. For example: 100 wide × 100 high × 24 (bits).

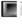

PROJECT
PREPARE A BACKGROUND FOR BUTTON COMPOSITING

1. Create five backgrounds. Try textures and photographs. Prep for compositing.
2. Do Adobe's Seamless Tiling tutorial, Creating Seamless Background Tiles.
 Check it out at http://www.adobe.com/studio/tipstechniques/wpdphsd5/main.html.
3. Do Eyewire's Background Tiling tutorial located at http://www.eyewire.com/.
4. Experiment with transparency techniques.

OPTIONS

1. Take a look at Netscape's Background Sampler of over sixty samples for ideas at http://www.netscape.com/assist/net_sites/bg/backgrounds.html.
2. Check out Killer Web Sites Transparent pixel and table techniques in preparation for Chapter 7 at http://www.killersites.com/1-design/index.html.
3. Prepare your five backgrounds with animation in mind. Animate the backgrounds to change with different subjects. The main navigation/wayfinding objects should stay the same.

CHAPTER 7

BUTTONS AND OTHER NAVIGATIONAL GRAPHICS

THIS CHAPTER WILL DISCUSS:

➤ Overview of Navigation
➤ Buttons, Bullets, Bars
➤ Using Photographs
➤ Haloing
➤ Project: Create One Button, Bullet, or Bar in Each Category

OVERVIEW OF NAVIGATION

In this age, people buy ideas, not just basic needs. It has been recognized by the global community that good design communication is good for relations. Navigation or wayfinding graphics are very important parts of the design considerations when planning a web site. This visual experience of navigation is often created with the aid of buttons and similar graphic objects. With these small graphics, we are also dealing with good composition for an overall pleasing look, and a visual navigation plan that is seamless, or almost unnoticeable by your site visitor. The experience of visiting your web site should be a pleasurable one, not fraught with a lot of graphics that don't go together, have no main idea to grasp, and fill the viewer with frustration. Bill Grant, president of i.e., design wrote, "What is required for the dawn of a new age that is already over-exposed and under-appreciated is clarity." He goes on to say that "design is a strategic weapon in the war on clutter . . ." These are initial items to think about as you begin to create your buttons, but please refer to Chapter 10 for more in-depth information on navigation, wayfinding, and metaphors.

Quick Review

Navigation has been part of art and design for centuries, just more subtly, and often not apparent to the untrained eye. Usually, a focal point was created as a starting place, supported by other principles such as gradients, line, texture, balance, and color to assist the viewer in movement toward a certain direction or along a point–by–point path. Often circular in motion, these directional techniques made sure that nothing would be missed within the composition, that the complete message of the artist/designer would be successfully communicated. For example, think of a simple gradient, moving from dark (left side) to light (right side) horizontally. The eye of the viewer would move easily from point A to point B.

The crystallographic or overall pattern compositional format has risen to new popularity more recently, and we can observe a variety of backgrounds on web sites made up of textures and objects of this type on which to navigate. The regular pattern without a strong focal point can produce a visual equality, a non-linear experience, and invite seemingly random interactivity.

What is important within the design experience is to engage the viewer to active participation; make direct connection. The design challenge is to create imagery that is so interesting and attractive that visitors will take a chance and click on the graphic image, in this case buttons, to proceed to a deeper level within the site.

BUTTONS, BULLETS, BARS

These graphic objects are created for the purpose of hyperlinking, and navigation occurs through these hyperlinks. Often, hyperlinks are words in blue that are underlined. Buttons and bullets offer a refreshing, more interesting alternative, and people are familiar with the use of button icons such as Play >, Reverse <, Stop ■ , and Record ●. Again, as with all web graphics, it is essential to create interesting visuals without making people wait for them to download.

As with other graphics discussed in previous chapters, if the button is small, it takes less memory and time to load, but if it is

too small, it may not be noticed or considered important. Some people like bullets, especially with text as it might appear on a typed paper document. Others dislike them because they are overused, serve no real purpose and look ugly. Evaluate these positions, make some innovative bullets yourself, then decide whether or not they add to the composition and are effective for your navigation and compositional scheme.

PROJECT 1
QUICK BUTTONS WITH THE ACTIONS PALETTE

1. Open Actions from the Window menu. Open a new document in Photoshop that is 2 × 3 inches (Figure 7–1).

■ **Figure 7–1.**

2. Click on Large Rectangular Button, then click on the Play icon (> triangle pointing to the right at the bottom of the window).

3. Go through the same steps for Large Square Button and Large Round Button (Figure 7–2).

4. For a quick button drop shadow, click on Cast Shadow in the Actions Palette. Locate the layer with the shadow, use the move tool to position, then drag the layer below the button layer.

5. Color can be added by first having it selected in the Tool Box Palette.

6. Choose another color for the background swatch, select the gradient tool and drag across the icon for a two-tone gradient. Try different gradients in the toolbox. Be sure and click on the Preserve Transparency box in the Layers Palette to apply the gradient fill to the button only and not the background. Figure 7–3 shows a more complex example of an Actions Palette button with a background using filters.

Figure 7–2. **Figure 7–3.**

PROJECT 2
SMALL GEL BUTTON USING ACTIONS

1. Make a small gel bullet by first opening a new document. (See Figure 7–4.)

2. Click on the Round Button in the Actions Palette and then click on Play >.

■ **Figure 7–4.**

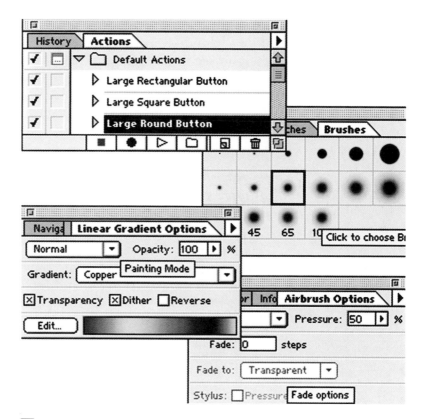

■ **Figure 7–5.**

3. Go to the Layers Palette and click on the Preserve Transparency box.
4. Double click on the gradient tool, click and drag the pull-down menu and choose Copper (Figure 7–5).
5. Drag the gradient tool across the Round Button. Try different directions and lengths until you are satisfied, but emulate the gel button illustration as closely as possible for your first attempt.
6. Click on the airbrush tool. Select white. Double click to adjust the pressure to 50%. Make sure the white swatch is on the foreground of the toolbox.
7. Open the Brushes Palette from the Window menu and click on a medium-sized brush.
8. As shown on the gel button, position the airbrush tool near the whiter edge and apply momentary pressure. Undo from

the Edit menu if it doesn't look right and try again until it looks rounded and slightly translucent. Squinting at it can help to see if the highlights and shadows work well.

PROJECT 3
USING THE SUCKING FISH SERIES FILTER TO MAKE BUTTONS

This Photoshop plug-in, created by Naoto Arakawa, is great for making quick 3-D rectangular convex/concave buttons and bars. It features Deko (convex) and Boko (concave) states. Deko and Boko mean convex and concave in Japanese. When these two buttons are superimposed, they can show different actions, seemingly on the same button for what is known as "active/inactive" states. Active on a web site is when a button is clicked on; inactive is its rest or unvisited position. Deko and Boko work very well to create these animated buttons. Another method is to open an image, make a duplicate, leave one the same (the positive) and invert the other, making it negative. A third option is to make the activated button state lighter in value, so it looks like it lights up when the mouse makes contact.

1. Draw a rectangle with the square marquee tool. Either draw and copy from a background texture, photograph, or another graphic, or start from scratch by filling the marquee square with a color and/or texture. Gradient blends also work well. (See Figures 7–6 and 7–7.)
2. Go to Filters in the menu, pull down to Sucking Fish Series, which you must pre-install by dragging the plug-in filter into

▇ **Figure 7–6.**

▇ **Figure 7–7.**

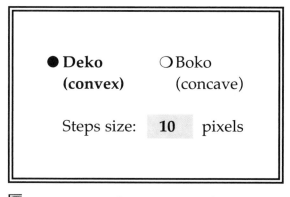

Photoshop's Plug-ins folder. (Quit Photoshop and then reopen to activate.)

3. First, try Deko, using the default settings and a level of 10. Click on OK and it is as simple as that. Experiment with the different lightings and gradients. Try Noise or Pinch filters (Figures 7–8 and 7–9).

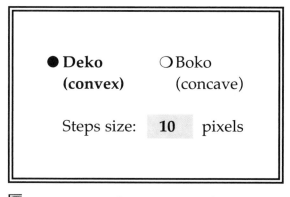

Figure 7–8. Default Deko Boko filter settings.

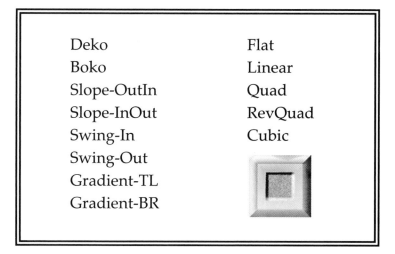

Figure 7–9. Deko Boko's Outside Patterns (left column) and Inside Patterns (right column, available at the Sucking Fish URL provided in the Download Appendix.

■ **Figure 7–10.**

There are also other filters such as Magic Curtain and non-rectangular Deko/Boko plug-ins from the same company, which can be reached at http://www.ruku.com/dekoboko.html. (See Figure 7–10.)

PROJECT 4
BEVELED BUTTONS AND BUMP MAPS FROM SCRATCH

Beveling can have a rounding effect on natural and mechanical objects. This not only enhances, but suggests a three-dimensional appearance, and has strong visual appeal. Instead of looking strictly mechanical and flat, objects look tactile, more real and inviting to the touch. Beveling enables viewers to quickly see and read objects due to highlights, shading, and linear enhancements. This is especially helpful for higher speed animation. (See Figures 7–11, 7–12 and 7–13.)

With button and other navigational graphics, you may create them as 2-D, 2 1/2-D or 3-D. It is important to be consistent with usage throughout your site. Two-dimensional looks relatively flat and relies on labeling for clarity; 3-D represents graphics that have hotspots and look highly realistic or modeled; and 2 1/2-D involves the beveled look and is effective, attractive, and relatively easy to make in Photoshop. Here we will create a simple bump map that shows values of gray to create a 2 1/2-D beveled look. Dark values usually indicate low areas and light values the opposite, and these are enhanced by applying the Lighting Effects Filter. (See Figures 7–14 and 7–15.)

■ **Figure 7–11.**

■ **Figure 7–12.**

■ **Figure 7–13.**

1. Create a new document 72 ppi, squared, 1 inch × 1 inch.
2. Make sure the swatches in the toolbox are black and white.
3. Click on Channels in the Layers Palette.
4. Select the Create New Channel icon (it looks like a small page, left of trash icon) or use the pull-down menu on the upper right of the palette. Name it Bump Map.
5. Select all.
6. Go to menu + Select + Modify + Border. Try a value of 20, click OK.
7. Invert the selection (Comm/Contr + I), and key in delete. Here is your Bump Map.
8. Click on the RGB channel in the Channels Palette, then go back to Layers.
9. Color choice should be carefully considered, and should have the capability of showing dimensional features. Select your color in the toolbox swatch and fill the background layer.
10. Go to menu + Filter + Render + Lighting Effects.
11. Try different choices for the Light type; the default is Spotlight. Then, choose Bump Map from the Texture Channel pull–down menu.
12. Try some gradient blends. Add textures by creating a new layer for a particular button. Fill the layer with a color and apply some different filters and modes from the Layers Palette. For a marbled effect, try Clouds from the Render option.

■ **Figure 7–14.**

■ **Figure 7–15.**

For fast beveling on a variety of button/bar shapes including square, round, and freeforms, download the freeware, Photo-Bevel®, listed at the end of the chapter. Figures 7–16, 7–17, and 7–18 are some samples. Note on the square button the texture inside, which is made with Midnight TV, from the Sucking Fish Series. The round button was begun by drawing a circle using the toolbox in Photoshop. The freeform button was started by draw-

■ **Figure 7–16.**

■ **Figure 7–17.**

■ **Figure 7–18.**

ing with the pencil tool in Photoshop, then going to Menu + Filters + Extensis + PhotoBevel.

Note: These plug-in filters must be installed into the plug-ins folder within the Adobe Photoshop software, found on your hard drive. Some have installer icons, which will place the filters for you. Others you will have to drag into the plug-ins folder yourself. After this is done, quit Photoshop and then reopen. Go to Filters from the menu, and your new plug-in filters should be accessible and ready to use.

PROJECT 5
GEL IN A FRAME

1. Open a new document, about 2 square inches for good visibility. Show Grid as before and draw a circle on the Background Layer to create a ball.
2. Double click on the gradient tool and either make your own gradient or choose one of the ready-made gradients in Photoshop. For this exercise, choose the red and green and apply it by dragging inside and across the selected circle. Choose Linear for the blend.
3. Use the airbrush tool (50% opacity) to drop in a white highlight (try Brush 35). Put the highlight on the dark portion for a slightly translucent look. You may have to experiment a bit to get a rounded, 3-D look. (See Figure 7–19.)
4. Open the sand texture tile you made in Chapter 6. Select it and go to Menu + Edit + Define pattern. With the circle or ball still selected, go to Menu + Select + Inverse. With the area outside the ball now selected, go to Menu + Edit + Fill, and fill with the sand pattern (See Figure 7–20).

 Figure 7–19. **Figure 7–20.**

5. Make a frame around your button by applying Stroke (try 8) from the Edit menu. Experiment with the Emboss filter, Hue/Saturation, and, if needed, Sharpen.
6. Select Hue/Saturation from Menu + Image + Adjust. Manipulate these features for the look you want to achieve.
7. Next, go to Menu + Filters + Render + Lighting Effects. Choose 2 o'clock Spotlight, adjust your button according to the illustration. Make sure it works with the darks and lights you have already applied so they are consistent. Click on OK. (See Figures 7–21, 7–22, 7–23.)
8. An optional touch would be to apply Fish Sucking Series Filters to the outside edge of the button background. When in the Deko/Boko dialog box, adjust the bevel width and lighting again to work with the other highlights and shadows. (See Figures 7–24, 7–25, 7–26.)

■ **Figure 7–21.**

■ **Figure 7–22.**

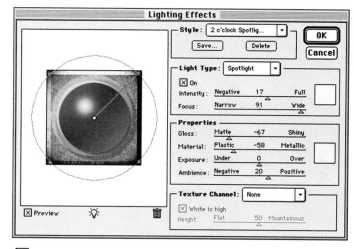

■ **Figure 7–23.**

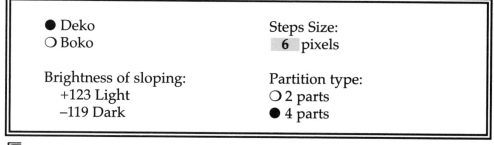

■ **Figure 7–24.** Some settings you may want to use when starting to experiment with highlight and shadows.

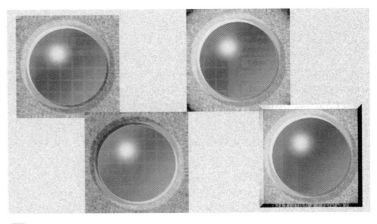

 Figure 7–25.

 Figure 7–26.

USING PHOTOGRAPHS

Photographs can be used for buttons in a variety of interesting ways. One of the more common uses is for an art gallery web site, or any site that wants to show larger photos or images, but needs to have a navigational page of smaller versions, such as GIF photobuttons. By setting up your site this way, visitors can look at the opening page with the small button versions of the larger images, then choose to view the larger version by clicking on the corresponding button. This is a courtesy to your viewers that they will appreciate, and will encourage repeat visits (Figure 7–27). This web site can be viewed at http://www.desktopcafe.com/art-gallery/gberryhill.

Assemble your images and open them in Photoshop. It is a good idea to save copies of each image at this point. The original image of Chicago (upper left photo in Figure 7–27) is 420 pixels wide by 320 pixels high. It was saved as a JPEG. But before, a button was made of the Chicago image 100 pixels wide by 71 pixels in height. Both resolutions were set to 72 ppi in the Image Size dialog box. To make the small button from the large image, it needed to be resampled. To do this, open your copy and alter the image dimensions to the new width and height dimensions in the Image Size dialog box (100 wide × 71 high). Change the resolution to 72 ppi by setting the width and height to something besides pixels, then enter 72 in the resolution box. Select Resample Image (bicubic) to keep proportions. Also select

Figure 7–27. http://www.desktopcafe.com/artgallery/gberryhill

Constrain Proportions. Resizing can also be done by going to Menu + Layer + Free Transform. Click and drag to the new size, then press Return. It may help to initially work on the button twice as large if you need to see detailing.

It may be necessary for an image background layer (image and background are on the same layer) to be transparent. If so, open the layer dialog box by double clicking on the background in the Layers Palette. Rename the background layer, then select areas of the background you want to be transparent. Key in Delete or go to Menu + Edit + Clear (Figure 7–28).

Tips for Unifying Your Buttons

1. Crop them to the same size.
2. Replace differing backgrounds with the same background by selecting the object, go to Menu + Select + Inverse. Import or paste in a new background, such as a texture you created earlier. (Open the texture document; click and drag it from the Layers Palette onto your photobutton.) Another method is to

■ **Figure 7–28.**

select the gradient tool and click/drag over your button images. Double click on the gradient tool to select a ready-made gradient, or create a new one (Figure 7–29).

3. Change them all from color to gray scale.
4. Create similar coloring using Colorize or adjust the button hues in Hue/Saturation (menu + Image + Adjust + Hue/Saturation). This manipulation will also help with your color palette, because there will be fewer colors to manage and less memory overall for the web site.

After the major work is done, you may need to sharpen the image buttons by going to Menu + Filters + Sharpen + Unsharp Mask. Go for an overall even look for all the buttons. Merge, Index, Save as GIFs.

Bubble Buttons

1. Open an RGB image. Use the Stylize Filter and try Emboss + Lighting Effects.
2. Open an RGB photograph. Go to the Distortion Filter and apply Spherize (12). Adjust to your liking. Select Pinch (10) from the Distortion Filter and apply your settings. You may need to sharpen, so go to Filters + Unsharp Mask.
3. Try the settings shown in the dialog boxes in Figure 7–30.

Figure 7–29.

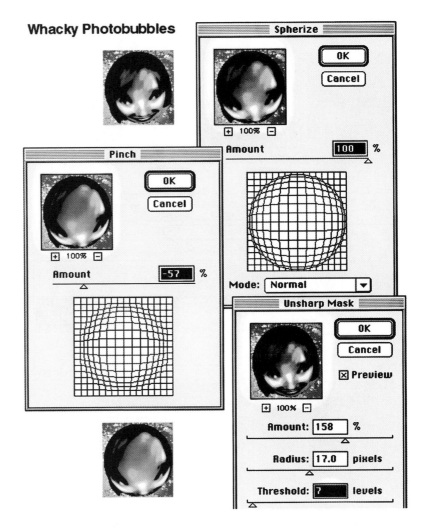

▨ **Figure 7–30.**

4. Touch up the final buttons with airbrushing highlights (white) on a new layer. (See Figure 7–31.)

HALOING

Anti-aliasing creates a whitish glow around objects due to the dithering of coloration. A dithered object on a fairly plain background can result in a new problem known as haloing (Figure 7–32).

Figure 7–31. **Figure 7–32.**

Quick Review

Dithering refers to a number of colors blended together that are not included within the indexed palette. It mixes some of the colors on the palette in an attempt to emulate actual colors. Large sections blended due to dithering can look unattractive and add more memory. Less colors in small graphics will not require as much dithering and will not be significant, but a larger image with reduced or palletized colors can have unsightly pale areas between significant colors created by excessive dithering or can show a spotty or flecked-looking surface. Too little dithering or diffusion can cause posterization, but with complex textures, haloing is not as much of a problem visually.

Prevention

1. Use alias only. Plan your images and colors so that jaggies are not noticeable.
2. Make the background layer of the image similar to the web page background, or select a solid color that blends well (Figure 7–33). When the layers are flattened, they will visually merge together.

Tips to Remember

1. Try to keep colors on buttons to a minimum because they are more difficult to compress. Decide how noticeable these graphics should be. Less color will often be more subtle.
2. When there is a lot of text, consider using small bullets, which can work as Fragments or anchor hotspots, placed through-

■ **Figure 7–33.**

out the text for the reader's navigational convenience. Think about what would look and work better, a small bullet or a colored hypertext link.

3. When a bullet or button is quite small, consider including it as part of the hyperlink, so it is easy to click and open.

Student Question
How many different types of button graphics should be used on one web site?

You want to have enough enticing, wayfinding visuals to make the journey interesting for your viewers. These graphics should grab enough attention to draw someone to want to click and go to the next tier, but not overwhelm the main features and most vital parts of the web site. Keep in mind that too many different types of graphics can be confusing to people. Plan on making your set of buttons, bars, and bullets reusable, remembering also that previously loaded graphics save time. The buttons then only load once on the homepage and are already in place on the subsequent pages. So, give careful thought to the navigational benefits of reusing the same button graphics.

Quick Review

PLACEMENT TRICKS

1. Using a transparent pixel:

 Create a 1 pixel transparent GIF document to use for placement/alignment of other images on your page. Alter the size of the pixel by changing the height and width measurements within the HTML tag. Then place it appropriately according to where you want your actual image to be positioned. For instance, if you want the image 1 inch from the left edge and 1 inch down from the top edge, you would type in into the transparent pixel tag.

2. Using a transparent table:

 Create the table cells according to the authoring software's instructions. This usually involves clicking and dragging on the Tables icon in the toolbar, then selecting how many cells and rows you wish to make. Turn table borders off, so they will not show. The HTML is BORDER=0. Place your images or text in the table cells where you want them to be located on your page layout. Since these cells can change in size from browser to browser, you may want to set the width of each cell. If you want relative size (changes according to the window size), use percentage. For absolute size, specify pixel width.

 Relative: <TD WIDTH="20%">
 Absolute: <TD WIDTH="72">

 More space may be added by using cellpadding or cellspacing. Padding has to do with the space inside the cell, and spacing deals with the area outside the cell. You may enter numbers after the names accordingly:

 CELLPADDING="5"
 CELLSPACING="5"

 To make color solids next to each other look seamless, place each section of color or image in one table cell, then place the second object in a cell next to the first. Turn the table borders off. It is important to be sure that the table tag is

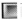

ended correctly for a seamless or invisible appearance. Do not press return and place the ending tag </td> on a separate line, or the gaps within the table will show.

PROJECT 6
CREATE ONE BUTTON, BULLET, OR BAR IN EACH CATEGORY

Create at least one type of button, bullet, or bar in each category. Experiment though and try to make several so you will have a good selection to choose from when putting your web site together. Be selective and then composite your best on a variety of backgrounds to see what works well. (See Figures 7–34 and 7–35.) Other ideas using PhotoBevel, bump maps, and Actions in combination are shown in Figures 7–36, 7–37, 7-38, 7–39, 7–40, 7–41, and 7–42.

Figure 7–34.

Figure 7–35.

 Figure 7–36.

 Figure 7–37.

 Figure 7–38.

 Figure 7–39.

 Figure 7–40.

 Figure 7–41.

 Figure 7–42.

➤ ON–LINE TUTORIALS

Compositing Graphics to a Background Tile
http://www.adobe.com/studio/tipstechniques/wpdphsd7/main.html

Creating Bevel Effects with Photoshop and Extensis PhotoBevel
http://www.adobe.com/studio/tipstechniques/phsphoto bevel/main.html

Creating Cross–Navigation Icons
http://www.adobe.com/studio/tipstechniques/wpdphse2/main.html

➤ ON–LINE REFERENCES

Free Plug-ins for Button Creation
AFH Systems Group-Windows
http://www.afh.com/web/pshop/free.html

Plug-in COM HQ–Mac and Windows
http://pico.i-us.com/

Free Photoshop Filters–NVR (New Virtual Research) BorderMania
http://www.mediaco.com/nvr/filters.html

Pure Mac Photoshop Plug–Ins
Freeware: Sucking Fish, PhotoText Solo, PhotoBevel Solo, plus several inexpensive shareware downloads such as PhotoGIF and ProJPEG.
http://www.eskimo.com/~pristine/photoplug.html

Chapter 8

TYPOGRAPHY AND TEXT

THIS CHAPTER WILL DISCUSS:

➤ Typography for Web sites
➤ Kerning/Tracking
➤ Illustrator to Photoshop – Photoshop to Illustrator
➤ Cascading Style Sheets (CSS): An Introduction
➤ Effects for Creating Logotypes
➤ Anti–Aliasing vs. Aliasing
➤ Project: Create One Logotype

TYPOGRAPHY FOR WEB SITES

One of the frustrations of early web site typography was the limits set on HTML size and style. Choice and variety have improved significantly with products like Extensis PhotoText Solo filter, which is a freeware plug-in for Photoshop (available for download at http://www.eskimo.com/~pristine/photo-plug.html). Here, we will discuss other techniques and considerations, but first a bit of type talk.

Type has physical attributes, such as stems, counters, bowls, swashes, crossbars, and serifs that are standard to all typographic uses (Figure 8–1). We can apply features like bold, extra bold, light, extra light, condensed, expanded, italics, and caps to the type (Figure 8–2). There are reasons for selecting serif or sans serif fonts, as well as certain size selections. Serif fonts are generally used for body text of 12 points or less because they are easier to read but sans serif fonts are better for smaller groups of type, like display type of 14 points or more. ALL CAPS (uppercase) applied to more than a few words is inadvisable, because the overall shape of the type is rectangular in form and not as easy to decipher quickly, whereas upper- and lower-case show a unique form characteristic to a particular word (Figures 8–3 and 8–4). Some serif fonts, unless you use slabs, are difficult to see on a web page,

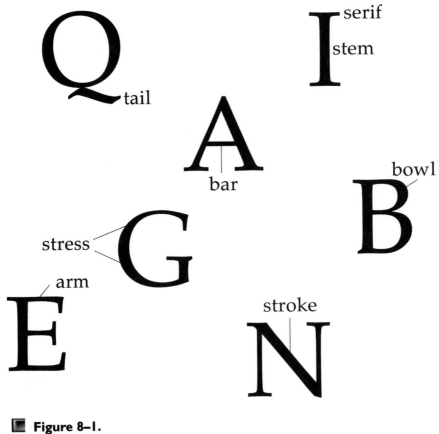

■ **Figure 8–1.**

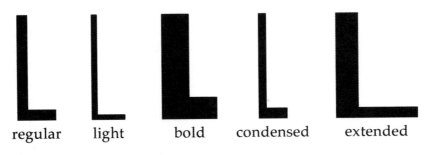

regular light bold condensed extended

■ **Figure 8–2.**

Figure 8–3.

ZED

Figure 8–4.

Zed

due to hairline thin areas on stems and serifs.

Italics on small text with thicks and thins is the best example of the most difficult type to read on a web site. The "jaggies" on diagonal 72 ppi letter stems make readability almost impossible on screen. Use of bolder weight and higher contrast between background and type can help, and careful consideration of font style and size is necessary when white or light-colored type is placed on a black or textured background. These can be extremely effective or become completely lost. Keep in mind that small white type on a black background can have a glittering almost kinetic effect, which may look highly attractive or very annoying, depending on how small and which font you choose. Some web designers utilize bump map techniques for white type on a dark background. The safest bet for large amounts of text is black on a light background with hypertext links or fragments (anchors) interspersed. As always, these are not strict rules to adhere to but guidelines to start from, with readability in mind.

Small amounts of larger text reversed out, sans serif may work better with extra leading (vertical spacing between lines of type). Some tips to apply extra leading are: use the transparent pixel trick from Chapter 5 to add extra space between lines, or within each line of type to be leaded, choose a larger font size and apply it to a number of empty spaces. Click and drag over the empty space, then select the bigger size.

Quick Review—Using a Transparent Pixel

Create a 1 pixel transparent GIF document to use for placement/alignment of other images (or in this case, lines of text) on your page. Alter the size of the pixel by changing the height and width measurements within the HTML tag. Then place it

appropriately according to where you want your actual image to be positioned. For instance, if you want the image 1 inch from the left edge and 1 inch down from the top edge, you would type the following into the transparent pixel tag:

Within the HTML, to remove excess leading after a title, eliminate the use of the paragraph tag <P>, or Return/Enter keys. Instead try the Break tag
 or key in Shift + Return. Yet another way to space out text and images is to type in characters that are the same color as your background on the edit page of your authoring software. Black, as shown in the example, is quick and easy to match (Figures 8–5 and 8–6).

KERNING AND TRACKING

Kerning is the space adjustment between two letters. Tracking adjusts the spacing between letters and words in a line or body of several lines of text. A general rule is to kern display type (14 point or larger) and track type that is 12 point or smaller. Kerning is necessary to give a balanced, pleasing professional look to your typography. To begin, look at a word and notice the negative spaces between each letter. Theoretically, each negative space should be equal with the other spaces. Include the space within

▪ **Figure 8–5.**

▪ **Figure 8–6.**

an open letter, such as the G. One approach is to imagine that you are pouring a liquid of equal amounts between each letter. So, if I poured 1 ounce between each letter of the word "kern," it would look like the example in Figure 8–7.

Kerning Type in Photoshop

Briefly, open the Text dialog box by clicking on the "T" in the toolbox. Type in a word at 60 point Deselect Auto Kern. Click the mouse between two of the letters; to narrow the negative space, in the Kern box try –10 (minus or negative 10), or whatever is appropriate. To add space, don't use the minus character. Or, to move a piece of type manually, place each letter on a separate layer. Hold down Comm/Ctrl to activate the move tool. With the layer selected, use the move tool or the arrows to nudge. Each nudge = 1 pixel. Holding down the shift key = 10 pixels. (See Figure 8–8.)

FROM THE ADOBE® PHOTOSHOP® HELP GUIDE:

Positive kerning or tracking values move characters apart; negative values move characters closer together. Kerning

■ **Figure 8–7.**

■ **Figure 8–8.**

and tracking values are measured in units that are 1/1000 of an *em space*. The width of an em space is relative to the current type size. In a 1-point font, 1 em corresponds to 1 point; in a 10-point font, 1 em corresponds to 10 points. Because kerning and tracking units are 1/1000 em, 100 units in a 10-point font are equivalent to 1 point.

Kerning in Illustrator

Briefly, you can kern in Illustrator by holding down the command and shift keys, while pressing the bracket key.

FROM THE ADOBE® ILLUSTRATOR® HELP GUIDE:

Kerning (or tracking) from the Keyboard
1. Select any type container or type path using a selection tool, or set an insertion point or select a block of type using the type tools.
2. Do one of the following:
 ❏ Press Option + Left Arrow (Macintosh) or Alt+Left Arrow (Windows) to move characters closer together. Press Option + Right Arrow (Macintosh) or Alt + Right Arrow (Windows) to move characters farther apart. The distance moved is equal to the Tracking value set in the Preferences > Units & Undo dialog box (the default is 20/1000 of an em space).
 ❏ Press Command + Option + Left Arrow (Macintosh) or Ctrl + Alt + Left Arrow (Windows) to move characters closer together by five times the Tracking value set in the Preferences > Keyboard Increments dialog box. Press Command + Option + Right Arrow (Macintosh) or Ctrl + Alt + Right Arrow (Windows) to move characters farther apart by five times the Tracking value set in the File > Preferences > Keyboard Increments dialog box.

To view the kerning value between two characters:

1. Set an insertion point between two characters whose kerning value you want to view, using the type tools.
2. Choose Window > Show Info.

The Info palette displays the total spacing value for the two characters. For example, if the Info palette displays "109 = 100 + 9/1000 em," the characters have 9/1000 em kerning and the word has 100/1000 em tracking.

Kerning (or tracking) from the Character Palette:
1. Select any type container or type path by using a selection tool, or set an insertion point or select a block of type by using the type tools.
2. Choose Type > Character.
3. Click the Kerning icon and enter a value in the Kerning text box; or click the Tracking icon and enter a value in the Tracking text box.
4. Press Enter or Tab to enter the new tracking or kerning value.

ILLUSTRATOR TO PHOTOSHOP—PHOTOSHOP TO ILLUSTRATOR

Student Question
How do you bring type that you have created in Illustrator into Photoshop?

Here are some methods for opening Illustrator text in Photoshop, and vice versa:

1. Place Illustrator Type into a Photoshop Graphic.
 After opening the Photoshop Image, go to Menu + Place. After finding the Illustrator type, open and click on Place.
2. Open EPS Illustrator Text in Photoshop.
 To transfer type prepared in Illustrator, save as an EPS file. Go to Open within Photoshop's File menu. Select your EPS and double click. Enter your new resolution. Keep in mind that when an Illustrator file (vector) is opened in Photoshop, it is then bitmapped and becomes the resolution of the existing Photoshop image.
3. Drag/Drop Copy/Paste Illustrator Text into a Photoshop Window.

Simply drag your Illustrator path from the window into a Photoshop window (it will show up on a new layer). You may also use Copy and Paste.

4. Open Bitmapped Photoshop Text into Illustrator
 Save the Photoshop graphic as an EPS, go to Open or Place (Placed EPS) in Illustrator. A Photoshop path can be exported by using the Export + Path to Illustrator selection.
5. Use a Photoshop image as an Illustrator Template
 Save the Photoshop file as a PICT. Open it in Illustrator as a template.

Vector programs such as Adobe® Illustrator® are widely used for creating lettering styles and logotypes, which ensures that your lettering will remain stable and constant from one browser to the next. After making your type, convert to Outline. Image maps can be developed in similar ways. Refer to Chapter 10 for more information. Photoshop text can also be used effectively if prepared and handled like a web graphic. For text where few colors are necessary (try 6), save them as GIFs and place them within your HTML as tags like any other flat–color image.

TIPS:
1. Instead of typing in larger amounts of text in Photoshop, copy and paste from your word processing document directly into the Photoshop Text dialog box.
2. To get a less blurry image on smaller type, create the text at a significantly larger size (at least four times), then reduce it by scaling down in Photoshop.

Gradations or change of color on series of type can be useful navigational tools. They are also helpful for categorization and identification. As with print design, remember to use a small selection of typefaces, and be consistent in your type choices from page to page throughout the site. Sometimes a client's chosen font style that looks good in print does not look as well on screen. If the font is important to the client's image, some adaptation may have to be done, such as thickening up thin lines. If you wish to thicken the lines, here are some tricks to try in Photoshop:

1. Select object, choose blur from the Filters menu, then apply Brightness/Contrast from the Image menu.
2. Make another layer of the first layer of text, then nudge down on one of the layers by no more than 1 or 2 pixels.

3. Copy and paste the text on top of itself.
4. Use the Minimum setting found in the Menu + Filters + Other.
5. Darken the midtones on anti-aliased text in the Levels dialog box. (See Figure 8–9.)

Tips to Remember

1. Use larger type whenever possible. Below 10 point is difficult to read. If it must be small, use a blockier, even width, more vertical and horizontal style.
2. Sufficient leading is as important as it is with print. The standard 14.4 point for 12 point type may need to be expanded, especially if sans serif is used.
3. Often larger x–heights can help readability. Experiment with different fonts. Font manufacturers have come out with typography designed specifically for web imagery.
4. Look for fonts with a wide variety of widths and weights within the particular font family, such as Myriad (refer to eye-wire.com).

text

text

80 pt, anti–aliased and aliased

text

Double layer with 2 nudges.

text

Regular

■ **Figure 8–9.**

5. Watch out for awkward hyphenations at the ends of lines of type and strive to keep them to a minimum.
6. Never allow widows (a short, last line, especially one word) and orphans (one line at the top of a column left over from the previous column and paragraph).

(See Figures 8–10, 8–11.)

Traditional costumes have been abandoned to a large degree as everyday wear. MTV dictates what the youth are to buy and wear. Baseball caps, emblazoned with corporate identity logos are worn worldwide as are similarly marked t-shirts. Signage, ads, the web and television have made logos like Coca-Cola's known in over 185 countries. The United Nations has less members. When 169 teenagers in 12 countries on 5 continents were asked to identify the soft drink logo, only 6 could not. Countries have lost control over sovereign information as it exchanges freely across borders.

◼ **Figure 8–10.** Widow

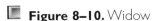

Since the 1950s, corporate identity has led the world visually into a unification of ideas and a commonalty that I believe has moved diverse cultures toward a unity never before possible. This visual culture via the world wide web has been a vehicle for transference of ideas without prejudice creating a cyberspace community which is potentially classless, ageless, genderless and raceless. The net has caused growth in some surprising and unexpected ways within graphic communications, and corporate design has played a socio-cultural role that has been progressive-

ly positive as a global networking tool.

Original creators of the logo based style manual may not have foreseen the entire impact of corporate identity on a global basis, but even before general Internet knowledge and use, the signs were there and continued to build. Significant portions of the world's population have responded to consumerism and media influence, especially the global teenager, who has been a strong factor in the cultural exchange.

◼ **Figure 8–11.** Orphan

CASCADING STYLE SHEETS (CSS): AN INTRODUCTION

CSS, or cascading style sheets, are similar to style sheets used in programs such as QuarkXPress or Pagemaker, and fortunately, the terminology is familiar if you have a desktop publishing background. CSS specifically applies to web site object and text–handling and it separates content from appearance. Use of style sheets in HTML is compatible with various browsers and works with Netscape Navigator and Microsoft Internet Explorer. Here is an introductory quote briefly explaining the features of CSS, written by Robert Walters in his article, "Putting Cascading Style Sheets to Work on Your Site" provided through WebPromote at http://www.webpromote.com/wpweekly/ nov98vol2/css.html. Or, check out Walters' direct site at BigCityDesign.com, http://www.bigcitydesign.com.

> In the past, Web designers were stuck to standard style HTML tags, such as bold face, and italics, <I>, to change the look of their document. These commands had to be entered for each block of text on a web page. The advent of Cascading Style Sheets (CSS) has made it possible to affect all the tags within a document in a certain way. Let's say you wanted all the paragraph text in your document to be in Arial and have a font size of 12. Or, let's say you want to fill your entire site with yellow background, blue text, maroon links and all <H2> headings assigned green. CSS can do all of this simply. As you become more familiar with CSS you will also be able to gain absolute positioning and spacing of your text, a technique familiar to desktop publishing.

Style sheets provide control over fonts, leading, margins, colors, borders, and padding and can work in conjunction with Javascript. Positioning of objects is also possible, and all of these elements go into one file, ready to work with your HTML. CSS also facilitates Dynamic HTML. A good book to refer to is *JavaScript for the World Wide Web: Visual QuickStart Guide,* by Tom Negrino and Dori Smith, published by Peachpit. Also, look at http://www.w3.org /Style/css/. There are several books, on–line resources, tutorials, updates, authoring tools, and hyperlinks, including links to the

HTML Writers' Guild and the Web Developer's Virtual Library (http://wdvl.internet.com).

CSS uses terms like rules (statements), selectors, declarations and properties. The rules are the determining factor of style application. All of the HTML elements are called selectors, any HTML tag can be a selector, and these can be type or attributes. The selector links the HTML to the style. Declarations have properties and values. These properties applied to the selectors can control a variety of attributes such as leading of type, spacing between words and letters, font sizes, font attributes, and background colors. There are thirty-five different properties you can apply with CSS. The property and value are known as the declaration. This means that the declaration comprises, for instance, the property of color and the color value which is the actual color name. The declaration and the selector make up each rule. To create styles, list your properties after an HTML tag and enclose within { } these braces. Colons are placed after the property name and before the value. If you have more than one property, use semicolons between them. Here is a sample designating type, color (white), and background (black).

(selector)	(property)	(value)
H1	**{font–family:**	**"helvetica";**
	color:	**"#FFFFFF";**
	background:	**"#000000";**
	}	
	(declaration=property + value)	

There are numerous ways to use style sheets within an HTML document, such as linking to an external style, or placing the style sheet within the <HEAD> tag sheet. Visit the following site for details at http://stars.com/Authoring/Style/Sheets/Linking.html.

EFFECTS FOR CREATING LOGOTYPES

Fill large text with an image

1. Open a new document in Photoshop. Select the type tool and key in a word or some letters for a logotype. Save a copy. We will be using this example for a number of projects, so keep it

handy on your desktop.

2. Select the areas with the Magic Wand (shift + click) you want filled with another image, such as a background. Feather it (Menu + Select) if you want a more rounded look.

3. Open the other image or background and select the area you want pasted into the logotype. Go to Menu + Edit + Copy from the layer of choice.

4. Use Copy Merged to copy from all of the visible layers, and make sure that layer is active. From the Edit menu, select Paste Into. Move to adjust position. (See Figure 8–12.)

5. Use Transform to rotate, resize, and the sharpen/blur tools for further enhancements.

Use the Maximum/Minimum Filter

1. These two effects are found within the Filters menu under Other. Maximum causes text to condense and Minimum expands.

2. On the example of the letter "a" one is superimposed over the other, the top layer having a transparent background. Use the Eliminate White filter plug-in (freeware download: http://www.edesign.com/filters) to make a quick transparency from the Filters menu. Do these procedures before Indexing. Experiment on separate Layers. (See Figures 8–13 and 8–14.)

Create a Drop Shadow

1. For basic shadow creation, as shown in the lower sample of Figure 8–14, open a new Photoshop document. Click on the text tool, click on the new window, and type in the text.

■ **Figure 8–12.**

■ **Figure 8–13.**

logotype
logotype

■ **Figure 8–14.**

2. Use the move tool to position. Be sure the text layer is active in the Layers Palette.

3. Go to Menu + Layer + Effects + Drop Shadow. Leave the settings if you are satisfied with the way the shadow appears, or make the changes you want. Click on OK. A soft shadow looks farther away and a hard shadow appears closer to the text.

Additional graphic ideas are shown in Figures 8–15, 8–16, 8–17, 8–18 and 8–19. Figure 8–17 also illustrates that soft shadows look farther away and hard shadows appear closer to the text.

■ **Figure 8–15.**

■ **Figure 8–16.**

■ **Figure 8–17.**

■ **Figure 8–18.**

■ **Figure 8–19.**

1. Make chrome using Eye Candy or try the Gaussian Blur filter in Photoshop by creating type and adding the Blur filter. "Merge Down" the Type layer to a copy of the Background layer.
2. Apply Curves until it resembles something like chrome (refer back to Figure 8–16 on page 175). Try three or four tall loops. Also try applying Gaussian Blur on a basic button shape, apply PhotoBevel, then go to Curves (refer back to Figure 8–17 on page 175). Gaussian Blur is handy for creating glows and again, drop shadows.

(See Figure 8–20.)

More manipulations

1. In the Levels dialog box, work with the histogram to remove midtones of gray on an anti-aliased image for a lesser bit depth. Text would need less varieties of gray than a gray scale photograph. (See Figure 8–21.)
2. Change the coloring with Hue/Saturation, under Menu + Image + Adjust. Try clicking on the Colorize box. Tip: If nothing changes, you may need to change from gray scale mode to RGB.
3. Further adjust your letterforms by adding and subtracting,

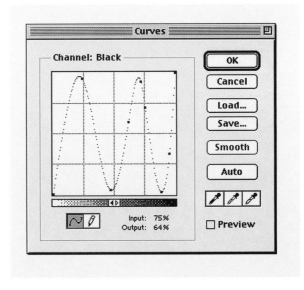

◼ **Figure 8–20.**

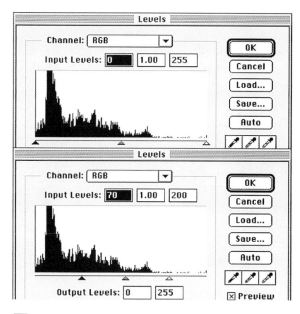

■ **Figure 8–21.**

merge different type styles, and try a variety of filters for distorted effects, like Pinch.

4. Go to Free Transform under Menu + Layer to manipulate the letter shapes by dragging on the handles.

5. Work with the Emboss filter on text for a modeled look on flat surfaces. Emboss appears convex (pushes out) and relief looks concave (recedes in, like a cave). For additional emphasis, keep in mind the color information from Chapter 4, that often warm colors advance, and cool colors recede. As we saw with button creation, it is a basic rule of thumb that highlights on the upper left and shadows on the lower right of an object look convex. Lighting from the bottom right gives a concave appearance.

6. **Tip:** Highlights and shadows need to be consistent throughout your imagery on the web page, and this includes drop shadows and airbrush hotspots added last on separate layers. Be creative and have fun, but remember to be selective and do not try to put every technique into play. It is the same principle as using too many fonts on a project. Also, keep in mind that additional filters add memory.

ANTI-ALIASING VS. ALIASING

To create text in Photoshop, it is a matter of opening a window and clicking on the Text icon in the toolbox. The dialog box comes up and you begin to type. Notice that the anti-alias box is already checked for you. This is a good thing if you want nice, smooth edges around the letters, with no jaggies. Problems can occur for web images, however. Again the haloing effect with the additional in-between shades of gray can make a whitish edge around the text or graphic unsightly on a contrasting background, and more values of gray add memory. As mentioned before, text does better compressed as a GIF than JPEG, and you can count your colors through Indexing. Six color values work pretty well for black type. And again, if you alias, choose a background that can blend well with the jaggies. (See Figures 8–22, 8–23, 8–24. Also refer back to Figure 8–9 on page 169.)

Look over final results without going on-line by using an application called Webwhacker, downloadable from the net at http://www.bluesquirrel.com. Sometimes type size changes, and so can color and font style from one browser to the next. Again, you may also want to try the freeware plug-in filter for Photoshop, Extensis® PhotoText Solo mentioned earlier. It offers several capabilities with text beyond HTML.

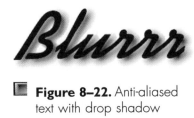

◼ **Figure 8–22.** Anti-aliased text with drop shadow

◼ **Figure 8–23.** Aliased text

COLORPLATE 1
Color Wheel

COLORPLATE 2
PC Palette

COLORPLATE 3
Macintosh
Palette

COLORPLATE 4
Web-safe
Color Cube

COLORPLATE 5
Browser Safe
Web Palette

COLORPLATE 6

COLORPLATE 7
CLUT

COLORPLATE 8
Tulips Custom
Palette

COLORPLATE 9
Photoshop Default
Swatch with loaded
palette

COLORPLATE 10
Tulips GIF89a Export
(menu + File + Export)

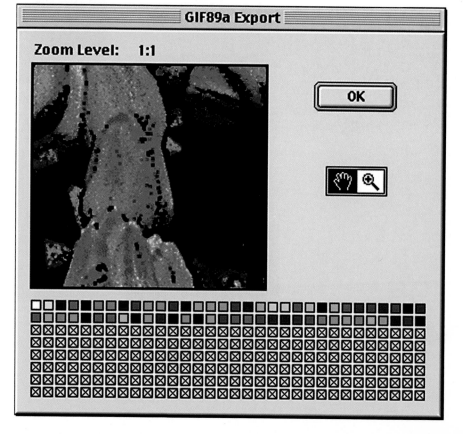

COLORPLATE 11
Multi-graphic palette,
Color

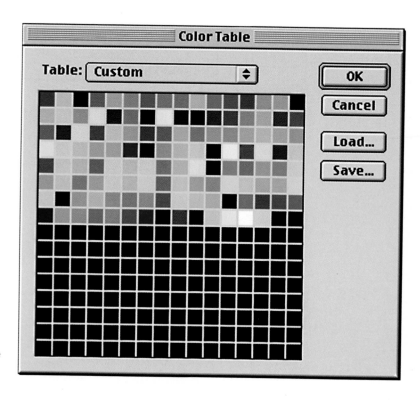

COLORPLATE 12
Custom Color Table

CUSTOM PALETTE-MULTIGRAPHIC

COLORPLATE 13
CLUT

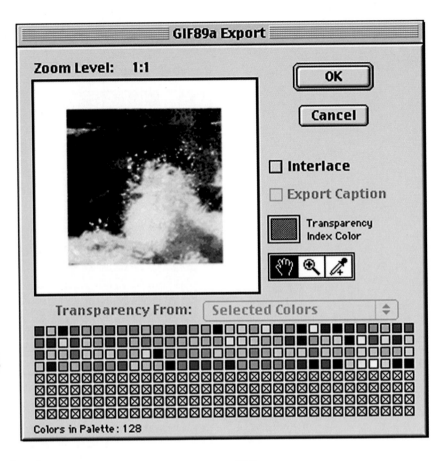

GIF89a Export

Zoom Level: 1:1

OK

Cancel

☐ Interlace

☐ Export Caption

Transparency Index Color

Transparency From: Selected Colors ⬍

Colors in Palette : 128

COLORPLATE 14
Multi–graphic
GIF89a Export
(menu + File +
Export)

Original
RGB

216 Colors
50k

256 Colors – 66k
Custom

8 Colors – 66k
Uniform/Dither

COLORPLATE 15
Color Compression
Samples

256 Colors – 99k
Adaptive

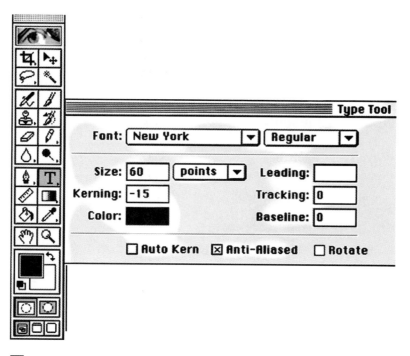

 Figure 8–24.

PROJECT
CREATE ONE LOGOTYPE

Create one logotype for a web site banner.

➤ ON-LINE TUTORIALS

1. Anti–aliased to Aliased.
 Adobe.com/studio/tipstechniques
2. Light and Shadows.
 Adobe.com/studio/tipstechniques

Optional: www.eyewire.com/tips
1. Chrome type

2. Spiral type.
3. Wrapping Text to an Image.

Fonts for Updates, Downloads and Purchases

ITC (International Typeface Corporation)
http://www.itcfonts.com/itc/

EyeWire/Image Club
www.eyewire.com/type

TreacyFaces
http://www.treacyfaces.com/

ANIMATING GIFS

THIS CHAPTER WILL DISCUSS:

➤ Simple Animations: HTML, Photoshop and Illustrator
➤ Onionskinning
➤ Optimization Quick Reviews
➤ Optimization Reviews
➤ Animation Flip Book
➤ GIFBuilder
➤ Photoshop Tips
➤ Project: Create One Animation

SIMPLE ANIMATIONS: HTML, PHOTOSHOP, AND ILLUSTRATOR

Using GIFs for animation is an easy, fun way to add interest and to enhance your web pages. While there is a variety of animation options such as Javascript, After Effects, Shockwave, and Flash, starting with GIFBuilder (GIF Movie Gear for PC) animation techniques is a good foundational beginning requiring no plug–ins, expensive authoring software, or programming languages. Also, what you learn will be applicable to more difficult programs as you progress. Frame animations can be as easy as blinking text or flashing lights. Without anything more than rudimentary HTML knowledge, you can create a simple blinking feature on text by adding "blink blink" to your HTML as shown below. The text, "This web site works with Netscape 4.6 or better" is contained in a blinking box.

```
<P><CENTER><B><I><FONT COLOR="#0099FF" SIZE=
1><BLINK><BLINK>This web site works with Netscape 4.6 or
better.</FONT></I></B></BLINK></BLINK></CENTER>
```

For now, let us begin by opening Photoshop. You will build all of your animation frames into one file and, ultimately, go through all of your layers, turning them on and off to check each one to decide which ones will end up in the final animation. Here are some simple ideas for practice.

Popping/Flashing Effect

1. Break apart your logotype on different layers, or cut up another graphic.
2. Have each separate piece pop or flash by having the piece on one layer only, quickly followed by something else on the very next layer (maybe nothing). For a slower change, adjust the timing later in GIFBuilder, or make more layers of the same item.
3. Decide your overall plan and layout and what you want to appear where and when. Do not merge or flatten the layers.

Vibrating Effect

1. Use a single layer of a complete object (you could use a 24 or 36 point word). Give it a name, like vib1.gif.
2. Create a duplicate layer, name it vib2.gif, and using the Move tool, key in the vertical and horizontal arrows one pixel each. Do not merge or flatten.
3. Open the layers in GIFBuilder and set the interframe delay to 3/100 (300ths of a second).

Animation Within a Logo

1. Create a logo that has an image within a larger image. On several separate layers, duplicate then remove and add parts to the smaller image of the logo by erasing, painting, and pasting.
2. Or, simply rotate, wobble, or spin the smaller image by slightly adjusting the position of the small object from layer to layer.

Using Illustrator

1. Create type on a curved path, and on different layers, move the position forward 1 increment, progressing from layer to layer, making running type. Save.

2. Place in Photoshop. Save as a GIF. For more information, see the on-line tutorials, Using Adobe Illustrator to Make Animated GIFS and Using Illustrator, Photoshop and ImageReady in Concert for Animation.

Quick Review

Methods for opening Illustrator text in Photoshop:

1. Place Illustrator Type into a Photoshop Graphic. After opening the Photoshop Image, go to menu + Place. After finding the Illustrator type, open and click on Place.
2. Open EPS Illustrator Text in Photoshop. To transfer type prepared in Illustrator, save as an EPS file. Go to Open within Photoshop's File menu. Select your EPS and double click. Enter your new resolution. Keep in mind that when an Illustrator file (vector) is opened in Photoshop, it is then bitmapped and becomes the resolution of the existing Photoshop image.
3. Drag/Drop Copy/Paste Illustrator Text into a Photoshop Window. Simply drag your Illustrator path from the window into a Photoshop window (it will show up on a new layer). You may also use Copy and Paste.

ONIONSKINNING

By reducing the opacity on selected layers, you can produce what is called an onionskinning effect. This technique has been used by animators for many years and in traditional terms, involves the use of semitransparent drawing paper, or onionskin. The animator starts with an original drawing of a character, overlays it with onionskin paper, then draws the next action of the character. Another layer of onionskin is superimposed, the following movement drawn, and so on. Each visual change of the character is seen as well as all of the movement positions through the onionskin layers. Due to computerization and Photoshop's layering capability, the process is considerably faster and easier. (See Figure 9–1.)

■ **Figure 9–1.**

Exercise

1. As a beginning exercise for onionskinning, you may want to try working with simple clip art images. Be sure to work with clip art that is legal for your use. You may also want to create your own black and white drawing in Illustrator or Freehand. (See Figures 9–2 and 9–3.)
2. Save your drawing as an EPS and export it into your Photoshop file. Open the image as an RGB; make selections and deletions as necessary on a number of layers.
3. If you wish to thicken the lines of the drawing, blur from the Filters menu, then apply Brightness/Contrast from the Image menu. (See Figures 9–4, 9–5 and 9-6.)

■ **Figure 9–2.** Clip art.

■ **Figure 9–3.** Copyright © 1999 Images with Impact! Lite.

Figure 9–4. Blur.

Figure 9–5. Apply Brightness/Contrast.

Figure 9–6.

4. Add color using a hard–edged brush, making selections from a web-safe palette, discussed in Chapter 4. In the Paint Brush options palette, choose Multiply Mode to keep the black lines from changing color.

5. Begin the onionskinning process by making the bottom and next up layers the only ones visible. Using the second layer's opacity slider, move to 50%. Now that both layers can be seen, use the move and free transform tools to line up the second layer's image (the onionskin) according to the first layer's image to create the first movement of the character. Free transform (Layer menu) allows a number of movements, such as rotation, distortion, and sizing. (See Figures 9–7 and 9–8.)

6. Repeat the onionskinning process on the rest of the layers; manipulate and check your alignments.

7. If you want to have your animation follow a certain pattern, such as making a bird fly or bouncing a ball, draw a tracking scheme using the pen tool. Select the top layer and click on

■ **Figure 9–7.**

■ **Figure 9–8.**

the New Layer icon. Draw your path with the pen. If you want to use a contrasting color, select your choice from the color palette, click on the path name in the Paths Palette. Stroke the Path, use the paintbrush tool and click on OK. Be sure to remove the tracking path layer when you are finished. (See Figures 9–9 and 9–10.)

Preparation

Create or import, then prepare (optimize) your images in Photoshop. Keep them all in one file. Remember that each layer will fill each frame in your GIF animation.

■ **Figure 9–9.** ■ **Figure 9–10.**

OPTIMIZATION QUICK REVIEWS

There are a number of steps that you need to take to optimize your images. To review, this involves the use of management strategies as applied to web sites, and finding the balance between quality and compression for quick user access. Some of these techniques covered in other chapters are sizing, compression applications, the use of web–safe color palettes, color limiting, posterization, aliasing, transparency usage, non–dithering, haloing correction, preloading, image repetition, selections and manipulations within an image, interlacing, and tiling. Refer to Chapter 2 for an extensive list of optimization management strategies. You may also want to try helpful softwares like Adobe's ImageReady®. Review the on–line tutorial using Photoshop, Illustrator, and ImageReady at the end of the chapter. Reviews on the multigraphic palette, transparency, haloing, anti-aliasing, and dithering are here for your convenience.

OPTIMIZATION REVIEWS

Multigraphic Palette

One optimizing technique is the use of a Multigraphic palette. For animation purposes, this palette not only reduces the file size for quick loading, but is also applied to avoid strange flashes between animation frames. This unwanted flashing occurs when each image has a different color palette. You can also use a web-safe $6 \times 6 \times 6$ palette for your animation. More complete information about color palettes can be found in Chapter 4. (See Figures 9–11 and 9–12.)

Exercise

1. Open the images that will occur in your animation. Copy a small sample that has all the colors from each different image onto a new Photoshop document.
2. Arrange the images so that they all appear on the one open page.
3. Flatten this multiple image document and choose Index from the Image + Mode menu. Select the Adaptive Palette, 7-bit to start; reduce amounts of colors as low as possible while keeping image integrity. (See Figure 9–13.)
4. Go back up to the Image + Mode menu and choose Color Table. Save, and you have the completed palette for these five images. (See Figure 9–14.)
5. Open the first of the five original images and select Custom Palette to begin applying the Indexing option. Load the Multicolor Palette for this first image.
6. For the rest of the images, choose Previous Palette.

■ **Figure 9–11.** Netscape color cube. See Plate 4 for color version.

◼ **Figure 9–12.** Multigraphic palette

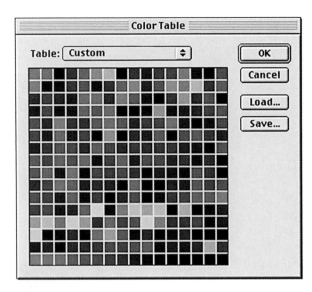

Indexed Color

Palette: Adaptive

Color Depth: 7 bits/pixel

Colors: 128

Options

Dither: None

Color Matching: ● Faster ○ Best

☐ Preserve Exact Colors

☑ Preview

OK

Cancel

■ **Figure 9–13.**

■ **Figure 9–14.**

Transparency

Image Layers in Photoshop often have many of the same elements repeated from layer to layer. This is often true of the background on each layer. Rather than creating a large file size (slower download time), these graphic elements that are repeated from layer to layer can simply be made transparent, after the first complete layer or frame. So, within each frame, only the portions that change between layers need to be stored. Here is a brief review from Chapter 5:

Exercise

1. Index your image, then use GIF89a feature in the File + Export menu. (See Figure 9–15.)
2. Designate one or more colors to be transparent. All browsers that support GIF89a will show pixels with those colors as transparent. This lets backgrounds and colors of other images to show through. (**Note:** The Save As + GIF option will not work.)
3. Choose a color to be your "transparent" color. This color will always show up as transparent, so select one that does not appear in any of your imagery with the eyedropper tool from an image or swatches. Holding down the Command/Control

■ **Figure 9–15.**

key will allow you to deselect colors. Change the preview
color by clicking on the Transparent Index Color swatch.
4. The Default color is gray. Pick a highly noticeable color like
red for transparency, unless there is red within your imagery.
Select the large color swatch for transparency color changes.
Hold down the space bar to pan.

Plain Background

Create a file with two layers, one a plain background, the other
with a brightly colored object. Reduce your file size by making
the background area in the second frame or layer transparent. Try
using the Eliminate White Plug–in filter (see Appendix 3).

Textured Background

Open a textured background that you have created. Select All.
Go to the Edit menu and select Define Pattern. Choose the back-
ground layer of your graphic. Go back to the Edit menu and Fill
with the Pattern option. Go to Menu, Index + GIF89a to choose
your transparent areas.

Haloing

On web sites, this is visually quite unattractive. Haloing is cre-ated by anti–aliasing, which is due to the dithering or blending effect between gradient colors. To smooth out the jagged edge, anti–aliasing is applied. When this object is placed on a web page background, a glowing halo, whitish edge may appear around the graphic. (See Figures 9–16, 9–17, 9–18, 9–19, 9–20.)

▤ **Figure 9–16.**

▤ **Figure 9–17.** Aliased.

▤ **Figure 9–18.** Anti-aliased.

17 colors

type

type

2 colors

■ **Figure 9–19.**

■ **Figure 9–20.** Haloing
(white edge around the
graphic)

Anti–aliasing creates more colors for the file, adding to the memory load due to several gray values added to blend the jaggies. It is always a major factor and goal to keep file sizes as low as possible for web site use. Here is a quick review for prevention of haloing for your animation project.

Anti–Aliasing

The easiest solution is to use aliasing only, if it works well enough. For type, leave the anti–alias button off in the Text dialog box. On other images, do not dither or diffuse. On the background layer of the image, use the same background as the web page. To start, decide which background you will use for your graphic object. Realize that if the background is heavily textured and too difficult to select, haloing cannot be avoided. (See Figure 9–21.) Instead of the same texture, try using a plain background layer that is similar in value and hue to the textured web page back-

▣ **Figure 9–21.** Background texture comparison

ground. An easy way to do this is to use the eyedropper tool to extract a median or heavily used color from the textured web page background. Flatten the two layers and merge. You can open the background texture's Color Table and click on the median hue and value. Record the RGB values, then use these to fill the background layer of your graphic object.

Dithering

Dithering creates intermediate colors not on the Indexed palette. It looks like gradual gradients between colors. If the colors extend over substantial space, a poor image is the result. Dithering works well with very texturized photo images, but adds to the file size of GIF images, reducing good, efficient optimization. Photos are already dithered and additional dithering is probably not necessary, so you will want to leave it turned off in most cases. Also keep in mind that GIF89a Export automatically dithers an image. The fewer colors, the less dithering. Remember to do these procedures before Indexing.

Final Preparation Check

At this point, your graphics intended for animation should be finished and in one Photoshop file. All optimization should be complete and images exported as GIFs using Photoshop's GIF89a feature. Each layer should show a separate character movement. Use enough layers to make smooth transitions in your character or graphic object action. So, each layer shows one small movement of the entire action.

Imagine that you have chosen a clip art image of an airplane and the action is the plane is going to fly a barrel roll maneuver (refer back to Figures 9–9, and 9–10 on page 187).

Using the tracking technique with a drawing tool, the path of the barrel roll is rendered on an added top layer in a contrasting color for easy visibility. You may also find it useful to apply grids to help with positioning objects (Figure 9–22).

Note: Parts of layers that extend over the canvas edges will cause problems with the finished animation. An application such as GIFBuilder will size its frames to adjust for these overlaps. To fix this, before exporting to the animation application, Select All and go to the Image menu. Choose Crop before the final save and export. When finished with compiling the progressive layers, remember to trash the tracking path layer before exporting to the animation program. Do not merge or flatten layers!

█ **Figure 9–22.**

ANIMATION FLIP BOOK

This is a simple, fun trick that will show what your animation will look like before it is exported to GIFBuilder (Mac), GIF Movie Gear (PC), or other program.

1. Change the Layers Palette Thumbnails to the largest size. This size is manipulated by using the Palette Options pop out menu on the right side of the Layers Palette (Figure 9–23).
2. Make the palette as small as possible vertically by dragging up on the sizing box so that only the top layer thumbnail is visible.
3. Click and drag the scroll box up and down or use the scrolling arrows to view the animation. You now have a mini movie or an electronic version of the old-fashioned flip book (Figure 9–24).

Animation Ideas–Review

1. Expanding or contracting circles or rectangles. Each change of circle or rectangle size goes onto a new Photoshop layer.

▣ **Figure 9–23.**

■ **Figure 9–24.**

2. Create a black outlined logo, letter or graphic. Each successive layer fills with a different color or background. This technique could work on a product photograph, such as a car.

3. The same graphic objects are superimposed on several layers, such as balls or spheres. The colors change on each layer to create a flashing light effect. You could lay out a lineup of 3–D balls horizontally or vertically, each layer (frame) 1 changes color. A yellow or white could look like a light flashing.

4. The same graphic goes through a series of filter changes, creating a metamorphosis. (This could also grow or shrink in size.)

5. Prepare a graphic image covered by a layer of solid color. The solid color cracks like glass or earth, progressively falls away, losing pieces layer after layer. Experiment with some of the Photoshop filters or try the Eye Candy effects, like flames.

6. Flashing type-1 layer on, the next off.

7. Open a larger background photo. Flash certain objects or selected areas on top.

8. Create text that can vibrate or move along a path.

9. Distort text in Photoshop's Free Transform. Each layer should show a different position of a progressive distortion. See Chapter 8 for other text manipulation ideas.

10. Create a logo or logotype (see Chapter 8 for ideas and exercises) that will move, break apart, or come together.

11. Make simple graphic objects that can spin, bounce, or fluctuate such as a 3–D disk, ball, or other basic shape symbols. Consider how these might evolve into animated logo designs.

12. Use mnemosynes as preliminary graphics for animation con-

struction and practice. Be sure and place each tangram piece on a separate layer, and check that all backgrounds are transparent. Later, you can replace the triangular objects with other images as you create them, such as letters, parts of a logo, or other graphic elements.

13. Use one graphic and put it through a series of filter changes, creating a metamorphosis. It could also grow or shrink in size. (See Figures 9–25, 9–26 and 9–27.)

■ **Figure 9–25.**
Copyright © 2000
Gene Berryhill

Figure 9–26. Metamorphosis.

■ **Figure 9–27.** Emboss Filter.

14. Cause an image to flash by having one layer on, then the next layer off.
15. Use a background photo and apply Screen Mode. Have selected areas flash, or use more intensive color values in those spots which would appear on selected frames. The positive/negative effect can be created by selecting the original graphic and going to Menu + Image + Adjust + Invert for the second layer as demonstrated in Figures 9–28 and 9–29. These can also be used for rollovers, covered in Chapter 10.

GIFBUILDER

GIFBuilder, GIF Movie Gear, or similar animation softwares are widely available shareware or freeware downloadable from the Internet and don't take a lot of memory to run. To find GIFBuilder (about 350 k) and other programs on the Internet, one source is

■ **Figure 9–28.**

■ **Figure 9–29.**

download.com (see Appendix 3). Search engines like Yahoo can find GIFBuilder quickly by simply typing in the name in the search box. You may have noticed that words like *frame* and *layer* have been used interchangeably at times in our text. This is because each activated layer in Photoshop now becomes a frame in GIFBuilder or similar program. (See Figures 9–30, 9–31 and 9–32.)

▣ **Figure 9–30.**
GIFBuilder - ©
1999 Yves Piguet

▣ **Figure 9–31.**
GIFBuilder - ©
1999 Yves Piguet

▣ **Figure 9–32.**
Photoshop layer,
activated.

Create each frame for animation by turning on only those layers necessary to generate the image. Again, each element that is to move is on a separate layer. Activate that layer when you want to use it in a frame.

Brief Procedure for GIFBuilder © 1999 Yves Piguet

1. Open the program by clicking on the GIFBuilder icon. Choose File + Open. Find your layered Photoshop file and open.
2. Go to Options menu and set up what you want for your animation. Read through the more detailed instructions for GIFBuilder to learn about the menu choices and suggested settings. For now, start with the defaults. You can adjust the timing of frames with interframe delay, make transparent backgrounds, use special effects, and apply looping, to name a few (Figures 9–33, 9–34 and 9–35).

Figure 9–33. GIFBuilder - © 1999 Yves Piguet

Figure 9–34. GIFBuilder - © 1999 Yves Piguet

Figure 9–35. GIFBuilder - © 1999 Yves Piguet

3. Select Window, Preview Window. Choose Animation, Start, to run your animation or use the Command + R keys. To stop the animation, press Command + Period.
4. To change an item in the Frames box, double click to make a new entry.

Start Your GIFBuilder Project

1. Create a simple animation plan, either your own or use one of the suggested ideas.
2. Do the assigned on–line tutorials.
3. Look over the Photoshop tips (page 205).
4. Read through the detailed instructions that come with the GIFBuilder Program.
5. Assemble your own project (Figures 9–36 and, 9–37).

▪ **Figure 9–36.**

12 frames	Length : 1.20 s	Size : 550x50		Loop : forever	
Name	Size	Position	Disp.	Delay	Transp.
Frame 1	550x50	(0 ; 0)	P	10	–
Frame 2	550x50	(0 ; 0)	P	10	–
Frame 3	550x50	(0 ; 0)	P	10	–
Frame 4	550x50	(0 ; 0)	N	10	–
Frame 5	550x50	(0 ; 0)	N	10	–
Frame 6	550x50	(0 ; 0)	N	10	–
Frame 7	371x41	(91 ; 3)	N	10	1
Frame 8	550x50	(0 ; 0)	N	10	W
Frame 9	550x50	(0 ; 0)	N	10	W
Frame 10	550x50	(0 ; 0)	N	10	W
Frame 11	550x50	(0 ; 0)	N	10	W
Frame 12	550x50	(0 ; 0)	N	10	W

▪ **Figure 9–37.** GIFBuilder - © 1999 Yves Piguet

PHOTOSHOP TIPS

1. Double click on zoom tool to make an object 100%.
2. To create a new layer, hold down Option/Alt and click on the new layer icon.
3. Use the Navigator feature (menu + window) to magnify certain areas.
4. Use Screen (Layers Palette + mode + screen) to bleach out an object. Try out all modes on one object to examine the results.
5. On the Layers palette, click and drag one layer to go between two others and rearrange the order of layers.
6. Control + click on a selected area to make the selection appear on a new layer.
7. Use Preserve Transparency when you want to manipulate opaque areas only.
8. Use Menu + Layer + Free Transform to resize an object.
9. Move pointer outside the selection handles to rotate freely (arrow icon will be bent).
10. Select an object with the marquee tool and use the move tool to move it into another frame.
11. Use Menu + Select + Similar to pick up similarly colored pixels.
12. Use Menu + Layer + Transform to scale, rotate, flip, and so on.
13. Add type to an image: Click on a Swatch color for the type, select the type tool, click on the image, type in the words, make attributes. Examine the kerning to see if it needs correction; decide whether to use anti–aliasing by leaving or unchecking.
14. To select an object on a layer, hold down the Command/Control key and click on the image in the Layers Palette.
15. Move objects on different layers by selecting the move tool, hold down the Command/Control key, then select the object in the window. Use the pointer or arrows to adjust the object's position in the window.

PROJECT
CREATE ONE ANIMATION

Create one animation using the information covered in this chapter.

➤ ON-LINE TUTORIALS

1. Building an Animation in Photoshop using Layers
 http://www.adobe.com/studio/tipstechniques/wpdph-sc2/main.html

2. Using Adobe Illustrator to Make Animated GIFS
 http://www.adobe.com/studio/tipstechniques/GIFanimation/main.html

3. Using Illustrator, Photoshop and ImageReady in Concert for Animation
 http://www.adobe.com/studio/tipstechniques/illexport/main.html (Optional)

Chapter 10

Collage, Image Maps, and Navigation

This chapter will discuss:

➤ Collage and Effect
➤ Image Maps
➤ Rollovers, and Other Features
➤ Creating Cyber–Environments
➤ Final Thoughts
➤ Final Project: Finished Layout for the Web Page
➤ Uploading Your Web Site Using FTP

COLLAGE AND EFFECT

Collage is a traditional technique dating back at least to the nineteenth century, during the Art Nouveau period. In French, it means "a pasting." Two brothers known as the Beggarstaffs created this technique, which was art or a design made up of various pieces pasted together. "Often they presented an incomplete image, challenging the viewer to participate in the design by deciphering the subject" (Meggs 1992, 198). Since the beginning of postmodernism and the advent of computer graphics, collages have realized enormous popularity because they are intriguing, beautiful, and can be made quite easily in a software like Photoshop. Advances in photography and other types of mass production imagery have fit in very well with this movement, widely accepted in the fine art and graphic design worlds. Photographs became more than just singular images, but could be collaged together, with other elements, making new statements, potentially suitable for image map use.

Some of these techniques and elements such as gradient blends, shadows, and text, manipulated with blurs, shadowing, opacity levels, colorizing, and feathering have given the ability to create depth and similarities on a group of images, heightening interest and making a number of graphics come together as one. Two of

these features, lighting and texture, are very useful in matching highlights and shadows on several objects, plus the grain levels of various photographs. Curves, Levels, and Lighting Effects (Filters menu) are well worth study and practice, as is the variety of texture possibilities found within the Filters menu such as Noise, Clouds, Pixelation, and several others. Shadow knowledge is highly useful in making convincing renderings.

Classes in traditional drawing and rendering should be part of your course of design study, and cannot be ignored for truly professional–looking work. Photoshop has a handy Drop Shadow feature in Effects, or you can use the Drop Shadow function in the Actions Palette. However, the software cannot tell you how to match up several objects with the same lighting and shadowing for a natural appearance, for a consistent web page design. It is a skill that you bring to the computer and apply according to your acquired knowledge. Study and draw examples of still lifes from drawing books. Start from the basic shapes such as a ball, rectangle, and cylinder. You can also set up these still lifes yourself with strong light positioned at the upper left side. This has been a typical lighting arrangement for many years, and you will find that it is commonly the default setting within softwares. (See Figures 10–1 and 10–2.)

Figure 10–1.

■ **Figure 10–2.**

Student Question

Speaking of highlights and shadows, in working with logo-types and buttons covered in Chapters 7 and 8, I found it difficult to get the chrome look I wanted using Curves. Also, the Chrome option under Filters (Sketch + Chrome) is not what I need either. What else can I do?

Many who learned how to use manual airbrushes powered by compressors in the '70s and 80's became masters at placing hotspots (not to be confused with image map hotspots), or just the right glint of white highlight, rendering chrome and other surfaces effectively. I suggest studying several examples, real and printed. You might also dig up an airbrush rendering book. (Yes, there are entire books covering just this topic.) On your computer, try this:

1. Within Photoshop, make a dark-colored text or graphic, then blur (Filters).
2. Take it through Curves manipulation. (See the Quick Review included from Chapter 8.)
3. If it doesn't seem sharp enough at 100% size, go to Filters + Sharpen + Unsharp Mask.
4. On a new layer, try placing some white or light-colored hotspots where it seems to lend itself; for instance, where two

bright areas are coming together place that extra shot of white to make it look more convincing (see Figures 10–3, and 10–4). Go to Undo in the menu when it doesn't look right. You may need to open the History palette later to trash a buildup of mistakes, or simply drag the airbrush layer into the palette trash icon and try again. Or, make a set of airbrush applications on one layer, turn it off by clicking on the eye in the Layers Palette. Make another set on another layer, and then another. Click the visibility of each layer on and off to find the keeper. Do these highlights primarily on the upper half of the graphic. Using some sky blue tones in the same way can also add to the success of the rendering.

5. For the lower half of the graphic, create a new layer, and go through the same procedure as above, but apply dark tones, such as black, brown and maybe a little violet.

So what we have is basically a reflected "sky and earth" on your object. You will probably have to experiment with Brush sizes (Menu + Window + Show Brushes) and Opacity settings. Double click on the airbrush tool for Pressure, Fade controls. (See Figures 10–5 and 10–6.)

■ **Figure 10–3.**

■ **Figure 10–4.**

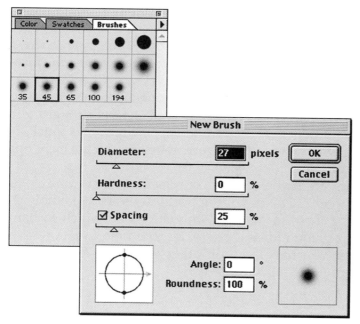

■ Figure 10–5.

■ Figure 10–6.

Quick Review

Make chrome with Gaussian Blur by creating type or a graphic and adding the Blur filter. "Merge Down" the type or graphic layer to a copy of the Background layer. Apply Curves (three or four loops) until it resembles something like chrome.

Note: Also try the Eyewire Tips on making chrome tutorial available at www.eyewire.com.

Starting a Page Composition

1. Select the set of graphics and photos you plan to use, having a theme or idea in mind. It is possible that just the facts about a company or organization will not be enough. Consider using a metaphor to add additional interest to the site.

2. Draw a number of preliminary sketches or roughs with pencil and paper. These can be very helpful and quick, because you will not have to concern yourself with the basic operation of computer tools.

3. Work from the design compositions that were covered in Chapter 1. This is your opportunity to be incredibly creative, using these formats as foundations on which to hang your own unique ideas. Now is not the time to feel restricted by what you have seen on other web sites. (See Figures 10–7, 10–8, 10–9 and 10–10.)

▣ **Figure 10–7.**

▣ **Figure 10–8.**

▣ **Figure 10–9.**

▣ **Figure 10–10.**

4. Select your best sketch and begin opening, placing, and resizing your images in Photoshop, each on a separate layer, maneuvering their positions with the move tool. You will probably want most of the layers (except for the Background layer) to have a transparent background.
5. Reshuffle the order of the layers appropriately.
6. Work with Blending and Opacity to integrate the images into a new composition.
7. Another technique involves the use of a gradient on a layer mask for gradual transition of the object, which seems to fade in or out of the other images around it. (See Figure 10–11.)

Student Question
I was asked to help work on a web site for a small business, and the owner has indicated that she wants a vertical menu bar on the left side, with image and text toward the middle. I would like to try something different, but don't know if this is possible. What should I do?

People often feel that the layout must be in this format just because so many others have used it. There are a number of innovative sites with this composition, but it is not the only solution. Designers can do so much more with a composition that can have

■ **Figure 10–11.** GIFBuilder - © 1999 Yves Piguet

a dynamic visual impact. With nicely prepared lettering and buttons that integrate well with the background, focal point, and other elements, menu items can be placed in areas besides flush left on the page and still be easy to find and read. If the person you are working with is set on this plan, do the best you can with it, but also present other ideas. Then let her choose, knowing that you have given it your best shot. (See Figures 10–12 and, 10–13.)

■ **Figure 10–12.**

■ **Figure 10–13.**

IMAGE MAPS

A navigational graphic for web sites that works well is the image map. With these graphics, browser problems with objects, placement, and font style and size can be virtually eliminated. Web–safe palettes control the color issues. An alternative to the image map is frames, which may not always look as nice, but they can display and scroll information that needs to be updated frequently. This chapter begins with information about collages, because they can be great foundational graphics for an image map, which will be our main focus. The term *image map* refers to navigational mapping of hyperlinks or hotspots placed on a larger image, possibly a collage or table graphic (Figure 10–14) that is clickable. When one of these spots is clicked on by viewers, it will take them to the new destination, either to a new page, to a location farther down on the same page, or another location on the web. You may wonder how a larger image can be acceptable due to download time, but this graphic is not only attractive to look at, but functional as well, and should be worth some wait. Give the viewer something else to do during this time, something that downloads quickly like a small animation, game, or something to read. Or, try the following brief exercise.

Figure 10–14. Simple image map with table borders

Exercise

1. Use small, previously loaded graphics from a splash page, all about the same size.
2. Place them within an invisible table (BORDER=0) and design them into a large graphic, logotype or small set of letters.
3. Use this compiled graphic as an image map. The good news is, there is no download wait.

Quick Review

Some designers prefer tables to making the traditional type of image map, though a table can become an image map as well. Use a single, larger image or a group of images. Take a photograph or graphic and cut it into block–like pieces. Each piece is on a separate layer. For creative variety, you can treat individual parts in a number of interesting ways, which can also facilitate varying download speeds due to different amounts of memory. Consider a variety of compression levels, filter applications, number of colors, opacities, modes, and so on. (See Figure 10–15.)

Following Indexing and GIF preparation (or other compression), place each piece within a table cell. Experiment until you get the effect and times you want. There is a downloadable software for PC called Picture Dicer that may perk your interest at (http://www.weblife2000.com/downloads.htm). Cut-up pieces can be assembled with tags in the HTML instead of using tables. Be aware that edges of the piece must be aligned on the pixel boundary and not in the middle of a pixel for a seamless appearance. Use Guides in Photoshop to fix potential errors (seams) caused by objects snapping to pixel boundaries after uploading.

Image maps with the map file in the HTML of a page are known as client–side maps. The x and y pixel coordinates of hotspot areas plus the URLs of the links are included. For instance, an image map map file starts with the default index.html, then follows with the different items with the URL and x and y coordinates. Here is an example:

■ **Figure 10–15.** Various modes are available within this pull-down menu

```
default index.html
rect blurrr.html              5,15     25,25
```

You would continue to add the x and y coordinates by each item listed. Rectangular hotspots are designated according to the upper left and lower right numbers, a circle is designated by the lower right x or horizontal number and upper y or vertical and one to locate its radius, and the polygon must be defined at each point of boundary change. The information is stored in your local browser's memory. This is in contrast to server–side image maps that must rely on a remote server to provide site information via

a reference file. To finish, each image map piece with a hotspot or hyperlink must have a separate tag and then is assembled within the HTML.

Often, it is helpful to viewers to let them know the plan of the image map so they do not become frustrated trying to find the items they want. Let them know either by visual indication on the graphics or give a written explanation. Simple word hyperlinks are traditionally bright blue and underlined (Figure 10–16).

Some image maps, known as random access, are simple, small text structures located at the top and/or bottom of web pages, sometimes separated by brackets, lines, or boxes. These are located on each page for easy navigation to any page, and from any page. Once this map is constructed, it is a simple matter to copy and paste the HTML onto every page. Since it is repetitive, after first load, it is in the cache, and will already be in place on each page when it is opened. Not everyone agrees with this navigational strategy, as they want the viewer to visit the homepage repeatedly. Both methods are effective, depending on the type of site.

Random Access Maps

Example 1:
[home][products][history][contact us][seminars]

Example 2:
Corepage | Art Gallery | Biography | E-Mail | Ordering

(See Figure 10–17.)

Animations can give visual signals to the navigational properties of the web site, such as vibrating or panting objects, pulsing buttons or bullets, or a flash or rotation of the focal point graphic on a splash page. These GIFs can be incorporated in an image

■ **Figure 10–16.**

■ **Figure 10–17.**

map with hotspots, just like any still graphic. It is recommended that the hotspots apply to the entire animation frame or equally to each frame for browser to browser consistency. As mentioned before, be selective with what you animate; don't use everything you know on one page or site. (Refer to Chapter 9 for more on animation techniques.) If the web site is exploratory or adventurous, discreet rollovers over hotspots (not to be confused with airbrush hotspots) can be exciting additions on the image map, and do not require obvious navigational information. The cursor simply appears as a pointing hand when you have "rolled over" a particular hyperlink with the mouse. Possibly the immediate surrounding area experiences a visual change as well.

The basic procedure to place hotspots on the image map graphic is as follows:

1. Within an image mapping software such as Adobe® ImageReady®, Adobe® Pagemill®, MapEdit (PC), WebMap, or Mapper (Mac), open an image then draw or choose a shape such as a rectangle, circle or polygon to create a hotspot (point of navigation) on the image map, each area on a separate layer. (See Figure 10–18.)

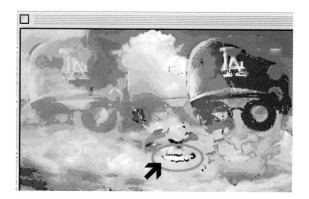

■ **Figure 10–18.**

2. Enter the URL to create the link.
3. Test your links with preview capability.
4. If you are not happy with the results, edit the hotspot either by selecting it in the edit mode and clicking on it, or follow the key command instructions with the software. With WebMap you may make adjustments to your hotspot shapes directly on your image. WebMap is a simple, straightforward program that works with GIF, PICT, and BMP (bitmapped) images. Mapper also uses JPEG files. To resize or reproportion in ImageReady, drag on a handle or use key commands. To move the location, drag from the middle of the hotspot. It is possible to change hotspot colors, layer hotspots over each other or delete by editing + delete. WebMap, Mapper, and Pagemill support the CERN and NCSA image map formats. These are server types specified by your Internet service provider (ISP) and you will use one or the other according to the ISP's specifications. (See Figure 10–19.)

It is possible to create the basics for an image map in Photoshop:

1. Open your image for the map in Photoshop.
2. With the marquee tool draw the hotspot shapes needed on separate layers.

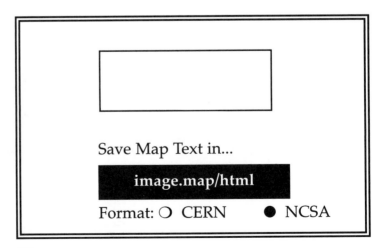

▄ **Figure 10–19.**

3. Open the Info Palette, and for every corner of a path, note the pixel coordinates. Write these down. (See Figures 10–20 and 10–21.)

Note: ImageReady makes this job easier, plus you can save the HTML file in the program, then open it in an application such as PageMill to continue editing and to finish the rest of your page.

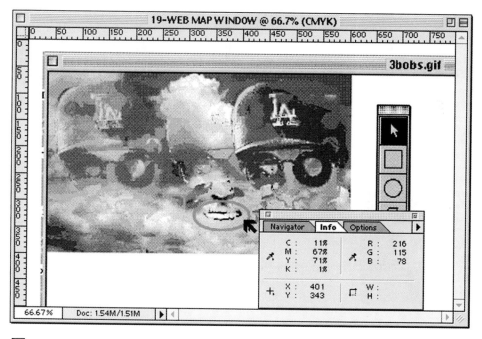

■ **Figure 10–20.**

■ **Figure 10–21.**

4. If you want to place an image such as a button on the original image, make sure that it fits within the hotspot shape you have drawn. Using the Opacity slider can help to visually integrate the images together.

ROLLOVERS AND OTHER FEATURES

There are many creative ways to handle graphics for rollovers or mouseover events, such as positive/negative (Invert) buttons, concave/convex bars, flashing light bullets, change of color text, appear/disappear objects, or the graphic or area around the graphic brightens or enlarges upon rollover—maybe both. (See Figures 10–22, 10–23 and 10–24.)

The first image can turn into an entirely different image within the event. To make the graphic object change into its next visual state, two preloaded versions must be present—a mouse over and a mouse off (examples: convex to concave or positive to negative).

■ **Figure 10–22.**
Positive button

■ **Figure 10–23.**
Negative button

■ **Figure 10–24.**

This action occurs with the rollover of the mouse by the viewer, made possible by a scripting language created by Netscape™ called Javascript®. Macromedia® Fireworks® offers web designers the following features: It can slice an image into sections, and designate them separately as GIFs, JPEGs or PNGs. There are also animation tools and Javascript capability.

It should be noted that Java and Javascript are not the same thing. Javascript is essentially for nonprogrammers and is run within the web browser on the client side rather than on the server side. Java is more complex and best left to programmers. It is necessary to have some understanding of HTML before jumping into Javascript, and doing one of the on–line tutorials suggested in the appendix will get you going. After preparation in the basics, you are ready to place Javascript code into your HTML document.

Here is a sample (see Voodoo in the tutorial appendix):

```
<html>
<body>
<br>
Welcome!
<br>
  <script language="Javascript">
  document.write("Design Web site!")
</script>
<br>
Begin Here.
</body>
<html>
```

The three sections that will show on the page are, Welcome!, Design Web site!, and Begin Here. All of the Javascript is placed between the <script> and the </script> tags; the rest is HTML. There is coding to do any number of things with Javascript, but since this is basically a book on image design for web sites, I will refer you again to the tutorial appendix. Here, we will touch on mouse events briefly. There are two mouse movements, rolling over a hotspot and clicking on a graphic that has been linked to another location. For our demonstration example, images are assigned number 1 and number 2.

1. Open your Sucking Fish Filters convex/concave buttons you made in Chapter 7.
2. Type in the following into your HTML.

```
<a href="#"
   onMouseOver="document.bluamoebae2.src='bluamoebae2.gif' "
   onMouseOut="document.bluamoebae2.src='bluamoebae1.gif' " >
<img src=" img1.gif" name=" bluamoebae2"  width=72 height=38
border=0></a>
```

(See Figures 10–25, 10–26.)

Macromedia® Flash® is a web software that handles animation, including mouseovers. It is Macromedia's web vector animation format. This URL (WebPerfect) will give you the information, download, and tutorial resources needed to get started: http://web.perfect.co.uk/shockwave.htm. Look for the Juggling with Flash tutorial at http://webreview.com/wr/pub/98/ 07/31/feature/index3.html.

CREATING CYBER-ENVIRONMENTS

Programs like Javascript and others enable interaction on web sites. Why do we share such an interest in this communal interaction made possible on the World Wide Web? One important reason is, any valid community is interactive. Individuals and organizations can exchange information back and forth, which is preferred over one–way broadcasting, like television. Ray Oldenburg formulated some unique thoughts about the deterioration of public gathering places in his book, *The Great, Good Place.* This is not a book about the web but gives insightful information that may be valuable to web site design and the cyber-community, as new environ-

■ **Figure 10–25.**
Convex button

■ **Figure 10–26.**
Concave button

ments are created to fill the needs of a changing world. Oldenburg begins by quoting Max Lerner from *America as a Civilization:*

> The critical question is not whether the small town can be rehabilitated in the image of its earlier strength and growth—for clearly it cannot—but whether American life will be able to evolve any other integral community to replace it (Oldenburg 1989, 3)

The cyber-community may very well be part of the solution to the loss of the small town, close–knit environment that Oldenburg believes people are missing. He feels that home and workplaces fulfill only two thirds of an individual's social needs, and that a vital third place is essential to basic human well–being. Churches have often filled these needs, but are not open 24 hours a day. "Domestic and work relationships are pressed to supply all that is wanting and much that is missing in the constricted life–styles of those without community." (Oldenburg 1989, 9). He also says, "No new form of integral community has been found; the small town has yet to greet its replacement. And Americans are not contented people" (Oldenburg 1989, 3). Another interesting note he makes is that great, good places should be socially equalizing public gatherings. Material wealth and high status are inconsequential. "The elderly and poor, the ragged and infirm, are interspersed among those looking and doing well. The full spectrum of local humanity is represented" (Oldenburg 1989, 14).

Here is where I begin to see relevant correlations between the traditional small town and the Internet's sociocultural roles. Third places, outside of home and work offer escape from drudgeries, duties, and hardships through interesting, interactive conversations and environments, without class distinction. "Even poverty loses much of its sting when communities can offer the settings and occasions where the disadvantaged can be accepted as equals" (Oldenburg 1989, 25). All that is necessary is that one be a good conversationalist, a good, interactive player, and be in a viable location. A person at the free access library and another individual with a laptop can easily realize that common ground. Oldenburg further explains:

> Third places that render the best and fullest service are those to which one may go alone at almost any time of the day or evening with assurance that acquaintances will be

there. To have such a place available whenever the demons of loneliness or boredom strike or when the pressures and frustrations of the day call for relaxation amid good company is a powerful resource (Oldenburg 1989, 32).

The cyberspace community is one that offers such opportunities, and the small town, close–knit gathering can be realized, through the spirit of friendship, mutual interest, and good conversation, even though the participants may literally be on opposite sides of the planet. Here is a major strength and function of web sites besides the growing success of business profits on the World Wide Web.

FINAL THOUGHTS

Web site design carries power to change the world in a positive, social manner as well as serving consumerism. Development of younger generations must be responsible and concerned with social marketing. Visual symbols, corporate identity, and branding, heavily used on the Net, must be seen and taught as development potential, as they have historically been a common thread that moves through class, financial and racial barriers, and are a key to unification of peoples throughout the world. In spite of a New Tribalism breaking out in areas such as Eastern Europe, this global bonding evolving up through the Internet continues to grow. Sovereignty holds a weaker stance as foreigners cross lines to lend a helping hand. Hopefully, more often, people are taking the time to learn from one another within peaceful means and are recognizing similarities, as the world continues to escalate as a vast melting pot, due in part to equalizing factors provided on–line. The foundation that corporate identity provided has been a forerunner of such common meeting grounds for continual widespread human development.

Cyberspace is presently a communal environment that heavily uses graphic symbolism and visual design. Web design has a great opportunity within this visual culture, and becomes more accessible and vital when integrated within this community. What group is better equipped and trained to create these great, good web sites? There are direct plug–in opportunities for graph-

ic designers in interactive design; it has a lot of familiar ground but it is also different as we create cyber–environments for chat/meeting rooms, forums, coffee bars, bulletin boards, stores, shopping malls, and museums. Browsing the web, you may think that the job is already covered, due to such an abundance of output, but help from the erudite and up–and–coming professional is needed here. Designing space for virtual reality, multimedia, and interactivity is our fertile ground, our new world. "Cyberspace may seem like uncharted territory to many of us. But we must recognize that this brave new world is not unlike the rest of our environment." (Detweiler 1996, XLII, n. 42: A40). (See Figure 10–27.)

▇ **Figure 10–27.**

FINAL PROJECT
WEB PAGE LAYOUT

Think of a final idea or theme for the web page. Consider using a metaphor. Lay out a design incorporating a number of graphic elements including an animation, text, background, buttons, and graphics. Integrate your original design layouts from Chapter 1. To go beyond the single page assignment, work with graphic material with some repetition on other pages in mind (example: buttons). Make several sketches, with consistency from page to page in mind (fonts, colors, 2–D, 3–D, style of imagery, repetitions). Design an effective navigation scheme. Build the site using your HTML skills or web authoring tools like Adobe® PageMill®, Macromedia® Dreamweaver®, or Netscape® Wizard®.

UPLOADING YOUR WEB SITE USING FTP

Uploading your web site to the Internet is the final step and is accomplished with File Transfer Protocol or FTP, which is provided by Internet Service Providers. There are many good resources available to make this process simple, quick and relatively pain–free. One of the better on–line resource sites is XOOM.com, located at http://www.xoom.com/helpcenter. WS_FTP is for Microsoft™ Windows users, and it is an easy step–by–step application that involves downloading the WS_FTP software from XOOM.com to your computer, then filling in the information in the Session Properties box, as shown in Figure 10–28. After logging onto XOOM's site, work with the WS_FTPLE screen window, shown in Figure 10–29, transferring files from your local hard drive on the left side to the XOOM web site box to the right. This is done by clicking on the file you wish to transfer, then by clicking on the right pointing arrow between the two boxes. Binary is for images and ASCII is for text (HTML). You may want to select Auto. When you are finished, click on Exit. To view your page on the Internet, type in the following URL: http://members.xoom.com/MemberName/filename. Replace the words, MemberName with the name you created for yourself with XOOM.com. Change the words "FileName" to the file name you created. You may want to name it index.html.

Figure 10–28. WS_FTP ©
1999 XOOM.com, Inc.

Figure 10–29.
© 1999
XOOM.com, Inc.

Some other FTP possibilities you may want to try are Netscape Communicator, AOL, and Fetch for MAC. The procedure works basically the same for Fetch as it does for WS_FTP. Fill in the New Connection box as shown in Figure 10–30, typing in Host: ftp.xoom.com, for User ID type in your MemberName, then place your XOOM.com password in the appropriate box. Click OK. Publish your site by using the Directory box, shown in Figure 10–31. Choose Automatic, then proceed to download by dou-

■ **Figure 10–30.** Fetch for Mac connection © 1999 XOOM.com, Inc.

■ **Figure 10–31.** Fetch for Mac file transfer © 1999 XOOM.com, Inc.

ble–clicking on a file name. To upload, select the file and choose Put File. Provide a name for the file as prompted. To view your site, type in the following URL: http://members.xoom.com/ MemberName/filename. Replace the words "MemberName" with the name you created for yourself with XOOM.com. Change the words "FileName" to the file name you created. You may want to name it index.html. Remember that HTML file names, member names, and passwords are case sensitive. (See Figure 10–32.)

■ **Figure 10–32.** © 1999 XOOM.com, Inc.

Navigation Resource

http://stars.com/Location/Navigation/

On–line Tutorials

Creating a Collage (potential image map)
http://www.adobe.com/studio/tipstechniques/wpdphsd9/main.html

Creating Cross–Navigation Icons
http://www.adobe.com/studio/tipstechniques/wpdphse2/main.html

PC On-line Tutorial: Quick and Dirty Guide to Image Maps
http://www.ozemail.com.au/~noeljc/quick&dirty/map.htm

Rollovers
http://www.webreference.com/js/column1/create.html

Javascript
http://rummelplatz.uni-mannheim.de/~skoch/

Downloads

Webmap
http://search.shareware.com/code/engine/File?archive=info-mac&file=text%2fhtml%2fweb%2dmap%2d101%2ehqx&size=170543

Mapper
http://www.download.com/mac/software/0,332,0-34582-s,1000.html?st.dl.search.results.tdtl

bMapedit (A Game)
http://search.shareware.com/code/engine/Find?logop=and&cfrom=quick&orfile=True&hits=25&search=mapedit&category=Macintosh
Or: go to www.shareware.com

APPENDICES

ON-LINE TUTORIALS, RESOURCES, DOWNLOADS, URLS, BOOKS

APPENDIX I
ON-LINE TUTORIALS

Adobe Tips: Tutorials

Web Page Design
http://www.adobe.com/studio/tipstechniques/web-pagedesign.html

Building an Animation in Photoshop
http://www.adobe.com/studio/tipstechniques/wpdphsc2/main.html

Creating Seamless Background Tiles
http://www.adobe.com/studio/tipstechniques/wpdphsd5/main.html

Web Safe Color Palettes
http://www.adobe.com/studio/tipstechniques/wpdphsf2/main.html

Compositing Graphics to a Background Tile
http://www.adobe.com/studio/tipstechniques/wpdphsd7/main.html

Trimming Graphics - Smallest Possible Size
http://www.adobe.com/studio/tipstechniques/wpdphsd4/main.html

Anti-aliased to Aliased
http://www.adobe.com/studio/tipstechniques/wpdphsd6/main.html

Light and Shadows
http://www.adobe.com/studio/tipstechniques/wpdphsd11/main.html

Creating a Collage
http://www.adobe.com/studio/tipstechniques/wpdphsd9/main.html

Creating Cross–Navigation Icons
http://www.adobe.com/studio/tipstechniques/wpdphse2/main.html

Creating Bevel Effects with Photoshop and Extensis PhotoBevel
http://www.adobe.com/studio/tipstechniques/phsphoto-bevel/main.html

Secrets of Layered Animations using Photoshop, Illustrator and ImageReady
http://www.adobe.com/studio/tipstechniques/illexport/main.html

Other Tutorials

Photographs to Illustrations
www.eyewire.com/tips

Java Tutorial
http://java.sun.com/docs/books/tutorial

Voodoo's Intro to Javascript
http://rummelplatz.uni-mannheim.de/~skoch/js/tutorial.htm

Using Adobe Illustrator to Make Animated GIFS
http://www.adobe.com/studio/tipstechniques/GIFanimation/main.html

Mapedit
On-line Tutorial: Quick and Dirty Guide to Image Maps
http://www.ozemail.com.au/~noeljc/quick&dirty/map.htm

APPENDIX 2
ON–LINE RESOURCES

Glossary of Web Site Terms
http://xoom.com/helpcenter/glossary

HTML Writers Guild
http://www.hwg.org/

HTML Writers Guild On–line Classes
http://www.hwg.org/services/classes/

Web Developer's Virtual Library
http://wdvl.internet.com

PNG Homepage
http://www.wco.com/~png/

FTP
http://www.xoom.com/helpcenter

Net Etiquette
http://www.webpromote.com/wpweekly/feb99vol1/
courtesy.html

Killer Web-site Design Tips
http://www.killersites.com/1-design/index.html

Javasoft
http://www.javasoft.com

Macromedia Shockwave
http://www.macromedia.com/shockwave

Earthweb's Java Directory
http://www.gamelan.com

Scanning Tips
http://www.hsdesign.com/scanning

Amazon Books
www.amazon.com

Optimizing Web Graphics
http://webreference.com/dev/graphics/compress.html

Creating Web Sites
http://home.netscape.com/browsers/createsites/index.html
http://home.netscape.com/communicator/creatingsites.html

Rollovers
http://www.webreference.com/js/column1/create.html

Navigation
http://stars.com/Location/Navigation/

In Design School, They Promised No Math
http://webreview.com/wr/pub/97/11/28/tools/index.html

CSS
http://www.bigcitydesign.com
http://www.w3.org/Style/css/

Typography
 itcfonts
 http://www.itcfonts.com/itc/
 treacyfaces
 http://www.treacyfaces.com
 eyewire
 http://www.eyewire.com
 fontnet (fuse)
 http://www.type.co.uk/home2.html

Jobs/Salaries

http://www.zdnet.com/intweek/supplements/salary/role.html

Audio/Video Resources

WAI
http://developer.netscape.com/docs/manuals/enterprise/
wai/index.htm

CGI

http://www.cgibook.com/cover.html

AVI

http://www.erinet.com/cunning1/avi_mov.htm

AVI Editor

http://www.flickerfree.com/index.html

AVI (audio video internet) Media

http://www.avim.com/

APPENDIX 3
DOWNLOADS

Download.com Toolkits
http://www.download.com/Mac/Ed/Index/0,43,0-t,00.html

GIF Wizard
http://www.gifwizard.com (free site scan for broken links/compression)

GIFBuilder download
http://iawww.epfl.ch/Staff/Yves.Piguet/clip2gif-home/GifBuilder.html

GIF Movie Gear (GIF animation for PC)
http://www.download.com/pc/software/0,332,0-55707-s,1000.html?st.dl.post.bc.tdtl

Netscape's Background Sampler of over 60 cached backgrounds
http://www.netscape.com/assist/net_sites/bg/backgrounds.html

PhotoGIF Photoshop plug-in filter, BoxTop Software, Inc.
http:;//www.boxtopsoft.com.

Macromedia Flash
http://web.perfect.co.uk/shockwave.htm

Image Mapping

For PC:

Map This (image mapping, editor)
http://www.zdnet.com/pcmag/features/webgraph/img-r4.htm

Image Map Editor
http://www.zdnet.com/pcmag/features/webgraph/img-r5.htm

Mapedit
Quick and Dirty Guide to Image Maps
http://www.ozemail.com.au/~noeljc/quick&dirty/map.htm

For Mac:
Download: bMapedit
http://search.shareware.com/code/engine/
Find?logop=and&cfrom=quick&orfile=True&hits=
25&search=mapedit&category=Macintosh
 Or: go to www.shareware.com

Mapper
http://www.download.com/mac/software/
0,332,0-34582-s,1000.html?st.dl.search.results.tdtl

WebMap
http://search.shareware.com/code/engine/
File?archive=info-mac&file=
text%2fhtml%2fweb%2dmap%2d101%2ehqx&size=170543

Enhance
http://www.download.com/Mac/Result/TitleList/
1,2,0-a-0-0-e-1,00.html?st.dl.fd.qs.results

ZDNet
http://www.zdnet.com/zdhelp/howto_help/
howto_mac_help.html#2

Download.Com
http://www.download.com

Shareware
www.shareware.com

PC:
http://www.download.com/PC/FrontDoor/0,1,0-0,00.html

WinZip download:
http://www.download.com/cgi-bin/acc_clickthru?clickid=
00000218c12ed4e700000000&edition=CNET&cat=
WINZIP&site=DL&url=http://www.download.com/
cgi-bin/dl%3F18840-ftp://ftp.winzip.com/winzip70.exe

PC and Mac:
http://www.zdnet.com/

White to transparent filter download:
 http://www.edesign.com/filters/

WebWhacker download:
 http://www.bluesquirrel.com/

Streaming Media: Audio/Video
 http://www.realplayer.com/

Pure Mac Photoshop Plug-Ins
 Freeware: Sucking Fish, PhotoText Solo, PhotoBevel Solo, plus
 several inexpensive shareware downloads such as PhotoGIF
 and ProJPEG.
 http://www.eskimo.com/~pristine/photoplug.html

Free Plug-Ins For Button Creation
 AFH Systems Group-Windows
 http://www.afh.com/web/pshop/free.html

Plug-in COM HQ-Mac and Windows
 http://pico.i-us.com/

Free Photoshop Filters-NVR (New Virtual Research)
BorderMania
 http://www.mediaco.com/nvr/filters.html

Text Editing–Download

BBEdit-free BBEdit demo and BBEdit Lite
 http://web.barebones.com/free/free.html

Downloads For PC Webmasters
 http://www.weblife2000.com/downloads.htm
 (Several items including Screen Ruler and Picture Dicer)

ImageStyler for Mac and PC–Demo Download
 http://www.adobe.com/prodindex/imagestyler/
 demodnld.html

APPENDIX 4
SOME FAVORITE URLS

ICSLA.com
foapom.com/
designory.com
landor.com
xe.net/currency
spectacle.com
trace.ntu.ac.uk/quilt/info.htm
http://www.brainiac.com/art/
itcfonts.com/itc
booktv.org
babelfish.altavista.digital.com/cgi–bin/translate?
isea.qc.ca/welcome.html

APPENDIX 5
BOOK SUGGESTIONS

Craig, James. 1999. *Designing with type: A basic course in typography.* 4th ed. Lakewood, NJ: Watson-Guptill Pubns.

Dayton, Linnea. 1997. *The photoshop wow book.* Berkeley, CA: Peachpit.

Erickson, Millard J. 1998. *Postmodernizing the faith.* Grand Rapids, MI: Baker Books.

Gombrich, E. H. 1960. *Art and illusion, a study in the psychology of pictorial representation.* New York: Princeton University Press and Phaidon Press.

Itten, Johannes. 1997. *Design and form: The basic course at the Bauhaus and later:* John Wiley & Sons.

Lauer, David. 1997. *Design basics.* Fort Worth, TX: Hbj College & School Div.

Lovejoy, Margot. 1997. *Postmodern currents: Art and artists in the age of electronic media.* Upper Saddle River, NJ: Prentice Hall.

Murphy, John. 1991. *How to design trademarks and logos.* Cincinnati, OH: North Light Books.

Negrino, Tom, and Dori Smith. 1998. *Javascript for the World Wide Web: Visual quick startguide.* Berkeley, CA: Peachpit Press.

Siegel, David. 1996. *Creating killer web-sites.* Indianapolis, IN: Hayden Books.

_____ . 1997. *Secrets of successful web sites: Project management on the World Wide Web.* Indianapolis, IN: Hayden Books.

Shlain, Leonard. 1991. *Art & physics: Parallel visions in space, time & light.* New York, NY: Quill, William Morrow.

Weinman, Lynda. 1998. *Deconstructing web graphics 2.* Indianapolis, IN: New Riders.

_____ . 1997. *Designing web graphics 2.* Indianapolis, IN: New Riders.

Weinmann, Elaine. 1998. *Photoshop for Windows and Macintosh: Visual quick startguide.* Berkeley, CA: Peachpit.

Wozencroft, Jon. 1994. *The Graphic Language of Neville Brody.* New York, NY: Universe Publishing.

Glossary

Absolute positioning and layering
Part of DHTML that affords definition for the placement of images, text, links, applets, and plug-ins on a web page. Can also use CSS (see Style Sheets).

Acrobat
PDF (Portable Document File) software made for universal transfer of various types of files on the World Wide Web. Manufactured by Adobe®.

Actions
A palette within Photoshop with default presettings such as drop shadow. Custom actions can also be made.

Algorithm
Systematic method or procedure to solve a mathematical problem.

Alpha channels
Handy for attaining graphic objects in Photoshop. When a selection is saved as an alpha channel, activate the selection by keying in Command/Control; follow with clicking on the channel name.

Analogous
Colors next to each other on the color wheel, such as red and orange.

Applet
A client–side program scripted in Java or JavaScript, often for animation purposes.

Batching
This refers to working with or making a group of images, using preset commands from the Actions Palette in Photoshop. A custom optimizing setup can be applied to several images for a web site.

BinHex
Used to send large graphic files over the Internet.

Bit depth
The number of available colors in an image.

Bookmark
Allows users to select a web page they want to keep on file for return visits.

Branding
More recently, a step beyond logo design and corporate identity, in that symbolism, and psychological, sociological, spiritual considerations of logo and visual identity are researched and seriously taken into account. Branding is handled by a team of professionals, primarily graphic designers who have interdisciplinary educations and can apply it to design.

Brandmark
A symbol often without lettering placed on products or services to distinguish one supplier's goods from another.

Cache
There are two kinds of caches: memory and disk. The memory cache keeps items in memory. Disk cache stores recent pages visited so you can reopen them again without having to wait through another download.

Client-server
A computer network that operates and shares information/interactions between clients and servers.

Client-side program
This uses the end user's computer hardware. Java and JavaScript are client-side programs.

CLUT
Color Lookup Table; palettes created for Indexed images and applied to reduce numbers of colors.

CMYK
The four–color process inks used for printing, cyan, magenta, yellow and black (K).

Common Gateway Interface (CGI)
This is a server–side action that accesses external programs. Whereas HTML has one–way communication via the server, CGI permits interaction between client and server.

Compression
Compression is necessary to reduce the file size of an image so it downloads quickly and works well on a web site. This is achieved by the reduction of data within the image. However, just enough data must be maintained so the image still holds its visual integrity and looks good.

Cookie
This is an item stored by a web server in file on your hard drive. It is a method used to track visitor information such as purchases on a web site.

Corporate Identity
Visual elements that represent a company or organization.

CSS
Cascading Style Sheets. See Style Sheets.

Diffusion
Diffusion dithering is preferred over pattern dithering, due to a better blending and less value contrasts.

Dithering
Numbers of colors blended together that are not included within the Indexed palette. It mixes the colors and tries to emulate actual colors. See Haloing.

Download
To receive a copy of a file from another computer via the net.

Downloadable fonts
This is a capability of Dynamic HTML allowing type fonts to be downloaded onto a viewer's computer, as the designer intended.

Dynamic HTML (DHTML)
Dynamic HTML mainly comprises HTML and Java, giving designers more control over their web graphics.

Encryption
Used for privacy on the Internet with such functions as e–mail, listservs, chat groups on the Internet.

Extranet
The extranet is for business network/interaction via the World Wide Web. Much like an intranet, but combines with vendors outside the organization through the web handling business dealings like collections and placing orders.

File Transfer Protocol (FTP)
A major use for FTP is to upload files for your web site, and it transfers files between computers.

Firewall
A device to prevent computer hacker invasions into another's computer system.

Fragments
These are anchors interspersed within long drafts of text and can be accessed at different points using navigation/hotspots.

Frames
Refers to scrolling sections that hold graphics or type on a web site. Also a term used for the area within an animation cel.

Freeware
Copyrighted software/programs available on the Internet that are downloadable and free for individual use. Any commercial usage usually requires permissions. See Shareware.

Gamma
Represents the brightness within values found in midtones.

Gestalt
Gestalt as applied to design is the process of putting a variety of visual objects such as type, photos, illustrations, and motifs together into a visually pleasing and meaningful composition. The final design works together as a unified whole.

GIF

Graphic Interchange Format. A popular mode of compression, is bitmapped and lossless.

GIF89a

An export plug–in operational in such softwares as Photoshop for the purpose of converting Photoshop graphics into GIFs, used after Indexing.

Graphical User Interface (GUI)

A user interface that displays in graphic format instead of just text.

Haloing

An unsightly visual problem created by dithering, which leaves a whitish "halo" around the graphic object.

Hexadecimal

Used within HTML for numerical values that indicate RGB color, often used for backgrounds. Example: #000000 (black)

Hotspots

Just the right glint of white highlight, applied with a traditional airbrush, which renders chrome and other surfaces effectively. Also refers to an image that has clickable areas or spots for navigation on an image map.

HTML editor

A software program for creating web pages. Learning HTML is not necessary to make basic pages. Netscape examples are Netscape Composer and Wizard.

Hue

The actual color, such as a pure red, blue, purple, or yellow.

Hyperlink

Also known as a hotspot or hotlink. A connection found within web pages that when clicked with a mouse, opens a location on a web page within a web browser.

Hypertext Markup Language (HTML)

HTML is a language used to create web pages with text, graphics, hotspots, and hyperlinks.

Hypertext Transfer Protocol (HTTP)
This is the acronym (http://) placed at the beginning of a URL, allowing users to access locations on the Internet.

Icon
Originally a religious image typically painted on a small wooden panel. Also used to identify small graphic objects that provide certain functions, such as the New Layer icon in Photoshop.

Image
A tangible or visual representation.

Image map
Graphic or photo with clickable hotspots for navigation.

Indexing
Refers to the reduction of an image's colors to 8 bits or less.

Interactive design
Creative composition that includes a variety of animations, sound, music, text, and video that others can share in and use.

Interface metaphor
Combined interactive design elements based on an existing idea that has some likeness. The classic definition of a metaphor is, one thing is spoken of as another, it suggests a kind of likeness between two things.

Interlacing
A process that makes an image visible on the web page in stages from low resolution to finished download quality.

ISDN
Integrated Services Digital Network. ISDN is utilized instead of a modem to gain access to the Internet, is separate from phone lines, and has a speed rate of at least five times faster.

Internet
Known as the information superhighway, comprising the World Wide Web news and user groups. It operates through the TCP/IP (transmission control protocols/Internet proto-

cols). Though initially developed in the '60s for the military, Al Gore claims to be "the father."

Internet Service Providers (ISP)

Company that provides services enabling customer access to the Internet via a modem. Users pay a monthly fee.

Intranet

A network that works like the Internet using browser software, but is contained within a particular company or organization for employee/member use.

Java/JavaScript

Javascript is a simpler language than Java, created for nonprogrammers by Netscape. Java was developed by Sun Microsystems. Both languages are client–sided and cross–platform.

JPEG

Acronym for Joint Photographic Experts Group. Used for photographic images on the Internet and supports 24-bit (millions of colors). This type of compression retains smooth blends and tonal qualities but is lossy, and color may not be as accurate as GIF.

Kerning

Adjusted space between two letter characters.

Logogram

A symbol, letter, or sign used to represent a word. Example: $.

Logotype

A graphic symbol including lettering or a name.

LZW compression

Lempel–Ziv–Welch. GIF's compression algorithm; decides the numeric of how many pixels of a color are in one horizontal row.

Metaphor

A statement or presentation that indicates a likeness or transference between things not necessarily related.

Metonymy
The naming of a thing by one of its attributes.

Minimalism
Great simplicity of form in design and art with only the absolute necessities present to communicate the visual message. If a particular mark or object is not essential to the piece, then it should be removed. In graphic design, often a large amount of white space is the backdrop for a composition created with extreme care and thought, especially concerning balance, alignment, form, visual flow, and the relationship between positive and negative space.

Mnemosyne
A mnemosyne is an image that is for the purpose of assisting or improving the memory. The word comes from Mnemosyne, the Greek goddess of memory. A concept for creating a type of code for a design project.

Modem
A machine or device allowing computer hookup to receive and transmit data over telephone lines, accessing the World Wide Web. Digital data is converted to analog data, and vise versa at the receiver end of the communication line.

Multipurpose Internet Mail Extension (MIME)
MIME is used for transmitting e-mail and attachments, which can include visuals and audio.

Optimization
Optimization involves compression, reductions of colors, size, use of transparency and frame differencing, which is a technique used for animation.

Phonogram
A visual character or sign that represents a sound.

Pictograph
A stylized picture that represents an idea.

Picture
A copy or image. A painting or drawing.

Platform
 Systems such as Macintosh Sun, Unix, Windows.

Plug-ins
 For softwares like Photoshop, they add additional graphic functions such as Filters.

PNG
 (Portable Network Graphics–sounds like ping). A replacement format for JPEG and GIF that claims to have superior qualities such as better compression and gamma correction. http://www.cdrom.com/pub/png/pngnews.html.

Real time
 No delay or wait time between people in communication. Similtaneous interaction. E-mail communication is an example of delayed time, whereas talking face– to– face or on the phone is real time.

Resolution
 Refers to the number of pixels in a certain distance and pixels are measured in pixels per inch or ppi. When you want to convert an image from pixels into inches, simply divide the pixel count by 72. An image will decrease in overall screen size as the screen resolution increases. Web pages viewed on monitors are commonly viewed as 640 x 480 pixels.

Reversed out
 The opposite of black type on a white background, inverted to a black background with white type (or graphic). Another traditional term is "knock out."

RGB
 Red, green, and blue, the screen monitor colors.

Rich
 Refers to text that maintains all of its formatting such as, colors, indents, font styles, and style applications such as bold, large caps, centered, and so on.

Shareware
 These are programs that can be downloaded for your personal

use that usually have a fee attached. The amount is often small and the copyright holders appreciate payment. See Freeware.

Sign
A mark having a conventional meaning and used in place of words or to represent a complex notion.

Signature
Identifying name or group of words used consistently in a certain typographic style.

Splash page
Entry page of a web site, often flashy with effects or animation.

Stem
Mainly the vertical parts of letters. These can be thick or thin.

Stress
Median line up of a letterform, such as centered, to the left, or to the right.

Style sheets–CCS
Extensions to standard HTML that allow designers to control multiple web page styles from a single file. Used to predefine page elements such as font size, color, style, image placement, background images, and have the same styles applied to a series of web pages.

Symbol
A mark, character, combination of letters such as the letters of the alphabet. A representation of something else or an innate image.

T1 and T3 lines
These lines are leased dedicated connection lines to the web and can transfer data at 44.7 mps and replace the use of a modem. A small file can download at a rate of 1 KB per second, while a larger file might move at 4 KB per second.

TCP/IP
Acronym for transmission control protocol. These are packets of data that reconstruct the information for a web site loading on the Internet and handle the routing.

Tracking

Refers to overall letterspacing, not just between two letters.

Trademark

A word, name, or symbol in any combination used by a merchant or manufacturer to identify goods.

Uncial

Lettering style that became the beginnings of lowercase or miniscule letters. Named so due to the Roman uncia (inch) measurement from the fourth century.

Universal Resource Locator (URL)

Pronounced as either U-R-L or Yuearl. The naming system used for locating web sites on the Internet. Also known as an address for the Internet.

Upload

To send a copy of a file from one computer to the next using a modem or T line.

User interface

The portion of a computer program that is seen by the user. Also deals with how people interact with what is on the screen; a good user interface is easy to use and is seamless.

Value

Lightness or darkness of hues or a range of values between black and white, known as the gray–scale.

Virtual Reality Markup Language (VRML)

A language using code that provides the ability to show 3–D imagery on web sites.

WAV

This means Waveform Audio and is a protocol for voicemail.

Web browser

An application for Internet navigation via GUI (graphical user interface), which provides visual items to click on rather than having to remember commands to get to where you want to go. The browser resides on the user's computer, and is client based.

Web page

A page viewed on a computer screen that is accessible through the Internet by entering its URL. The page can contain a variety of objects such as type, hyperlinks, image maps, buttons, frames, video, sound, and animations.

Web–safe palette

Designated color palette that comprises 216 colors and remains consistent for Mac and PC as well as different browsers, including Netscape Communicator and Internet Explorer.

Web site

A coordinated set of pages viewed on a computer screen that are connected by hyperlinks. See Web Page.

World Wide Web

Part of the Internet that utilizes a GUI of servers that provides the ability to surf the net.

WYSIWYG

This acronym means what you are seeing on your screen is what its final outcome will be and stands for What You See Is What You Get.

x-height

The part of the lowercase letter used for height measurement, sans ascenders and descenders.

BIBLIOGRAPHY

Arnheim, Rudolf. 1974. *Art and visual perception,* the new version. Berkeley and Los Angeles, CA: University of California Press, Ltd. and London, England.

_____ . 1969. *Visual thinking.* Berkeley and Los Angeles, CA: University of California Press, Ltd. and London, England.

Barnwell, Maurice. 1993. "Collaborative design: The liberal arts and interdisciplinary education." Paper presented at the annual meeting of the School of Visual Art's National Conference on Liberal Arts and the Education of Artists, September 1993. New York.

Carter, Sebastian. 1987. *Twentieth century type designers.* NY: Taplinger Publishing.

Chambers, Karen. 1991. "Hidden Music."(Milton Glaser) *Upper & lower Case,* 18.

Detweiler, Richard. 1996. "Democracy and decency on the internet." *The Chronicle of Higher Education* XLII, n. 42: A40.

Gates, David. 1969. *Lettering for reproduction.* New York: Watson–Guptill Publications.

Gombrich, E. H. 1960. *Art and illusion, a study in the psychology of pictorial representation.* New York: Princeton University Press and Phaidon Press.

Gorb, Peter. 1990. *Design management.* New York: Van Nostrand Reinhold.

Grant, Bill. (January 1999). "Great 21st century brands will be measured by design dharma." *Graphic Design: USA.*

Jung, Carl. 1969. *Man and his symbols.* New York: Dell Publishing Co., Inc.

Lewis, John Noel Claude. 1978. *Typography: Design and practice.* New York: Taplinger Publishing.

Lopuck, Lisa. 1998. "Discriminating Color Palettes."(On-line). *Adobe Magazine.* Available from http://www.adobe.com/ news features/palette/main.html.

Lovejoy, Margot. 1998. *Postmodern currents: Art and artists in the age of electronic media.* Upper Saddle River, NJ: Prentice Hall.

Meggs, Philip. 1992. *A history of graphic design.* 2nd ed. New York: Van Nostrand Reinhold.

_____ . 1989. *Type and image.* New York: Van Nostrand Reinhold.

Neisser, Ulric. 1976. *Cognition and reality, principles and implications of cognitive psychology.* San Francisco: W. H. Freeman and Co.

Oldenburg, Ray. 1989. *The great, good place.* St. Paul, MN: Paragon House.

Schmitt, Bob. 1998. "In Design School, They Promised No Math ." Available from: http://webreview.com/wr/pub/97/11/28/ tools/index.html.

Sebeok, Thomas. 1972. *Perspectives in zoosemiotics.* The Hague: Mouton.

Shlain, Leonard M. 1991. *Art & physics.* New York: William Morrow and Company.

Soberanis, Pat. 1998. "Review for ditherbox for web designers who require more than the 216-color web-safe palette, put out by RDG Tools." *MacWeek* 11: 34.

Solomon, M. 1986. The *art of typography: An introduction to typo.icon.ography.* New York: Watson–Guptill Publications.

Spitz, Ellen H. 1991. *Image and insight.* New York: Columbia University Press.

Steiner, Wendy, ed. 1981. *Image and code.* Ann Arbor, Michigan: University of Michigan.

Walters, Robert. 1999. "Webpromote-online CSS article." Available from http://www.webpromote.com/wpweekly/ nov98vol2/ css.html.

Wozencroft, Jon. 1994. *The graphic language of Neville Brody.* New York: Universe Publishing.

INDEX

A

B